KALILA WA DIMNA

KALILA WA DIMNA

An Animal Allegory of the Mongol Court

The Istanbul University Album

JILL SANCHIA COWEN

New York, Oxford Oxford University Press 1989

Oxford University Press

Oxford New York Toronto
Delhi Bombay Calcutta Madras Karachi
Petaling Jaya Singapore Hong Kong Tokyo
Nairobi Dar es Salaam Cape Town
Melbourne Auckland

and associated companies in
Berlin Ibadan

Published by Oxford University Press, Inc.,
200 Madison Avenue, New York, New York 10016

Oxford is a registered trademark of Oxford University Press

Library of Congress Cataloging-in-Publication Data
Cowen, Jill Sanchia.
Kalila wa Dimna.
Bibliography: p. Includes index.
1. Kalila wa-Dimnah—Illustrations. 2. Illumination of books and manuscripts,
Iranian—Iran—Tabriz. 3. İstanbul Üniversitesi. Kütüphane. Manuscript.
F. 1422. I. Title.
ND3399.K32C68 1989 745.6'7'09553 88-12540
ISBN 0-19-505681-7

1 3 5 7 9 8 6 4 2

Printed in the United States of America

To my mother

who taught me to see where once I only looked and who gave me an artist's vision
of the East that is here partially returned, in gratitude

and

To my father

the "mirror of a prince," whose statecraft, loyalty, and wit reflect
the spirit of these tales

PREFACE

My fascination with the paintings of the *Kalila wa Dimna* in the Yildiz Album dates back to my days in graduate school, when I knew only those reproductions found in journals and among the vivid illustrations of Basil Gray's *Persian Painting.* Although the paintings were acknowledged by Arménag Bey Sakasian in 1923 as the finest examples produced by a royal Persian scriptorium, they were never studied as part of a narrative cycle or compared with such a cycle's larger tradition.

When I began my research in 1976, at the Istanbul University Library, the *Kalila wa Dimna* paintings claimed me immediately, as must have been true for their patron six hundred years earlier. Through the generosity of Dr. Husamettin Aksu, the library's former Curator of Manuscripts, I was able to examine the paintings daily. Many were unknown, having never been published. My first questions were not purely scholarly; enticed by the picture album, I wondered what impression the paintings had made in their original book form and how they had been perceived as cultural objects by their patron.

The fourteenth-century manuscript had been the size of a large atlas, too cumbersome and heavy to hold in one's hands. The patron, seated on the floor, would have slowly turned its pages on a traditional folding book stand. The paradisiacal gardens painted in the outer margins had been yet loftier, and the terrestrial inner regions, set close to the binding, still more confining. The patron must have rejoiced to see the sly jackal, a court advisor like himself, ennobled at the book's end, when an inexperienced lion-king seeks his advice. For the erudite patron, who knew the stories by heart, these newly commissioned illustrations enriched the text by portraying the concerns of the Mongol court and his political and moral beliefs as animal allegory.

My first endeavor was to reconstruct the sequence of the Mongol paintings, which had been cropped and remounted in a large picture album (IUL F.1422) for Shah Tahmasp in the mid-sixteenth century. But these paintings were grouped by size and shape, with no regard for subject matter. They no longer included three narrow vertical scenes and lacked almost all the original text, which had been lost when they were cropped. The fif-

teen lines of text that did remain, however, were sufficient to identify the fourteenth-century manuscript as a version of the twelfth-century Persian *Kalila wa Dimna,* by Nasr Allah Munshi. The more familiar paintings were in excellent condition, but the fragmented state of others (with pieces totally missing, and parts on other pages or repositioned upside down) posed an immediate puzzle. I sketched, photographed, and measured each fragment and, in my room at the Park Hotel at night, tried to assemble a paper model.

To restore the paintings' sequence, I followed Nasr Allah's *Kalila wa Dimna* and then compared the Mongol cycle with a sixteenth-century copy (Ms. 2982) in the Nawab Collection in Rampur, India, which was made before the fourteenth-century manuscript was disassembled for the royal album. The Rampur copy provides essential evidence: the paintings in the Istanbul Yildiz Album represent more than 90 percent of the original cycle, which had existed as a completed codex. With the format of the Mongol cycle preserved in the sixteenth-century copy, the crucial relation between text and image could now be restored.

Having reconstructed the sequence, I was now able to explore certain issues central to the study of manuscript painting. How do the paintings relate—physically and thematically—to the text? How do the paintings exceed the dimensions of a handbook of polity? In what ways do the illustrations of the Mongol *Kalila wa Dimna* adhere to and deviate from the traditions of this cycle? Why, and under what conditions, were the paintings produced? To what extent is this animal allegory infused with the personal concerns and ambitions of its court patron?

The monumental scale and formal grandeur of these paintings are comparable with other Tabriz court productions from the first half of the fourteenth century. Since many of these works are undated, the dating of this cycle remains open. The 1343/44 *Kalila wa Dimna* in the Cairo National Library (Adab farsi 61), however, provides a *terminus ante quem* for the Istanbul *Kalila wa Dimna:* the treatment of several scenes in the 1343/44 *Kalila wa Dimna* is indisputably derived from it. From what is known of mid-fourteenth-century Persian paint-

ing, the art of the book degenerated into a largely provincial style, and the later paintings of the Jalayirid court presage the classical style of Timurid painting to suggest such affinities with the Istanbul *Kalila wa Dimna*. Greater similarities can be found with work produced in Tabriz between 1306 and 1336, such as the Rashidiya *Jami al-Tavarikh* and, more particularly, a group of *Shahnama* and *Mirajnama* album pages in Istanbul (TKS H.2153 and H.2154) and the "Demotte" *Shahnama*. This suggests that the *Kalila wa Dimna* in the Istanbul University Library was executed after 1315 and before 1336. It is, then, the Mongol (IlKhanid) *Kalila wa Dimna*, recorded in 1544 by Dust Muhammad, from the period of Abu Said (1317–35). The presence in this version of sixteenth-century formulas characteristic of Safavid painting, until now usually thought to have evolved at the later fourteenth-century Jalayirid court, supports Dust Muhammad's important claim that a *Kalila wa Dimna* from Abu Said's reign established the precedent for later Persian painting.

Like many Western nations of its time, fourteenth-century Persia was transformed from a stagnant medieval culture to a sophisticated society. The assimilation of foreign ideas and visionary figures gave birth to the artistic explosion that would reverberate into the following centuries. In the early thirteenth century, Persia's political system was defenseless against Ghengis Khan's army of 200,000 soldiers. As a result of the execution of Mongol envoys, Ghengis Khan redirected his plan of conquest westward from China and attacked Bukhara and Samarkand. The defeat of these cities launched the era of Mongol rule in Persia. After an initial period of Pax Mongolia, the Persian khans forged an autonomous identity (the IlKhans, or lesser khans), embracing both the settled life and the Muslim religion. With the help of the Persian elite, the Mongols solidified their power and established a strong regime. During the reign of Ghazan Khan (1295–1304), this political collaboration spurred economic expansion and artistic patronage. The renowned vizier Rashid al-Din—stimulated by foreign ideas, books, and informants—was emboldened to record the first encyclopedic world history, the *Jami al-Tavarikh* (of which no complete illustrated version remains). The survival of his work was ensured by Rashid al-Din's large atelier, composed of talented Turko-Mongol and Persian artists, which had been established to copy and illustrate his manuscripts. This system of patronage provided the blueprint for later artistic patronage, as exemplified by this unsurpassed version of the *Kalila wa Dimna*.

New York J.S.C.
March 1988

ACKNOWLEDGMENTS

Many people gave of their time and expertise to improve this book, and it is a pleasure to be able to thank them now: Metin And, Oleg Grabar, and Marie L. Swietochowski, who read my manuscript at various stages and whose learned insights enhanced this work; Hasan Tehranchian, who ably assisted with translation; Ehsan Yarshater, who cheerfully helped with difficult problems of translation and textual interpretation; and Robert McChesney, who facilitated the arduous task of transliteration.

Others who contributed useful material and thoughtful suggestions include Peter Chelkowski, Richard Ettinghausen, Elizabeth Childs Johnson, Chris Philstrip, Basil Robinson, Eleanor Sims, and Alexander Soper.

Those who read the manuscript and offered valuable editorial comments include Kenneth Cavander, Katherine Fischer (who also made the schematic format drawings), Walis Gilman, David Sachs (a special appreciation), Claudia Swan, Estelle Whelan, and particularly Herbert Siegel, who has been a steadfast friend and to whom I feel a special gratitude.

Much needed photographs of the Rampur *Kalila wa Dimna* were provided by Promod Chandra, Robert Skelton, and John Seyler; other photographs were taken by Nurhan Atasoy, Ernst Grube, Zoran Tosic, and Phil Evola. Bernard O'Kane supplied the folio numbers for the Cairo *Kalila wa Dimna*.

Identifying fauna and flora was achieved with the help of Frank J. Anderson, Honorary Curator of Rare Books and Manuscripts, New York Botanical Garden; John Bull, Field Associate, Department of Ornithology, American Museum of Natural History; and Richard Lattis, Director of City Zoos, New York Zoological Society.

This book would not have been possible without the generosity of the Turkish government; the Istanbul University Library; Gülgün Sayari, president of Istanbul University, who kindly gave permission to study and publish this material; Husamettin Aksu, former Curator of Manuscripts, Istanbul University Library, through whose efforts the album was always made available; Nurhan Atasoy, Dean of the School of Arts and Letters, Istanbul University, whose hospitality and invaluable assistance made my stay in Istanbul even more enjoyable; and Feliz Çağman, Curator of the Topkapi Seray Museum Library, for her kindness in making comparative material available. I am also grateful to the librarians at the British Library, Bibliothèque Nationale, New York Public Library, and Institute of Fine Arts, New York University, where I did much of my research.

To friends and family (especially Julian S. Bach and Judy Angelo Cowen), I owe special thanks.

Finally, special appreciation goes to Joyce Berry, senior editor at Oxford University Press, for her belief in this work and indispensible efforts in seeing it through publication. I also thank Susan Meigs and Irene Pavitt of Oxford University Press for their superb editing. Thanks also goes to Phyllis Toohey for word-processing the manuscript with speed and accuracy.

The publication of this book has been partially supported by the Persian Heritage Foundation, to which I am very grateful.

CONTENTS

Color plates follow page 50

A NOTE ON TRANSLITERATION

I have opted for simplicity in transliteration and have eliminated hamza, ʿayn, and diacritical marks except where a misreading can occur. However, Persian, Turkish, and Arabic words that have entered American English and are found in *The Random House Dictionary of the English Language* are used in the form employed there. These include dynastic and other proper names: for example, "cadi," "Sasanian," and "vizier." Exceptions are made for more commonly used words, such as "Mamluk" and "Uighur." Place names are transliterated in accordance with the Permanent Committee of Geographical Names (London) and the United States Board of Geographical Names. For consistency, exceptions are made for such place names as Maragha and Sultaniya.

KALILA WA DIMNA

INTRODUCTION

Beast fables are the most beloved form of instructional literature in the East. Collections of these tales, in which animals speak artfully although mockingly of human behavior, evolved during the Middle Ages as literary handbooks for rulers and as sources of practical wisdom. Their social and political status can be understood in the West, perhaps, if we consider the kind of appeal Machiavelli's *The Prince* would have had if it had been presented in the voices of familiar and knowing animals. In our age, Charles Granville's *Les Animaux* and George Orwell's *Animal Farm* come closest to the genre. The vivacious tales of the *Kalila wa Dimna*, compiled nearly two thousand years ago, have been kept alive through countless adaptations and translations. The origin of the tales of the *Kalila wa Dimna* can be traced to the popular Indian animal tales, the *Pañchatantra*, first translated from Sanskrit in a lost Pahlavi text. The Persian *Kalila wa Dimna* of Abu al-Maali Nasr Allah Munshi—a translation of Ibn Muqaffa's mid-eighth-century Arabic version—takes its name from the scheming jackals Kalila and Dimna, the central characters of the main chapter. They and their compatriots—the ox Shanzaba, the loyal mouse Zirak, and the clever monkey Kardana—inhabit tales that mirror a real world of intrigue, morality, and statecraft.

The charm and strength of the text lie in its amusing and witty dialogue, radiant display of human behavior, and shrewd lessons in diplomacy. The tales are grouped in chapters, each dwelling on a different aspect of the human condition that is illustrated by tales within tales. The narrative structure binding the stories together is a dialogue between the Indian ruler Dabishlim and the wise advisor and legendary author Bidpai, who introduce each chapter and conclude it with a moral lesson.

The tales were widely disseminated in the East; translations survive in languages from Malay to Hebrew. The *Kalila wa Dimna* was a familiar source of inspiration, whose influence is clearly discernible in the *Masnavi* of Rumi (circa 1260), the *Humayunnama* of Ali-Celebi (early sixteenth century), and the *Thousand and One Nights*. The *Shahnama* of Firdawsi (1010) and "Khusraw and Shirin" in the *Khamsa* of Nizami (circa 1200) also pay tribute to the *Kalila wa Dimna*.

During the Middle Ages, the *Kalila wa Dimna* was widely read as the *Bidpai Tales*. (The name of the tales' legendary Indian author means "wise man" or "court scholar" in Sanskrit.) A Latin translation (circa 1270) by John of Capua spawned the wide circulation of diverse versions, such as Sir Thomas North's *The Morall Philosophie of Doni* (1570), Jean de la Fontaine's *Fables choisies, mises en vers* (1668–94), and Sir A. N. Wollaston's *Anwar-i Suhayli*, or *Lights of Canopus* (1877), that so delighted Victorian literati; there is even an Icelandic version. In the introduction to a recent English adaptation by Ramsey Wood, Doris Lessing remarks that through these fables, "we are led into realm after realm, doors opening as if one were to push a mirror and find it a door."[1]

Illustrated versions are as widespread and as varied as their unadorned counterparts. In Sri Lanka, a fragment of second- or third-century Indian red polished ware depicting a crocodile carrying a monkey has been unearthed.[2] The scene, which probably decorated the shoulder of a sprinkler bottle, is bordered by double lines, suggesting that it was part of a sequence. Other Indian illustrations of the *Pañchatantra* appear on a seventh-century rock relief at Mamallapuram,[3] on molded terra cotta plaques from a circa tenth-century temple in Bengal,[4] and on the painted ceiling of a circa twelfth-century Vishnu temple at Mandapur.[5] There is little narrative progression in these examples, however, to relate them to later cycles.

In Central Asia, at Panjikent, seventh- and eighth-century Soghdian artists decorated the walls of a house with scenes from the *Pañchatantra* and Aesop's fables. The paintings are simple, but their friezelike monumentality, iconography, and synoptic narrative foreshadow imagery and style in Arab and Persian painting.[6]

The *Kalila wa Dimna* was one of the first texts to be illustrated in the Islamic world. Its existence was recorded in 841 by the historian Tabari, when he spoke of the Afshin of Ushrusana in Turkish Central Asia. Soon after, Firdawsi tells us, the Samanid Amir Nasr ibn Ahmad (913–42) ordered Chinese artists to illustrate Rudaki's *Kalila wa Dimna*. The earliest extant illustrations date to only the tenth century: painting fragments

of an incomplete southern Italian manuscript in Greek (Ms. 397, Pierpont Morgan Library, New York) schematically illustrate part of Ibn Muqaffa's translation of the *Kalila wa Dimna*.[7] The heraldic poses of the animals, unusually awkward gestures of the figures, and textual inconsistencies suggest that this cycle draws on an earlier Arab prototype and uses universalized Persian stylistic conventions.[8] The early-thirteenth-century Ayyubid *Kalila wa Dimna* (Arabe 3465) in the Bibliothèque Nationale in Paris, probably painted in Syria or Egypt, is less provincial and more narrative in content; the symmetry and grandeur of the animals are in keeping with the Persian courtly style popular at the time.

Considering the popularity of the stories and the copious production of illustrated manuscripts in the Near East during the fourteenth and fifteenth centuries, it is not surprising that almost every known school of painting should have produced at least one illustrated copy of the *Kalila wa Dimna*. However, the Syrian and Egyptian Mamluk school cycles, inspired by the Ayyubid Arabe 3465 version,[9] are markedly diagrammatic. The portrayal of animals is consistently heraldic, and the development of drama minimal. The *Kalila wa Dimna* paintings of the provincial Persian Inju school (1333)[10] are again exemplary of nonspecific naive representation, recalling the Soghdian wall paintings.

Yet it is two thirteenth-century versions of the *Kalila wa Dimna* (Hazine 363 and 2152) in the library of Istanbul's Topkapi Saray Museum, probably made in northwestern Iran, that anticipate the IlKhanid *Kalila wa Dimna*. Most of the stories illustrated in the IlKhanid cycle are also illustrated in the post-Seljuk TKS H.363 version,[11] whose images are studded with similar expressive details. Devices such as a stepped format and striking color combinations appear wholly realistic in the IlKhanid cycle through the greater elaboration of setting. The TKS H.2152 early Mongol album paintings,[12] though incomplete as a cycle, suggest cohesive narrative progression and are also notable for their sympathetic landscape elements, which are such a striking feature of IlKhanid painting. By the first third of the mid-fourteenth century, a new attitude toward illustration had developed: the emblematic restraints of earlier works

disappear, and the later IlKhanid images become independent of the text. The paintings are monumental, often full-page illustrations.

Most scholars agree that the *Kalila wa Dimna*'s imperial quality attests to the cycle's having been painted in Tabriz during the reign of Abu Said (1317–35). To discern how these forty-nine paintings belong to and diverge from the earlier tradition of illustrating these tales, and to confirm their place in late IlKhanid art, the cycle's original appearance first had to be reconstructed. When the paintings were diassembled and mounted in a *muraqqa* (album) for the Safavid ruler Shah Tahmasp, they were cropped and grouped by shape and size, without regard to the narrative sequence and keeping only fifteen lines of original text.

The reconstruction of the cycle was accomplished by comparing the Istanbul paintings with the sixteenth-century copy in the Nawab Collection in Rampur, India (*Kalila wa Dimna* Ms. 2982),[13] which was probably made in Herat or Bukhara before the IlKhanid manuscript was taken apart. With its conversion back into its original form, after four hundred years of being a book without text, it is possible to see how the illustrations and narrative function as an eloquent whole.

The Istanbul *Kalila wa Dimna* epitomizes the Mongols' literary sophistication and artistic predilection. Its patron and the atelier director worked closely together to organize rambling narratives, flesh out sketchy descriptions, and fashion multidimensional characters from the dialogue of the text. The artists interpreted rather than literally depicted the text, expressing a consistent ethical point of view that attests to the hand of an attentive court patron, interested in seeing portrayed the ramifications of court deceit, reverence for experience, and the influential role of a court advisor. Unencumbered by tradition, the artists modified standard pictorial devices in their innovative interpretation and incorporated contemporary problems and personal allegory. The "kingdom of animals" comes to represent a specific court, whose characters (particularly the royal advisor) and intrigues are graphically magnified.

The thorough treatment of the jackal's character—which fully depicts his fall, punishment, and restitution

as court advisor—typifies how unrelated characters in the text are reinterpreted in this cycle. In the narrative, the jackals in the beginning of the book are unrelated to those at the end.

The remarkable Istanbul *Kalila wa Dimna*, a product of late Mongol court production, was created during the efflorescence of early-fourteenth-century Tabriz, the cultural center and cosmopolitan capital[14] of the Persian Mongol empire. At the crossroads of East and West in northwestern Persian Azerbaijan, the city quickly developed into a thriving commercial and political center. Tabriz fostered a convergence of diverse trades and cultures: Venetian and Genoese ambassadors and merchants (among them, the Polo brothers); Chinese and papal envoys; Eastern engineers, irrigation experts, and physicians; and international artists flocked to its courts and bazaars. The early devastation wrought by Mongol invasions of the Islamic world began to reverse itself in the late thirteenth century in the wake of the Mongols' independence from their kin in China of the Yüan dynasty. Under Ghazan Khan, seventh ruler of the Il-Khanid dynasty, important political and cultural territory was restored to the Persian bureaucratic elite. It was an invigorating time artistically: the intellectual traditions of Persia were revived and flourished, as foreign culture was assimilated. Under the feudal rule of the Mongols, large private fortunes were amassed and court patronage became lavish: splendid public monuments were built, great libraries were established, and the large-scale production of manuscripts was unprecedented (over thirty remain). The first third of the fourteenth century witnessed the beginnings of a Persian renaissance, which, under the Timurid dynasty in the next century, would come to full flower.

The most illustrious patrons and royal advisors of the late IlKhanid dynasty (1295–1336) were the viziers Rashid al-Din and Ghiyas al-Din—exemplars of taste, literary cultivation, and entrepreneurship. Rashid al-Din (1247–1318) so dominates the intellectual and cosmopolitan spirit of the period that one expects to find him at the Medici court in Florence. A man of Persian letters, encyclopedic historian, city planner, and statesman, he was an eminent patron of the arts during the reigns of Gha-

zan Khan, Oljeitu, and Abu Said. He encouraged the development of Tabriz as a center of international trade and built an entire new city, Rashidiya,[15] in its suburbs, where he established a university, his own scriptorium, and a library (reputedly of sixty thousand volumes). The fame and productivity of the atelier helped to make Tabiz a major cultural capital of the Mongol period and attracted artists from China, Central Asia, and Mesopotamia. Two decades after the founding of the scriptorium, with the IlKhanid style now matured, Tabriz artists would produce the *Kalila wa Dimna*: Rashid al-Din's scriptorium had set the standard of production for its successors, as had Rashid al-Din for his progeny. The most illustrious of his thirteen sons, Ghiyas al-Din Muhammad, was politically active and adroit and also became an outstanding patron of the arts. In 1327, he was appointed to his father's important government position as vizier, a post he held for nine years under Abu Said and Arpa Khan. His status at court and his father's legacy would have enabled him to support such an ambitious enterprise as the Istanbul *Kalila wa Dimna*.

This monumental work could have been achieved only through the close cooperation of the patron and the atelier director: heavy, ivory-colored paper was hand-woven, polished, and made in folio size; palettes of semiprecious mineral and vegetable pigments, inks and gold leaf, and the finest brushes were specially prepared; the scenes were selected and their individual compositions scrupulously planned to ensure that the text, painting, and margin embellishment would intermesh; calligraphers were instructed to supply the appropriate textual framework, and artists were chosen to illustrate subjects according to their special talents and instructed in the conventions used; and, finally, a leather binding, probably blind-tooled and stamped, with a decorated flap and doublure, would have been made to grace the work.

The choice of stories in the Istanbul cycle is uniquely similar to the illustrated tales of the post-Seljuk TKS H.363 *Kalila wa Dimna* and is perhaps drawn from it. In fact, the two may have been created in the same province of Azerbaijan—even in Tabriz—and both express a distinct point of view, reflecting their period's

cultural milieu. Although every school of early-four-teenth-century Near Eastern painting produced a version of the *Kalila wa Dimna* that was, in some way, literate and Sinicized in details of style like the Mongol cycle, only this version epitomizes a tradition of superior patronage and atelier production. Stylistic similarities and coherent narrative interpretation also characterize Rashid al-Din's 1306/7 and 1314/15 *Jami al-Tava-rikh (World History),*[16] al-Biruni's 1307/8 *al-Athar al Baqiyah (The Chronology of Ancient Nations),*[17] the *Shahnama (King's Book of Kings)* paintings and scenes from a book on exotic travel in the Topkapi Saray and Diez Berlin albums,[18] the Topkapi Saray *Mirajnama (Book of the Prophet's Ascension),*[19] and the Demotte *Shahnama.*[20] Nevertheless, the Istanbul *Kalila wa Dimna* stands with the Demotte *Shahnama* above the artistic

norms of the early fourteenth century. It is an incomparable distillation of Eastern influences into a dynamic Mongol court style and is the full realization of manuscript painting as personal allegory. In it, we witness the culmination of the work of artists who for half a century had grappled with the expansive drama of the *Kalila wa Dimna* tales.

The paintings' expressiveness was the result of the patron's thoughtful and consistent interpretation of the text, which unifies the cycle; the artists' realization of the full narrative and psychological potential of the fables through their mastery of thinking pictorially; and, finally, the brilliant synthesis of Near Eastern traditions and Eastern influences in a uniquely identifiable IlKhanid aesthetic, which stressed movement, violence, and pathos.

I. THE MANUSCRIPT

The paintings for the Mongol manuscript would have originally followed the sequence of the *Kalila wa Dimna* translated by Abu al-Maali Nasr Allah Munshi in the mid-twelfth century. When the cycle was disassembled and mounted in an album by Shah Quli Kalifa, keeper of seals, for the Safavid ruler and bibliophile Shah Tahmasp[1] between 1533 and 1558, its sequence and format were drastically altered. To reconstruct the paintings as a complete cycle in book format, the history of the original manuscript must be considered.

The *Kalila wa Dimna* images are featured prominently at the beginning of the Shah Tahmasp album, on folios 6 through 28v, with fifteen line fragments of their original text.[2] Every scene differed in size and shape, but the average one filled slightly more than half the dimensions of the text block, which measured 30 × 19 cm, while four or five scenes were nearly full-page illustrations. The painted side and top margins often added another 4 to 7 cm in height and width. The principal criteria for reorganizing the paintings was common animals, original proximity, and, most important, shape and size—the degree to which they lend themselves to grouping in tightly woven, symmetrical patterns recalling the bolder arrangement of text and image in the original.

When the Mongol cycle was remounted in the album, many of the paintings were cut down in size and three were eliminated altogether. Protruding vertical landscape elements were often cropped off and either eliminated or moved. The paintings have withstood these alterations, occasional damage, and slight retouching, and they are still radiant. The reconstruction of the cycle has accounted for the missing paintings.

The comparison of the extant illustrations—forty-nine paintings and two fragments—with the sixteenth-century Rampur copy (*Kalila wa Dimna* Ms. 2982), made in Herat or Bukhara before the original Mongol *Kalila wa Dimna* was disassembled, provided the identification of five additional paintings, two of which are represented by fragments in the album.[3] Three are copies of the lost Mongol illustrations. It has also clarified the physical relation of image to word in the original. The fifty-four scenes that it initially comprised are restored to their original form, their proper sequence established and missing sections reinstated. It is now possible to appreciate the choice of scenes as a complete cycle.

The Rampur cycle is typical of the early-sixteenth-century Shaybanid style; transmutations of pictorial conventions and dramatic tone are attributable to the later taste of Herat or Bukhara patrons.[4] Although the dating of the Rampur manuscript has been controversial, the signature of its colophon is by the well-known calligrapher Mawlana Sultan Muhammad ibn Nur Allah, active in Herat and Bukhara between 1513 and 1550.[5] When Mawlana Sultan Muhammad copied the text, he modified it somewhat by incorporating the language of the contemporary version of the *Kalila wa Dimna*—*Anwar-i Suhayli (Lights of Canopus)*—in preparation for its illustration.

Upon the copy's completion by artists working in Herat and Bukhara, the Mongol manuscript must have been returned to Tabriz, where it was to be disassembled sometime after 1533 and before 1558 to be incorporated in the *muraqqa*. It is not unusual that a manuscript of this caliber should have been previously transported to the Timurid capital of Herat, renowned for its bibliophilic rulers. Some honored the Mongol accomplishment by commissioning their own versions of the *Kalila wa Dimna*.[6] In the great scriptorium of Herat, the Tabriz *Kalila wa Dimna* would have been especially appreciated by such accomplished artists as Behzad, whose own paintings share the earthy humor and naturalistic settings of the Mongol works. Given the superb artistry of the Istanbul *Kalila wa Dimna*, it is highly possible that Shah Tahmasp, when recalled by his father, returned to Tabriz in 1522 with the manuscript in tow. The *Kalila wa Dimna* paintings, however, did not stay in Tabriz long after this; as part of the *muraqqa*, they were among the lavish ascension gifts sent by Shah Tahmasp in 1576 to the Ottoman Sultan Murad III. They have remained in Istanbul since that time.[7]

While the copies of the Mongol paintings would have been completed before they left Herat, the numerous paintings that exceed the original format were apparently added in Bukhara, the Uzbek capital, after the return of the manuscript to Tabriz. These additions were

probably commissioned for Ubayd Allah Khan (1522–39), the illustrious bibliophilic patron who, to avail himself of his atelier's talents, enlarged the original cycle.

Although the Shaybanid artists increased the number of paintings in their *Kalila wa Dimna* from fifty-four to a total of eighty-two, the individual copies of the Mongol cycle were rendered faithfully: the copyists followed the Mongol prototype in their choice and placement of text accompanying the paintings, and, though they conventionally updated details of setting and costume to accommodate early-sixteenth-century taste, they generally replicated the Mongol composition; parts at the top and side, however, including the margin embellishment, sometimes had to be omitted because of the smaller size of the Rampur format. The energies invested in the lavish and monumental paintings of the Mongol cycle—each of which embodies an original conception—were thereby dispersed in creating the smaller Rampur copies and their many additions. Yet the content of the Mongol masterpiece was accurately transcribed, albeit in a perfunctory manner.

If the transcription was accurate, and the original Mongol cycle is fully represented in the Rampur manuscript, on what grounds can we ascertain that the twenty-eight additions were not included in the original Istanbul *Kalila wa Dimna?*

Despite expected discrepancies between levels of artistic capacity and changes in style from the IlKhanid to the Shaybanid period, these twenty-eight paintings are characterized by a consistent failure to achieve the dramatic and pictorial conventions binding the Istanbul cycle. The sixteenth-century artists' approach is painfully literal: a story's narrator is portrayed, and characters are introduced before they participate in the dramatic action. These examples reveal none of the Mongols' ardent appreciation for condensed, intense sequences. Furthermore, whereas every composition and setting is unique in the Istanbul cycle, the Rampur artists unabashedly recycled compositions, figures, and settings every three or four pages. Images are reused not only in copies of Istanbul paintings; the Rampur miniatures that are not directly related to the original cycle are derivative of Timurid paintings or variations of them. These additions

are recognizable by their small, square formats, emphatic symmetry, abundance of Shaybanid figure-types with distended, puffy faces, and casual use of the margin. The Rampur manuscript avails itself of neither the challenge of the text nor the pictorial standards set by the Istanbul cycle.

The physical dimensions of the original text of the Mongol cycle may be inferred from an examination of the present contents of the Shah Tahmasp album. Based on the measurements of existing text fragments, penned in fine naskh, unillustrated pages had a text block 30 cm high and 19 cm wide, permitting nineteen lines on a page.[8] No unillustrated text folios—of which there must have been over two hundred—or lines from them remain in the album; like their predecessors, the Safavids considered the paintings the *raison d'être* of their album. They also preferred their own calligraphy to that of the Mongols, and fine specimens by Shah Ismail, founder of the Safavid dynasty, and his son Shah Tahmasp are interspersed among the folios.[9]

The only Mongol illuminated calligraphy from the *Kalila wa Dimna* is the cartouche found on folio 20 (Figure 1) in the album. There is no evidence that chapter titles were also decorated. Written in graceful foliated Eastern Kufic with gold arabesque on a blue ground, the *bismillah* (benediction of Islam)—"In the name of God, the Compassionate, the Merciful"—would have opened the IlKhanid manuscript. A dual meaning appears in the vocalization of its letters: "Allah" is twice invoked. Both the calligraphy and the cyclic repetition of the spiraling arabesque echo the meaning of these sacred words.

Speculation about the sources and nature of the precise text of the IlKhanid *Kalila wa Dimna* must unfortunately depend on the extant lines in the album. A comparison of these lines with the Rampur text reveals

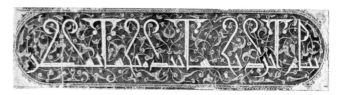

FIGURE 1

close similarities, but the connection is ultimately weak due to the many sixteenth-century interpolations. Copious mistakes, modifications, and stylistic alterations preclude the reconstitution of the original. Yet, when supplemented by additional Rampur text, these line fragments generally correspond to Mujtaba Minuvi's admirable reconstruction of Nasr Allah's mid-twelfth-century Persian translation of the *Kalila wa Dimna*.[10] Nevertheless, too little remains and too little is known about the evolution of Nasr Allah's text and its later recensions in the Mongol period to hypothesize about the specific text of the IlKhanid *Kalila wa Dimna*.

History and Analysis of the Text

The *Kalila wa Dimna* stories illustrated in the Mongol manuscript belong to a family of animal fables nearly two millennia old. Conceived in India between the first century B.C. and A.D. 500, they became common to the languages and cultures of nations from Java to Iceland. This tradition of animal allegory was inspired in India by Buddha's Jataka stories (his birth tales) and by ancient folk tales. Sometime during the fourth century, a compilation of these tales, in Sanskrit, was organized in five chapters—hence the name *Panchatantra*, or "five-fold warp."[11]

The *Panchatantra* fables are told to the legendary Indian King Dabishlim by his wise advisor Bidpai as allegorical instruction and as a mirror for magistrates. The *Panchatantra* often quotes verbatim from the celebrated Sanskrit book of polity, the *Kantiliya Arthasastra;*[12] like that work, it is meant to advise those who rule in the principles of exercising power and diplomacy.

The earliest version of the *Kalila wa Dimna* text is the lost Pahlavi translation, ordered by the Sasanian ruler Khusraw Anushirvan (531–79) and translated by his physician Burzuya, whom he had sent to India for that purpose. Burzuya supplements the recension's original text, of which he preserved the better part,[13] with his own preface and a biographical introduction signed by the eminent vizier Buzurgmihr. Most of the stories come from the *Panchatantra* (and from the twelfth book of the Sanskrit classic, the *Mahābhārata),* while others derive from Manichean and Persian folk tradition.[14] Al-

though the Pahlavi text is now lost, it survives in an old Syriac translation, made by Periodent Bud sometime before 570 and called *Kalilag and Damnag*—a corruption of the Sanskrit names of the two central characters, the jackals Karataka and Damanaka. In about 750, the Pahlavi version was translated into Arabic by Abd Allah ibn Muqaffa and titled *Kalila wa Dimna*.[15] Ibn Muqaffa added an original preface and two chapters and made some alterations in the existing text. Though Ibn Muqaffa's original text is lost, its influence has been greatly felt, as it inspired the more than two hundred recensions, translations, and adaptations that have appeared throughout the East and the West. His Arabic version is the original source of the Hebrew translation (twelfth or thirteenth century, dubiously attributed to a Rabbi Joel), which, in turn, gave rise to a series of Western translations. Most prominent among them is the Latin *Directorium Vitae Humanae* of John of Capua (circa 1270), which, having become immensely popular during the Middle Ages, appeared in countless later versions.

Ibn Muqaffa's translation also spawned a number of Persian versions, but they were all surpassed by the work of Nasr Allah, who, sometime after 1144, was commissioned by the Ghaznavid Bahram Shah to write a revised edition. Nasr Allah's translation is the closest in flavor to Ibn Muqaffa's work, despite the inclusion of period rhetorical adornments and mannered prose reflecting the intellectual taste of the court. For its combination of eloquence and instruction, Nasr Allah's *Kalila wa Dimna* is a fine example of twelfth-century Persian *belles lettres*.[16] His introduction includes a eulogy to Persian kings, a history of previous translations, and a tribute to the *Kalila wa Dimna* itself:

And indeed this is a mine of wisdom, sagacity, and a treasure of experience. It can help the policy of the kings in bringing order into their kingdoms, and people of middle status in preserving their possessions.[17]

Nasr Allah also condensed and clarified the meaning of the text, expanded the discussion of mysticism, and adorned the prose with Persian and Arabic poetry.

Essentially, the structure of the book remained intact. The chapters are unified by the conversation of the In-

dian ruler Dabishlim and the wise Brahman Bidpai, as they introduce each chapter with a discussion of an aspect of the human condition and conclude it with the moral lesson to be learned. Individual chapters contain "frame" stories whose characters frequently introduce subplots. In the Eastern tradition of unraveling complex bundles of tales, Nasr Allah weaves the subtleties of the fivefold warp with unsurpassed lyricism.

Highly praised during the Mongol period, Nasr Allah's work occupied a foremost position in Persian literature until it was superseded by the revised version, *Anwar-i Suhayli (Lights of Canopus)* of Husayn Vaiz Kashifi, made in 1504 for the bibliophile Husayn Bayqara of Herat; its name honors the court minister Ahmad Suhayli. This version is often florid and bombastic, employing strange tropes and metaphors, and is filled with far-fetched epithets. Its verbal arabesques remained in vogue until the threshold of the modern period. The work was widely celebrated by the Victorians: it was printed in its first complete edition in 1836 in England, where it was used to examine the language skills of English officials in Iran and India.

The translations of the Reverend Wyndham Knatchbull (1819) (from the Arabic), E. B. Eastwick (1854), and Sir A. N. Wollaston (1877) (both based on the *Lights of Canopus*) also enjoyed vast popularity in England. Somewhat earlier in France, Gaulmier adapted the *Livre des lumières* from the Arabic; this and a 1666 version of a Greek translation strongly influenced the work of Jean de la Fontaine. Later, the Galland version (1724, completed by Cardonne, 1778) was adapted from the sixteenth-century Turkish adaptation of the *Lights of Canopus*, the *Humayunnama* of Ali-Celebi—another example of the descendants of Nasr Allah's prolific *Kalila wa Dimna*.

The premise of the *Kalila wa Dimna* is established in the first book: as in the *Pañchatantra*, a learned figure—here the merchant-father—undertakes to instruct his inexperienced sons in the principles of polity. This he proposes to do by means of fables. The practical value of the *Kalila wa Dimna* is reiterated in each chapter in the conversations of Dabishlim and Bidpai. Initially, the subject is general polity, but the wise Brahman who illustrates the tactics of diplomacy for his ruler applies his illustrations to specific court circles. As such, it is a "mirror for princes," or *Fürstenspiegel* (a literary genre long popular in Persia[18] and the East.)

The Brahman chose wisely when he proposed these stories as the most expedient means of teaching the science of polity. The choice of an animal world to reflect a human kingdom is not arbitrary; this allegory of human experience evolved naturally from the Buddhist and Indian empathy for animals and nature. Nasr Allah's text is remarkable in the context of the Persian literary tradition, which focuses on man and his deeds. Here, animals represent man, with his weaknesses and strengths, humor and suffering; they portray his generosity, courage, and love as well as his greed, stupidity, and treachery. The jackal, an inveterate scavenger, is portrayed first as conniving and ambitious, then later in the cycle as unselfish and pacifistic. The lion, a mighty ruler, is seen as impulsive, while at times the lioness is the embodiment of wisdom. The monkey is as agile mentally as he is physically, and his wits allow him to survive in old age.

In the *Kalila wa Dimna*, a consistent set of values is developed: of primary importance are self-reliance and adaptability; naiveté and dependence are denigrated; cleverness and ingenuity are the tools for survival. The law of the jungle is frequently amended when strength of character and cleverness triumph over brute force. Polity involves the mastery of the strong by the weak. The mouse, a folk hero in India, relies on his guile to outwit his adversaries, and the cunning crows easily outsmart the proud and gullible owls.

Shrewdness, guile, and adaptability are the heralded attributes of wise and practical characters, and self-protective deceit seems to be exempt from moral judgment. However, deceit practiced against the ruler is clearly punishable. This specific moral injunction occurs for the first time in Ibn Muqaffa's Arabic version. In the *Pañchatantra*, Dimna suffers no punishment for having deceived the lion-king and is reinstated at the royal court. Ibn Muqaffa significantly alters this story by adding the trial and punishment of Dimna, who is ultimately starved to death for his treachery. This commentary on court

intrigue may be said to reflect the close influence of court patronage and the stringent morality of Islamic society (also evident in the dual punishment of the monkey by the carpenter).

Although the didactic content could have constrained the tales, the dialogue in the *Kalila wa Dimna* sparkles with wit and insight and advances the dramatic action as if it were part of a play.

II. THE MASTERY OF ILLUSTRATION
Word into Image

The beauty and dramatic character of the Istanbul *Kalila wa Dimna* can be appreciated in its present truncated format. Its unique interpretation of the text can be best understood if one considers the paintings in their original context as book illustration and in light of their earlier tradition.

The *Kalila wa Dimna* was one of the first works in the Islamic world to be illustrated in book format. The ninth-century historian Tabari records its existence when telling of the heresy charge brought against the Abbasid general Afshin Haydar in Samarra:

In 841, the Afshin of Ushrusana, a Central Asian Turkish prince, was prosecuted for possessing idols and a gold and silver illuminated non-Moslem sacred book. When questioned by the judge about this book, the Afshin replied that he had inherited [it] from "barbarian ancestors." The Afshin also pointed out that the judge himself owned such a work, a *Kalila wa Dimna*.[1]

Another, more widespread account holds that the Samanid Amir Nasr ibn Ahmad (913–42) ordered the poet Rudaki to compose a Persian versification of Ibn Muqaffa's Arabic text. The Amir was so delighted with the text that he "ordered Chinese artists to illustrate the stories, and all who saw and heard the work were filled with happiness."[2]

The early-thirteenth-century Ayyubid *Kalila wa Dimna* in the Bibliothèque Nationale in Paris (Arabe 3465) with Ibn Muqqafa's text contains the earliest extant complete Islamic cycle of these stories. As L. A. Hunt argues convincingly, this manuscript, with its assimilated cultural traditions, was probably illustrated around 1230 by the Ayyubid school in Egypt, known for its cosmopolitan workshop with wide eastern Mediterranean associations, which produced Christian and secular manuscripts simultaneously.[3]

The many scenes in Arabe 3465 are characterized by their emblematic yet lively depiction. Consistently horizontal and sizable (approximately 20 × 13 cm) rectangular paintings are artlessly sandwiched between the text blocks; the unpainted backgrounds complement the diagrammatic tone. Illustration here is primarily nonspe-

cific and decorative; like the Rampur *Kalila wa Dimna*, its purpose is to embellish every so often, not to comment on the text.[4] By dwelling mainly on scenes in which the characters (both human and animal) merely converse with one another, textual interpretation, moral didacticism, and dramatic continuity are lacking. An emphatic or a consistent point of view is missing. Yet, the profusion of gold, the repetition of audience scenes, and the emphasis on the advisor figure are probable clues to the status and sympathies of its patron.

Of the other *Kalila wa Dimna* cycles painted before 1336 (the *terminus ante quem* for Persian manuscripts painted in the courtly IlKhanid style),[5] two more skillfully illustrated cycles are useful in interpreting and commenting on the text: the earliest cycle based on Nasr Allah's text—TKS H.363—and the first Mongol version—TKS H.2152—though incomplete. Both of these variations were probably composed in northwestern Iran and are distinctly closer to the Istanbul cycle than to Arabe 3465.

The 124 miniatures of the TKS H.363 *Kalila wa Dimna* are of particular importance for the Istanbul cycle for their similar eccentric, iconographic features and for their similar selection of illustrated stories. Measuring roughly 23 × 15 cm, these small paintings are subordinated to the physical and literal dimensions of the text more than are those in the later Mongol cycle.

The moon-faced and Near Eastern figures of the TKS H.363 are often dressed in scroll-patterned or solid-colored robes and arranged symmetrically in horizontal registers with minimal formulaic settings on red backgrounds. Relatively free of any Far Eastern influence, the cycle combines a Seljuk two-dimensional style with Mesopotamian elements;[6] though action is stayed, its style is reminiscent of the earlier *Warqa wa Gulshah* (TKS H.841).[7] Although replete with human figures, the TKS H.363 manuscript, like the Istanbul cycle, illustrates predominantly animal tales.

On the basis of the stories and scenes chosen for illustration, it would seem the TKS H.363 cycle takes an ambivalent view toward crime and deceit: in many of the stories, deceit not only is the central issue, but also is sanctioned, in that its rewards are portrayed. Most

often, it is the immediate gain from a crime rather than its due punishment that is depicted.

The TKS H.363 artists—concerned primarily with rendering the text literally—illustrated a story's narrator, its full cast of characters, abundant sequences, and details staged like props to give the illustrations specificity. A bending tree or ruffled bedcover is all that signifies the emotion of these schematic, expressionless characters. Nevertheless, the repetition of particular themes in the choice of scenes and the manner of representation give the cycle its particular flavor: bawdy, popular, and morally flexible. In "The Cuckolded Carpenter," for example, the wife unabashedly receives her husband's apologies for his suspicions after witnessing her adultery (ff. 136 and 137), and in "The Painter's Veil" (f. 87) the wife is enjoying the servant's attention. Two respected members of society—the learned judge and the religious ascetic—are minimized to the point of insignificance.

The choice of illustrations and their conspicuously uninspired style suggest that the TKS H.363 manuscript was painted in a provincial urban milieu rather than a court atelier. Like the *Warqa wa Gulshah*—the only extant manuscript from Seljuk Iran—this cycle was also probably painted in Azerbaijan, where there was an active cross-fertilization of Mesopotamian, Turkish, Central Asian, and Persian cultures during the thirteenth century.[8] Though provincial and unsophisticated, the TKS H.363 cycle is important as a prototype for the later Mongol cycle.

Further development in illustrated manuscripts of the *Kalila wa Dimna* is apparent in the seventeen paintings that remain in a large album in the library of the Topkapi Saray Museum (H.2152, f. 60). The illustrations have been cropped to measure approximately 8×14.8 cm and today form seven registers on a single folio. The first predominantly Mongol-style illustrations of the *Kalila wa Dimna*, they were probably painted at the end of the thirteenth century in the western part of the Mongol empire, possibly in Maragha. They anticipate the 1297 *Manafi al-Hayawan (Usefulness of Animals)* (Ms. 500, Pierpont Morgan Library, New York) in their combination of Persian, Central Asian, and Chinese styles with expressionistic, calligraphic landscape elements.[9]

There is no text accompanying them. Because the illustrations follow one another in close sequence, presenting a fully comprehensible story, it is likely that no text ever existed.[10] The absence of text probably necessitated a more focused and dramatic organization of the illustrations. While the artist was evidently interested in portraying the complete narrative, special attention was given to the action leading to and following the climax. The emphasis on the specific consequence of an action, which suggests a certain sophistication, foreshadows a similar interest in the work of the Mongol artists of Tabriz. In addition, the preoccupation with the behavior of a single character achieves striking psychological and narrative effect, setting the stage for the more mature expression of the later cycle.

Initially, the illustrations, most of which are composed of two animals on a grassy or rocky groundline, appear redundant. However, the suggestive poses of the animals—particularly those of the lion—and the empathetic landscape elements anticipate the more dramatic Istanbul *Kalila wa Dimna*. With the exception of one painting from Aesop's fables ("The Monkey and the Fox"), the TKS H.2152 miniatures illustrate two stories: "Dimna and the Lion-King"[11] and a tale within that tale, "The Attack on the Camel."

The story of Dimna's intervention between the lion-king and Shanzaba is told in the following sequence of scenes:

PRELUDE
1. Kalila and Dimna Scheming
2. The Lion-King Receives Dimna
3. Dimna Observes the Cowering Lion-King
4. Dimna Watches the Lion-King Dining
5. Dimna and the Terrorized Lion-King

CLIMAX
6. The Lion-King Attacks Shanzaba

AFTERMATH
7. The Angry Lion-King Receives Dimna
8. The Lion-King Scolds Dimna
9. The Lion-King Ostracizes Dimna

The story of the attack on the camel is told in the following sequence:

PRELUDE
CLIMAX
AFTERMATH

Both stories explore a problem ignored in previous versions, which is central to the ideology of the Istanbul cycle: the physical and emotional effects of a heinous act. The role of the jackal, who intervenes as a crafty manipulator, is preeminent. The subject of culpability is fully explored and explicitly depicted.

The Istanbul *Kalila wa Dimna* differs from previous versions in several important respects, from which we can make some assertions about the composition of the original manuscript. In pre-Mongol versions of these tales, illustrations appear regularly every two or three pages. They were not meant to express a particular point of view, but merely to ensure that the manuscript was abundantly embellished. In the Mongol *Kalila wa Dimna*, the placement of illustrations is irregular. The long episodic tale "The Lion-King and the Ascetic Jackal" has only one illustration, while the short tale "The Old Snake and the Frogs" has two in rapid succession. Many stories are not illustrated at all. This erratic distribution of the paintings was carefully planned; the illustrated scenes were chosen for their suitability as dramatizations of the patron's ethics.

This careful selection and arrangement of subjects cannot be attributed to the artists themselves, who, as employees, were technicians with little freedom of expression or literary training. The conception had to come from the patron, working closely with the atelier director, who ensured the aesthetic consistency of its execution.

The moment depicted seems to have been carefully chosen to stress the ramifications of an act, rather than the act itself. In some stories, an illustration of the cli-max is conspicuously absent, and another sequence, considered more significant, is portrayed. Other illustrations incorporate characters not found in the text to enhance the allegorical implications. These choices of subject matter expand on themes of deceit and loyalty, inexperience and polity, and selfish desire and punishment.

A comparison with the TKS H.363 cycle reveals a further point of interest. The earlier manuscript comprises nearly two hundred stories (including tales and tales within tales). Fifty illustrated scenes from these are to be found in the IlKhanid *Kalila wa Dimna* as well. However, the IlKhanid cycle includes some new stories not found in the TKS illustrations. For instance, illustrated in the IlKhanid manuscript, but not found in any of the earlier cycles, are "The Fool and the Well" (3), "The Father's Advice" (8), "The Lioness Laments Her Dead Cubs" (53), and "The Crow Imitates the Partridge" (54). In the first of these tales, prudent conduct is advocated, while the others are concerned with changing one's nature. Two original scenes not found in earlier cycles, though derived from stories within them, are included: "The Old Snake" (41) and "Kardana's Deposition" (43), both of which portray the trials of old age. "Kardana's Deposition" is also a didactic example of the peaceful transfer of power. The *Kalila wa Dimna* tales that are traditionally illustrated but not represented in the IlKhanid cycle are those in which deception is rewarded: unlike the TKS versions, the Istanbul paintings avoid depicting the fruits of ruses and deceit. Furthermore, ascetics who act rashly or foolishly are rarely portrayed, and in accordance with the Mongol preference for dramatic action, few nondramatic tales are illustrated. The cumulative effect of these omissions and emphases is to express a consistent ethical point of view.

Another departure from the earlier tradition of this cycle is the addition or exclusion of specific characters; four of the Istanbul scenes deviate from the text in significant ways. In "The Lioness Confronts Dimna" (25), which recounts a crisis in leadership, a sleeping cub is introduced to suggest the tripartite cycle of the ages of man; in "The Stars' Reflections and the Bird's Illusions" (21), a pair of swans replaces the solitary duck described

in the text; and in "The Lark and the Blinded Prince" (51), a queen appears who is absent from the text. These added characters function to underline the stories' lesson—in the first scene, by contrasting the behavior of two characters, and in the second, by comparing two grieving mothers. In "The Crow Spy" (36), the number of the king's advisors is significantly cut in keeping with the Mongol aversion to glorifying deceitful ways. Such interpretive emphasis heightens the narrative impact.

Because the Mongols did not conceive of their illustrations as a series of genre scenes whose appeal lay in their entertainment (as is the case with the TKS H.363 *Kalila wa Dimna)*, they tended to illustrate the more profound issues the text raised—murder, deceit, and hypocrisy in friendship. This ethical approach is apparent in the tales in which the moment following the climax is illustrated; the act itself is only implicit in the scenes, while the physical and emotional aftermath is shown. The expressive capacity of such sequences—and of the few in which the moment preceding the climax is depicted—is unmistakable.

In the Mongol cycle, animals or humans who have killed, attempted to kill, or encouraged others to kill are always shown suffering the punishment the text prescribes. The murderous madam in "The Old Madam and the Young Couple" (14) is shown suffering at the very moment her attempted murder backfires, and the prince in "The Lark and the Blinded Prince" (51) gropes on the floor, with his eyes bloodied and blinded, as retribution for having murdered the infant lark. The TKS H.363 illustrations, however, neglect to show the physical and emotional ramifications of murder and theft: the madam is shown attempting murder, and the prince is being blinded.

The Mongol cycle is also notable for the many stories in which the transgressor suffers the fate he has caused others to suffer, such as "The Crab Kills the Heron" (18), "The Weasel and the Deceitful Frog" (23), "Dimna's Death" (26), and "The Crows Attack the Owls" (40). Although these scenes appear in TKS H.363, their impact is greater in the later cycle, with its demonstration of a morally consistent ethos.

When illustrating stories of immorality, the Mongols

would depict moments early in the narrative sequence, thereby visually "denying" the offenders the fruits of their crimes. The illustrations for "The Ascetic Cat and His Prey" (35), "The Old Snake and the Frogs" (42), and "The Ass and the Fox En Route to the Lion" (48) mock gullibility and susceptibility to flattery; they do not glorify the rewards of harmful or deceitful actions, in marked contrast to the otherwise prototypical TKS H.363. Bawdy stories and scenes are also excluded from the later version: the denouement of "The Cuckolded Carpenter" (38),[12] for example, does not appear in the Mongol cycle. Punishment for other, more serious transgressions—avarice, betrayal, and self-deception—is, however, consistently exhibited. In "The Clever Merchant and the Gullible Thief" (4), the perpetrator receives a dual punishment: lying bloodied on the floor, he suffers the pain of his own self-deception and the pain of the merchant's blows simultaneously. Other transgressions include failing to heed prudent advice, meddling in the affairs of others, and harming friendship with deceit. In all cases, the perpetrators of these acts are shown being punished and suffering. Lesser transgressions arising from blind and selfish desires—like the gluttony of the dog seeking a second bone, the man grasping for honey, and the fox lapping up the spilled blood of the battling rams—are depicted relatively casually, setting into relief the deliberate care that was taken to illustrate punishments for crimes that harm others.

The Mongol atelier director had the sensibility and aesthetic sophistication necessary to compress an entire story into just a few dramatic scenes. An analysis of the correspondence of scenes reveals that the cycle is organized in pairs, giving structure to the narrative and highlighting particular themes. Nearly half of the Istanbul cycle consists of pairs of scenes in which the same characters are represented in two different moments of action. Other scenes are paired by a common narrator, by a moral stated in one and illustrated in the other, or by a common moral lesson. These correspondences bind together individual chapters as well as the book as a whole: seemingly unrelated stories with similar themes are given double exposure; the tenets of each, as well as the overall ethos, are thereby reinforced. In this way,

the recurrence and visual prominence of lions and jackals at the beginning and end of the IlKhanid *Kalila wa Dimna* enhance the cyclic structure of the text.

Pairing gives the paintings an organization that the text fails to do. Just as the moments depicted are chosen to magnify specific moral issues, the placement of pairs of scenes is carefully planned to enhance the drama and broaden the meaning of particular events—that is, to demonstrate that certain actions lead to inevitable consequences; stubborn obtuseness, for instance, will cause an early demise, as is shown by the two illustrations of the story of the fox and the ass. Pairs of illustrations depicting two moments of the same story are repeatedly used to dramatize a pattern of cause and effect. Since it is a pattern that often does not appear clearly in the text, in stressing the consequences of one's acts, the IlKhanid illustrations surpass the written narrative in complexity and ethical content.

Though perhaps inherent in the general nature of narrative painting, this conscious and symmetrical ordering of images merits particular consideration in Mongol painting. Given thirteenth- and early-fourteenth-century examples, it seems that the growing sophistication of narrative painting, the effectiveness of earlier double frontispieces with ceremonial and author portraits,[13] and the Persian predilection for symmetry culminated in the pairing of images. For example, pairs of types of animals—feline, equine, spotted—are integral to the visual organization of the 1297 *Manafi*.[14] Later, in the Rashidiya *World History*[15] and in the Demotte *Shahnama*,[16] symmetrical groupings of illustrations convey the narrative. Pairing as a narrative technique was fully realized in the expanded double-page compositions of the later fourteenth-century Muzaffarid and Timurid periods.[17]

The Istanbul cycle is unique not in its use of paired images, but in the appreciable sophistication of its use of this and other devices. Pairing is only one example of repetition enhancing the narrative's meaning. Distinctive compositions and character types also recur in the paintings. Although seemingly unrelated, the paintings of "The Father's Advice" (8) and "The Ascetic Jackal and His Brothers" (52) have a similar composition; from this we may infer a thematic correspondence too. Consider the initial enthronement scene, "The Ghaznavids" (1). In this scene, certain criteria for understanding later enthronement scenes are established. First, we notice a pattern of hierarchical arrangements of figures. Each is ranked according to his attributes and his relationship to nature. Second, figures seated on the right of the painting have a position of special honor. The repetition of parallel compositions within the initial illustrations echoes and thereby reinforces the pattern. "The Ghaznavids" (1) alone would not render these guidelines. But its close similarity to "The Indians" (7) accentuates their crucial differences. Two illustrations of the Kardana story (44 and 46) have the same composition, and in both the landscape in the margin—the realm of idealized nature—comments on the action. When the friendship of the monkey and the tortoise turns to enmity, this reversal is complemented by a reversal of the natural order—trees grow downward, and the landscape exerts a gravitational pull that is unnatural, empathically reflecting the narrative.

When Nasr Allah translated the *Kalila wa Dimna* in the twelfth century, he emphasized the philosophical framework of the stories by expanding and elaborating on mystical concepts found within the text. It is difficult, however, to isolate Nasr Allah's precise contribution. It is equally difficult to define the pervasive mysticism of the Istanbul paintings.

Sufi metaphysical belief appears to have influenced the selection of scenes and the manner of representation in the IlKhanid *Kalila wa Dimna*. The cycle deviates from the prototypical TKS H.363 to include certain didactic scenes—"The Fool in the Well" (3), "The Father's Advice" (8), and "The Crow Imitates the Partridge" (54)—that emphasize cause and effect, reverence for knowledge, and enlightenment. The scenes call to mind the stages of a spiritual journey and are the primary evidence for the influence of Sufi belief. By the early fourteenth century, mysticism was integral to Persian Islam. It had become institutionalized by government practice and was now overtly celebrated in all forms of art. The

Istanbul *Kalila wa Dimna* can be appreciated for having provided a body of visual metaphor that was to become standard. The hierarchical supremacy of nature in the order of being and of its animal inhabitants, the ecstatic use of color, the extension of a mystical notion of duality to the thematic pairing of images, the introduction of spirits who inhabit nature, the significance of the inner garden, the development of the ideal, transcendental world of the margin, the use of circular compositions with cyclic rhythm—all foreshadow the work at the Jalayirid court of Sultan Ahmad.[18]

The most poetic infusion of mystical imagery in the Mongol paintings can be seen in their gardens, whose iconography recalls the paradisiacal ideal of the Koran. The Koran is filled with analogies between nature and man's state.[19] Mystics thus believe that man's resurrection must be possible because nature is in a process of constant regeneration. In the Istanbul cycle, gardens appear in two settings: one is the celestial sphere of the margin, painted without background, which offers unlimited splendor, while the physical world of the painting proper is limited by its boundaries. The second type is the earthly garden,[20] a symbolic inner realm used to consecrate figures who are not themselves in the garden but are associated with it. Access to a garden is permitted to a few individuals as a sign of their virtue. For example, in "The Father's Advice" (8), a garden with mallow roses glorifies the wisdom imparted by the merchant father. Celebrated in Persian and Sufi literature as absolute perfection, the rose is the essence of everything spiritual, a blessing.[21] Like roses, doors to this garden, both open and shut, carry a symbolic meaning; in "The Old Madam and the Young Couple" (14) and "The Cuckolded Carpenter" (38), closed doors suggest a region inaccessible to illicit earthly lovers, but in "The Clever Merchant and the Gullible Thief" (4), the doors behind the merchant's wife stand open to honor her virtue and ethereal nature. In the three court scenes, the garden is a symbol not only of human virtue, but also of the nobility of a highly revered period of rule. Here, the gardens of the Ghaznavid and Sasanian courts (1 and 2) include only the rulers' crown (not their persons) within their boundaries—evidence of the high esteem in which the Mongols hold the dynasties, as opposed to the individual rulers. In contrast, in the portrayal of the Indian court there is no interior garden.

Whereas the variety of vegetation of the inner garden is limited, gardens in the margin display a great range of flora—a full emblematic vocabulary. Trees, the consummate Persian metaphysical symbol, figure prominently: they blossom, remain evergreen, decay, intertwine, and grow eccentrically in response to the ethics and state of being of the characters they represent. Moral transgressions upset the garden's natural order. Good deeds are symbolized by intertwined fruit trees, friendship is a life-giving force signified by the nurturing embrace of tree-vines, and roses symbolize spiritual love. As specified in the Koran, cool pavilions and fences adorn these lofty shaded arenas. Although the gardens are full of idealized natural forms, their limitless skies and transparent horizons confirm their role as metaphors for paradise.

Nasr Allah's text provides no direction whatsoever for such embellishment. Since the narrative makes no mention of gardens, their incorporation in the illustrations may be seen as the representation of the larger meaning of the stories by a system of visual metaphor[22] that amplifies and deepens the tales' ethical and spiritual content. The text of the *Kalila wa Dimna* is grounded in Islamic doctrine, the cornerstone of the Mongols' own interpretation of these stories. The worldly wisdom expounded by the text could be interpreted as a program of spiritual knowledge. Although no one can say with certainty what the artists intended, it is illuminating to look at these paintings in the light of Sufi belief. The traditional stages of the Sufi mystic's path toward union with the divine—the pursuit of the quest, love, understanding, detachment, unity, astonishment, and nothingness—all seem to be suggested by the paintings, particularly in their deviations from the text. This symbolic overlay can be inferred from the inclusion of original scenes, changes in the nature of some of the characters, the addition of traditional mystical literary imagery, and the expansion of the metaphorical role to the margin.

Seen in this way, the first stage—the "pursuit of the

quest"—is suggested by its opposite. In "The Fool and the Well" (3), a foolish traveler (the opposite of the "wise" Sufi mystic) is seen suffering at the bottom of a cave, having failed to learn in this world. The "stage of love" would then be represented by the union of lover and beloved, as exemplified by the artist's treatment of the lovers in "The Old Madam and the Young Couple" (14). Their spiritual union is celebrated by the pair of roses blooming in the margin's paradisiacal realm, with which they are associated, creating a bridge between the physical love of this world and the ideal love of the divine. The "stage of understanding" is suggested by "The Father's Advice" (8), a scene without precedent, in which the merchant father is represented as a sage teaching his sons. The "stage of detachment" is suggested in "The Clever Merchant and the Gullible Thief" (4) by the wife's unusually ethereal and aloof composure; she is separated from the material world and associated with nature and the paradisiacal (the margin). The "stage of unity" with the ideal world is exemplified by the animal kingdom— the mirror of the human world—and its affinity with nature. The imminent union of Kardana and the tortoise (44) is shown in a lush setting of intertwined fruit trees and circular forms.

The "stage of astonishment" is perhaps suggested by the supernatural power of the ascetic in "The Ascetic and the Adopted Mouse" (39). His truly astonishing size, along with his trancelike expression, dramatizes his ability to transform the humble mouse.

The "stage of nothingness" achieved in "The Crow Imitates the Partridge" (54) fittingly concludes the cycle. The partridge's intuitive understanding leads to his harmonious equilibrium with the terrestrial world and draws him into the celestial realm beyond. By contrast, the crow's lack of wisdom makes him a clumsy fool. This image brings us back in cyclic manner to its opposite, "The Fool and the Well" (3), in which the fool is trapped in the darkness of his bottomless ignorance.

The consistency and ingenuity with which these themes appear to have been threaded throughout the IlKhanid *Kalila wa Dimna* are a tribute to the intellectual energy and spiritual fervor of its creators.

III. ARTISTRY

"Lifting the Veil from the Face of Painting"

The Istanbul *Kalila wa Dimna* cycle, painted at the Mongol court in northwestern Iran, belongs to a group of manuscripts that reflect the last flowering of IlKhanid culture. Of these, the most closely related are the dismembered *Mirajnama* (TKS H.2154) and the dispersed Demotte *Shahnama*. The stylistic correlations between the *Kalila wa Dimna* and other IlKhanid cycles—paintings of the *Shahnama* and a book of exotic travels in Istanbul (TKS H.2153)—are also evident, though not always prominent.

Varying in quality and style, these related works do not always show a clear progression of the monumental or "metropolitan"[1] manner of painting; some recall the Rashidiya style, while others are less robust or more inventive.

Predecessors of the *Kalila wa Dimna* do not equal its stylistic synthesis. In the works that directly precede it— the 1297 *Manafi* and three or four dated manuscripts produced between 1306 and 1328—Chinese and Central Asian traditions were either superimposed on Persian and Mesopotamian styles, or directly adopted to create the tinted, spacious ink paintings like those found in the Rashidiya *World History*. While these cycles employ a related vocabulary of Eastern landscape elements and a variety of expressive drawing techniques, they do not exhibit so spiritual a portrayal of nature, meticulous an elaboration of setting, or ambitious and accomplished a format as the *Kalila wa Dimna*. Produced by Tabriz artists during the first third of the fourteenth century, the paintings are the culmination of the IlKhanid style.

Dust Muhammad, the sixteenth-century Vasari of Persian art, identifies a *Mirajnama* and a *Kalila wa Dimna* in his discussion of the seminal works in the evolution of Persian painting:

It was then [during the reign of Abu Said] that Usted Ahmed Musa, who learned his art from his father, withdrew the covering from the face of painting, and invented the kind of painting which is current at the present time. An *Abu Saidnama*, a *Kalila wa Dimna*, and a *Mirajnama*, copied by Mawlana Abd Allah, were illustrated by this painter.[2]

Because of the dismembered state of the *Kalila wa Dimna* manuscript, its place in Persian painting, though much discussed, could not be immediately confirmed. Since its reconstruction, however, the manuscript's remarkable dramatic and aesthetic cohesion can be appreciated, as well as its variations on received tradition, which, in turn, created new conventions.

Planning the format of the large-sized, generously illustrated *Kalila wa Dimna* required the collaboration of its patron and atelier director to ensure the thematic and visual dovetailing of text and illustration. Though a general format prevailed, each painting differs in shape and size. The extant lines of text attached to the paintings in the album, like those in the close Rampur copies of Mongol originals, consistently pertain to the action illustrated. Since the paintings need no narration and are self-sufficient, the text block is maximized for its design potential. On illustrated pages, the size of the predominantly L-shaped text is fitted to the dimensions of the painting, including its painted side and upper margins. The illustration dominates the text, though the two interlock like pieces of a puzzle.

Not surprisingly, most paintings without their margins have a traditional rectangular horizontal format, but at least ten of the images rise vertically, some to a height of 30 cm, supplemented by 4 to 7 cm of the upper margin.[3] Almost all of the paintings have articulated side margins with prominent vegetation rising to great heights, expressing the Mongol delight in vertical proportion. Experimentation with format led to a variety of predominantly L-shaped configurations: the L-shaped painting and margin extensions and the similarly shaped text that together form a monumental rectangle. In "The Lion-King Receives Shanzaba" (Figure 2A), the L-shaped text frames and punctuates the scene,[4] whereas in "Man's Fate" (Figure 2B), the painting is L-shaped and the text is an implied mirror image—a vertical rectangle with an extending line at the top. Though "Man's Fate" is the only extant example of narrow verticality, its shape was used in other paintings that now exist only in Rampur copies: "The Fool and the Well" and "The Crab Kills the Heron." In "The Clever Merchant and the Gullible Thief" (Figure 2C), the L-shaped text frames a vertical, rectangular painting, forming a larger rectangle that is bracketed by the painted L-shaped margin. The same

FIGURE 2

asymmetrical, but the geometric interplay of text and colonized margin is balanced by equivalent oppositions. In "The Frightened Mouse and the Trapped Cat" (49), for example, the page is subtly balanced: the majestic tree that sweeps out of the painting and reappears in the upper margin provides a form symmetrically opposed to the L-shaped text.

Originally the fifty-four miniatures lacked the traditional ruled borders that in earlier manuscripts separated the painting from its margins; the Tabriz artists found the borders superfluous, but continued the tradition of distinguishing painting from margin by using the standard length of the text line. In some cases, a single line of standard length (approximately 18.8 cm) was sufficient; for example, the one line of text at the top of the close Rampur copy of "Man's Fate" determines the width of the painting proper (with its painted sky) and distinguishes it from the margin (unpainted background). This attention to the various components of the page is important for the compositional and metaphoric role that the margin assumed for these artists.

Composition and Figure Arrangement

The consistency of composition and mood throughout the Istanbul cycle may be explained by two factors: the influence of traditional modes of representation and the controlling hand of the atelier director/master artist.

In the thirteenth century, Islamic artists were varying traditional compositional formulas to accommodate an expanding repertory of subject matter. Greater innovation in the fourteenth century—the result of attentive patronage and the growing sophistication of artists—can also be traced to the stimulus of other traditions and the greater availability of models to copy as a result of the expansion of wealth and trade. The most striking development—the shift from merely emblematic figures to characters in episodic narrative—signals the incipient self-sufficiency of painting as narrative. The *Kalila wa Dimna* paintings in the Istanbul album exemplify this self-sufficiency, with their narrative rhythm and the remarkable subtlety of their pictorial commentary.

occurs in the full-page illustration of "The Owls Attack the Crows" (Figure 2D), where the side and upper margins, filled with curving branches and a star-studded sky, interlock with another L-shape, the text block, which, in turn, frames a rectangular painting.

Such variation in format is unique among contemporary manuscripts. The artists' attentiveness to individual images is apparent in the complexity of these configurations and the alternation of patterns. Although these paintings anticipate the striking compositions of the Jalayirid and Safavid periods, the *Kalila wa Dimna* is a monument to the Mongol fondness for interaction of forms.

Composition in the *Kalila wa Dimna* cycle is always

The arrangement of figures in the Istanbul cycle is not particularly innovative (it is common to examples like the 1237 *Maqamat* of al-Hariri [BN Arabe 5847] and the more contemporary Demotte *Shahnama*), relying on such traditional configurations as the circle, triangle, square, or some part thereof.[5] These forms may also be echoed in the landscape. This can be seen, for example, in two illustrations of the Kardana story (46 and 44). In the first, "Kardana's Escape," a diagonal axis structures the painting: the perversity of the animals' broken friendship is reiterated by the reversed twisting of the dominant tree. However, a vertical axis is more appropriate in the second, "Kardana and the Tortoise Become Friends," where the growing friendship is reinforced by the tree's bracketing.

A circular composition is used less frequently than diagonal organization but is not less effective at subtly expressing layered meaning. In "Dimna Deceives the Lion-King" (19), the semicircular configuration of the two animals is repeated in the spongy rock, vegetation, and clouds, which compress the figures and intensify their encounter. The swirling clouds especially evoke the lion's confusion. In "The Crab Hears the Heron's Story" (17) the impending linkage of the fishes' fate with the heron's is prefigured in their arclike configuration around the crab, who, as protagonist and hero, is central to the plot.

The concentric configuration in "The Greedy Dog and His Bone" (5) is more complex. The circle of the stooped hound and his reflection is strengthened by the correspondence—or echoes—of natural forms: windswept grasses and arched branches implicitly restrict his movement, and the drooping foliage repeats his hunched, greedy posture. These repeated circles illustrate the causal chain of heedless action—as the hound and monkey (10), by giving in to greed, bring about their own ruin.

The most popular configuration for positioning figures is the scalene triangle. Appropriate to the Mongols' appreciation for asymmetry and drama, it is prominent in three of the traditionally most conservative hierarchical audience scenes. In "The Ghaznavids" (1), "The Sasanians" (2), and "The Indians" (7), the ruler, at the

apex, forms a triangle with his closest advisors. The intimacy enjoyed by the eldest of the advisors is reflected by his position along the shorter segment radiating from the ruler. In "Kardana's Deposition" (46), the old monkey-king's imminent exile from the paired younger monkeys is admirably conveyed by his forming the odd angle in an isosceles triangle. In the unique equilateral triangle in "The Lark and the Blinded Prince" (51), the boy forms the odd angle between two mothers, thereby reflecting the emotional web into which the prince's act has thrown both his and the lark's mother.

Although the isosceles triangle is already a standard feature in some of the enthronement scenes in the 1306/7 *World History*,[6] its dramatic possibilities are still unrealized. It designates a hierarchy, but the figures are only loosely integrated. In the *Kalila wa Dimna*, setting more actively reinforces geometric groupings.

Configurations within configurations are used with sophistication to specify dramatic relationships among larger groups of characters. In "The Frightened Mouse and the Trapped Cat" (49), the four animals form a square, the enemies paired at the top and the two soon-to-be allies at the bottom; an inner triangle—formed by the mouse, the weasel, and the owl—conveys their more immediate interaction. The same grouping appears in "The Ascetic Jackal and His Brothers" (52) and "The Father's Advice" (8): one character is pitted against the group that he is addressing. In "The Father's Advice," the wise merchant lectures his three sons from the odd point in the configuration; his stature is reinforced by his forming the eccentric angle. The lines of the heads of these figures also form a triangle, the apex of which is crowned by a blooming rose that draws attention to the merchant's discursive gesture.

In four of the most dramatic scenes, the characters embroiled in a struggle are arranged in a conical ray that radiates from the eyes of the observer above—in accordance with the Islamic idea of vision as a dynamic act in which images radiate from the eye.[7] In the first instance, "The Clever Merchant and the Gullible Thief" (4), the wife's field of vision spotlights the combatants' charged interaction—enforced by the raised cane, the outstretched arm, and the merchant's body—to form a causal

chain. And in the second instance, "The Old Madam and the Young Couple" (14), the focus within the ascetic's field of vision is on the madam and the innocent couple, drawing attention to the grotesque consequences of the frustrated murder. The ascetic in "The Go-Between and the Shoemaker" (15) occupies a similar position, with a conical ray shaping his field of vision. In the most dramatic use of this device, in "The Battle of the Lion-King and Shanzaba" (22), the ox's curvilinear tail is mirrored in the lion's to create a continuous helical movement that reflects the charged entanglement, seen from the jackal's position. The hill's precipitous elevation radiates from the vortex of the fight to generate a centrifugal force that threatens to explode the scene.

The Margin: Space and Meaning

The developed use of the margin as a significant element of the painting it surrounds is not universal.[8] General

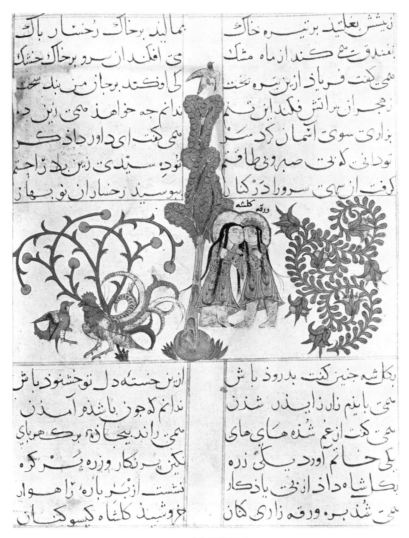

FIGURE 3

tradition in medieval Islamic manuscripts held that the margin contained the overflow of the painting proper. However, expressive use of the margin in Persian manuscript painting can be observed in the *Warqa wa Gulshah;* here, a red border surrounds "Warqa and Gulshah Under a Cypress" (Figure 3), and the two blocks of text above it provide a marginal area for the metaphorical intertwining branches of a majestic tree to echo the spiritual union of the two lovers. Though this painting anticipates the role of the margin in the *Kalila wa Dimna,* the earlier cycle has but few such examples: the full potential of the margin is as yet unrealized.

Margins play a crucial part in the overall composition of the *Kalila wa Dimna* and perform an artistic and narrative role of great subtlety. Whereas the 1297 *Manafi* has ruled borders and undramatic margins, as do the Rashidiya *World History* and the Demotte *Shahnama,* in which only an occasional foot, spear, or rooftop strays beyond the border, in the *Kalila wa Dimna,* the artists use the margin in purposeful ways.

The Mongol artists developed a narrational relationship between the margin and the painting that may be best described by an analogy suggested by its theatrical nuances. The painting proper can be compared to an "on-stage" area—for dramatizing the narrative—while characters in the margin operate "off-stage." In accordance with his active role in the scene, the bird in "The Lark and the Blinded Prince" (51) flies within the painting, whereas the bird in "The Ascetic and the Adopted Mouse" (39) flies away into the limitless, backgroundless space of the margin.

Two distinct approaches to background color and space reflect differences in how the paintings and their margins function. The background of the side margin is discrete, sharing neither sky nor architecture with the background of the central painting. In landscape and interior scenes, the large side margin is distinguished by an unpainted background: even a building's walls are unpainted, while the architecture of the central painting has precise color definition.

In keeping with the "on-stage/off-stage" relationship of the painting and the margin, the margin represents a world inaccessible to the central painting. Both may function in the same time zone or in opposing ones. When both areas depict simultaneous, parallel actions—as in "The Owls Attack the Crows" (33) and "The Battle of the Lion-King and Shanzaba" (22)—the occupants of the margin observe unnoticed. Although their actions are interrelated with those of the central characters, the animals in the margins cannot be seen or communicate across this border.

The effect of the charged relation between these two distinct spheres is clear from the importance given to the imaginary division between them. For example, in "The Lion-King Receives Shanzaba" (12), the ox's position perfectly conveys his hesitancy to cross the threshold of the lion's domain. And in "The Ascetic, the Thief, and the Demon" (37), the demon's half-human, half-otherworldly character is expressed not just by his physiognomy and clothing, but also by his straddling the divide between the painting and the margin.

In other paintings, the abstract space of the margin, like its undefined background, assumes larger significance: it suggests release and freedom. In "The Escape of the Cat and the Mouse" (50), the mouse burrows into a hole that opens at the edge of the painting into the margin, where the escaped cat is safely perched; in "The Hunter Pursues the Gazelle" (32), the gazelle leaps into the margin to find safety and liberty. This interpretation can be figurative as well as literal: the crows fanning the flames in "The Crows Attack the Owls" (40) fly freely in the space of the margin, while the owls remain trapped within the painting.

Dual time zones are depicted in paintings in which the margin signifies a paradisiacal garden—and, as such, reflects the opposition of eternity to the temporal realm of the central painting. In the margin of "The Old Madam and the Young Couple" (14), two roses signify the spiritual union of the sleeping lovers, and in "Kardana's Escape" (46), the upside-down tree in the margin conveys the reversal of the natural order that is brought about by deceit.

The artists took advantage of the three realms fixed by their arrangement of text, painting, and margin. Though the text and margin serve a variety of purposes, both correspond directly to the central image, and their

hierarchical relationship adds layered meaning and irony. The text provides the story's outline and dialogue; the painted image dramatizes its action, supplementing the written narrative; and the margin extension—an entirely original realm—reveals the spiritual responses to the painting proper.

The text line, by defining the physical boundaries of the playing field of the painting, is not unlike the rug in Arab and Yüan theater (Figure 4).[9] There, such figures as musicians and technicians—like the cycle's crows and jackals—occupy an area adjacent to that in which the central action is occurring. Though they contribute to the performance and can be seen by the audience, they are conventionally perceived as being "off-stage." In its fullest sense, the margins of the cycle also appear to be a Persian adaptation of limitless space—as Schroeder has astutely noted, the "successor to the misty void before the crags of Sung and Yüan landscape."[10] Whereas Chinese artists focused on limitlessness in their borderless paintings, the Persian Mongols ingeniously modified this idea by adapting the margin to their own theatrical and mystical interpretation of the *Kalila wa Dimna*.

FIGURE 4

Setting

Individualized settings, elaborated to enhance plot and mood, distinguish the Istanbul *Kalila wa Dimna* from its predecessors, which are interchangeable and use minimal props. Earlier paintings also lack a sense of palpable depth and spatial complexity, and depend on undramatic, formulaic compositions. Even the schematic foreground-middleground-background patterns of the most advanced precedents [11] are rendered obsolete by the more organic approach of the artists of this cycle.

ARCHITECTURE

Scenes are generally composed of realistic architectural and decorative elements: a blue-tiled floor and dado, a keel-arched cupboard, and a rear window or door giving onto a central garden are standard. The abundance of detail, showing the trappings of Ilkhanid court life, personalizes the scenes and serves as a period document. The audience room in "The Ghaznavids" (1), with its stunning blue-tiled dado, intricate red-and-white brick- or plasterwork, and painted wall ornaments, calls to mind the embellishment of IlKhanid architecture, such as the Mausoleum of Oljeitu at Sultaniya, built and decorated between 1306 and 1320. The best of Mongol manuscript painting—the Rashidiya *World History,* the TKS H.2153 related *Shahnama* paintings, and the Demotte *Shahnama*, products of court patronage—abound with such pictorial references to architecture.

The purposefulness of setting is seen in the only example of an undecorated audience room in the Istanbul cycle, but "The Indians" (7) is the exception that proves the rule in that its architectural impoverishment reinforces the satirization of the foreign Indian ruler and his court.[12] The simple setting constructed for ascetics is significant too; the realistic depiction of an *ivan* cell without tiled walls and furnishings approximates the austerity of an ascetic's dwelling.

Architectural organization enhances the hierarchical grouping of figures. In "The Ghaznavids" (1), the sumptuous dado frames the intimate grouping of the ruler and his two closest advisors, while the remaining four courtiers are crowded before a doorway. In this case, as in others, setting assumes a designating and ordering function, and physical positions can be read as attributes. In "The Sasanians" (2), the composition of which is based largely on that of "The Ghaznavids" (1), an obvious rearrangement of architectural elements and figures presents a more hierarchical view of the ruler.

The arrangement of elements is not dictated exclusively by narrative, though: setting also works to incorporate the physical dimensions of the text. The vertical axis of the closed doors in "The Cuckolded Carpenter" (38) relieves the pronounced horizontality of the composition while it mirrors the position of the text. The L-shaped architectural design of "The Old Madam and the Young Couple" (14) unifies the composition and, by incorporating the text block, the page.

Unlike the deep-spaced landscapes, interior settings appear shallow. In keeping with Islamic pictorial aesthetics, space is flattened by the parallel alignment of ground and wall, and attention is drawn to the surface by the coordination of colors and designs in tiled floors and dados, carpets and plasterwork, and mattress coverings and curtains. In scenes where lush gardens are glimpsed through a rear window or door, the exploration of depth is suggested but always restrained by window grilles fragmenting space, by dense vegetation and clouds limiting the vista, or by oversized plants. Such surface tension between emphatic horizontals and verticals energizes potentially rigid compositions, complementing the pitch and vibrancy of color peculiar to an indoor environment.

The colors' intensity is achieved by using pure hues, thick impasto, and rich geometric patterns. Though generally used realistically, color sometimes subtly comments on the figures in the paintings. In "The Clever Merchant and the Gullible Thief" (4), for instance, the exceptional use of green for the tiled dado intensifies the complementary color of the intruder's bloodied head and crimson robe; the green of the tiles, however, blends with the etheralized wife. The blue tiles of the floor and dado in "The Old Madam and the Young Couple" (14) accentuate the malicious madam and her swirling orange and red attire. The tiles, however, harmonize with the young lovers' covers.

LANDSCAPES

The mystical conception of God as the eternal gardener inspired the ubiquitous portrayal of nature, and of landscapes in particular. In addition to responding to the physical and emotional states of the characters—most effectively the animals—the dynamism of nature may elicit empathy or irony. The natural forms imitate the characters' movements by bending or twisting, celebrate their wisdom by sprouting or blossoming, and express disapproval by growing eccentrically.

The artists, with their visionary view of nature, incorporated Sinicized elements—rock and mountain formations, hillocks strewn with tufts of grass, craggy ground, types of trees, jutting landforms, wave patterns, swirling clouds—into the natural settings. Though these elements pervade early Mongol painting as diagrammatic and uninterrupted patterns, they now are integral and appear naturalistic and animated. In the sequence of paintings illustrating "The Chapter of the Owls and the Crows," the dramatic landscapes fall just short of overpowering the characters. The setting of "The Owls Attack the Crows" (33) gives the battle a violent and sinister tenor. Writhing, tortured forms predominate: jagged rocks, a choppy stream, swirling clouds, and a primordial tree whose clawlike roots twist into an agonized face. The finality of the confrontation in "The Crows Attack the Owls" (40) finds expression in the huge jagged mountain blocking the horizon: the owl's terror is captured in the mountain's precipitous drop and scarred, twisted terrain.

The cohesiveness of the landscapes is achieved by their being infused with pervasive moods. In their most successful work, the artists make a qualitative leap to reinforce the themes expressed in the choice of scenes: violence, upheaval, and pathos characteristic of the late IlKhanid period.

In "Kardana and the Tortoise Become Friends" (44), the lush, fertile setting magnifies the animals' joy in their new friendship. Pairs of intertwined fruit trees, an upright central tree contoured to the rising shoreline, and lapping waves with playful spray all merge into a single rhythm to set a harmonious, happy mood. In "Kardana's Escape" (46), the same landscape is distorted to

reflect the ruptured friendship. The central tree, now angular and twisting, the steeply descending shoreline, precariously balanced rocks, and a drooping tree are all pulled downward, reversing the natural order.

The cultivation of the fantastic (also a central theme of the Demotte *Shahnama,* where, however, it is expressed by the choice of subject matter)[13] is striking in the landscapes, with their heightened sense of animism. Overhanging rocks, agitated clouds, tree stumps, and root systems are inhabited by spirits, whose barely visible faces emerge from these forms, their expressions ranging from anguished to contemplative. The expressions are not simply anthropomorphic or animalistic; the closed or hollow eyes seem to signify interior vision. These mysterious, often satiric faces—camel, human, or demon/div—also work as caricature. This animistic convention appears in Chinese landscape painting as an expression of popular and Taoist belief,[14] but here it assumes narrative and dramatic functions. The use of animal forms to broaden allegorical interpretation was a technique already found in the inhabited scroll work of the thirteenth-century *Warqa wa Gulshah,*[15] which seems to have paved the way for the Mongol adoption of Eastern-style spirits in the *Kalila wa Dimna* cycle. Ubiquitous in later Persian and Persian-influenced painting, these nature spirits came to assume in the sixteenth-century Houghton *Shahnama,* for instance, a more general, burlesque character that related only indirectly to the story at hand.

In reacting to the central animal characters, these spirits—the faces of nature—project the moods and actions of the animals and give voice to the supernatural. The rock-hewn bodies and fearsome, skull-like faces at the head and the foot of the lion in "The Lion-King Receives Shanzaba" (12) can be interpreted as foreboding the tragic result of this encounter. The rock shaped into a grimacing face overlooking the margin seems to sneer in "Man's Fate" (6) at the figure's stupidity and self-wrought fate. Massive and prominent tree roots twisted into a howling face voice the terror of battle in "The Owls Attack the Crows" (33). As the spirit of nature, the sneering camel, with eyes closed and head fashioned into the earth along the horizon, in "The Monkey Who Tries Carpentry" (10) appears to be mocking the con-

sequences of unmindful action. In "The Ascetic Cat and His Prey" (35), the open-jawed demon carved into a rock-hewn mihrab helps to satirize the hypocrisy of the ascetic cat. In "The Fox Deceives the Ass" (47), the rock giant's mimicking expression may be interpreted as a reflection of the ingrained naiveté of the ass, who is being duped yet a second time. Mottled with sinister grotesques, the bank of clouds in "The Lion-King Receives Shanzaba" (12) creates a fantastic environment for the central character. The use of these nature spirits epitomizes the Mongol love for animated, dramatic landscape.

Dynamic environments described with windswept vegetation and bending trees—ash, pine, plum, and Persian plane *(Plantanus orientalis) (chinar)*—and their contorted, weathered trunks, clawlike roots, and exuberant foliage are prominent and effective. Deformed and distorted trees can be found in Chinese painting of this period, and many appear in the *Manafi* and the Rashidiya *World History*. But the Mongol appreciation for such mannerisms encouraged the cultivation of eccentric and expressionistic forms such as these. A tree's growth is rich in metaphoric meaning, as observed in the discussion of "The Greedy Dog and His Bone" (5). The father–son relationship in "The Ghaznavids" (1) and "The Father's Advice" (8) may be shown by the growth of the vigorous shoot sprouting from the mature tree. In "Kardana and the Tortoise Become Friends" (44), the pairs of intertwined fruit trees—one pair dead and one living—suggest the rewards and portend the fate of the animals' new union. In "The Mouse Frees the Doves" (27), a dead tree wrapped in ivy reflects the life-giving power of the mouse's friendship. The metaphoric language of trees, though not unique to this manuscript, is used less subtly in the Demotte *Shahnama*,[16] the TKS H.363 *Kalila wa Dimna*, and the *Warqa wa Gulshah*.

The immediate sources of the stylistic conventions used to depict landscape are obscure. Besides the influence of Seljuk and Mesopotamian art, certain conventions derive from Central Asian Buddhist painting and, apparently, several Chinese styles of landscape painting. Even more than during the Yüan period, the Mongols in Persia used Eastern archaistic conventions decoratively. Some of the most obvious references are the T'ang "blue-and-green" style, the receding tufted-grass motif characteristic of certain Liao painting, and Sung-type cubelike rocks that enhance depth. These conventions are so well understood that they are effectively assimilated into dynamic IlKhanid portraits of nature. The specific distortion of motifs, the interest in rich coloring, and the decorative tendency toward simplification approximate the spirit of much of Chinese landscape painting during the Yüan period.[17] Whether it was an influx of Eastern artistry,[18] a new appreciation for old Chinese and Central Asian models, or the emergence of extraordinarily creative artists filled with heightened fervor at the late IlKhanid court remains an open question.

The effectiveness of the *Kalila wa Dimna* landscapes also lies in the rendering of internally consistent, cohesive space, enhanced by the positioning of characters. To heighten the dramatic effect, artists devised imaginative ways to clarify and concretize depth. As in Eastern painting, space is molded, and three-dimensional views are rendered with overlapping or tipped-up planes. The landscape in "The Hunter Pursues the Tortoise" (31) is tightly organized to accentuate the drama: the sloping hill and vegetation parallel the thrust of the hunter's body, adding weight to his action and echoing the threat of doom to the tortoise. In "The Lioness Laments Her Dead Cubs" (53), traditional superimposed registers are modified to reflect the animals' shapes and to mirror the narrative: a series of howling forms recedes into depth and enhances the dramatic tone. In "The Crows Attack the Owls" (40), the lack of horizon and the shallow foreground create a suffocating space that heightens the constriction suffered by the owls, whereas a low horizon and an exaggerated sense of depth in "The Owls Attack the Crows" (33) provide an energized field of combat.

In all cases, the compelling depth is achieved by an overall attention to the subtleties of volume. The shifts in mass of extended and projecting forms, the differentiated proportions of neighboring elements, and the distinctions between the near and far describe, in natural colors and textures, an essential relationship to the solid ground. In light of these examples and with reference to

Eastern landscape painting, artists made a pointed distinction between mass and void, which were integrated elements in a Chinese work. Because the IlKhanid artists extracted the limitless void and its ethereality from the natural landscape and relegated them to the margin, the central painting is given immediacy. Landscape is rendered according to the laws of nature: volume, mass, weight, and (to a far lesser degree) proportion are indicated by a variety of pictorial means not simply adopted from the East, but assimilated to the Persian Mongol aesthetic.

Through the modulation of color and refinement of brush techniques, artists were able to describe movement and form. Calligraphic brushwork gives way to the even more expressive language of color. An extensive palette of rich earth and greenish blue tones suggests the transitions between varying volumes: a wash-like layered application accentuates textural patterns and sets the tone of naturalistic settings. Undulating contours of dense or bleeding ink outline enunciate forms that are finely textured by individualized brush strokes. Finally, additional color is applied and subtly graded to round the forms.

Even when compared with the competence of the closely related *Shahnama* album pages (TKS H.2153), the sophistication of these highly developed techniques is marked. In both instances, the application of similar colors effectively conveys the movement into depth of

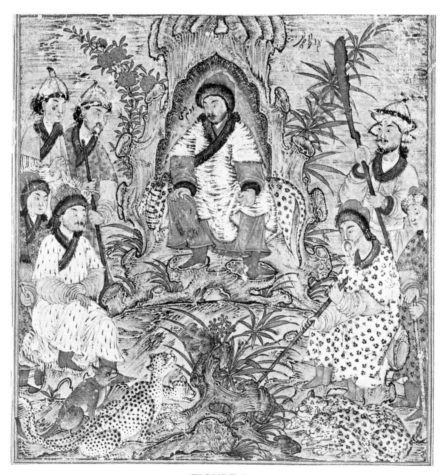

FIGURE 5

three-dimensional form. However, the Central Asian convention of modulating color to render plasticity is, in "Gayumars, the First King, in the Mountains" (Figure 5), stilted; the overall color scheme is not integrated, resulting in a frozen, undynamic pattern. Texture is rendered, though hardly convincingly, by uniform and patterned strokes; dash-and-eye openings along the edges of planes mechanically texture rocks. These elements are formalized in mid-fourteenth-century work and are common thereafter to most Persian landscapes. In the *Kalila wa Dimna*, however, these conventions are more successfully integrated, by color and texture, into the recession of the landscape.

The combination of heavy outlining with individualized patterns of line demonstrates the artists' proficiency with texture. Although solid, dark outlining should flatten form, texturing builds form to resist the planar effect of its outline. Furthermore, the landscapes abound with fields of such patterns: no one is dominant, but they weave an active and varied surface.

Wedges of brilliant blue or golden sky, though seemingly decorative, are instrumental in integrating the low-key hues of the landscape. The golden tone, for example, harmonizes with a wide range of descriptive earth tones.

A naturalistic and mystical attitude toward nature resulted, on the one hand, in a limited palette (mostly blues, greens, and earth tones) to blend animals and their natural habitat, and, on the other, in a kinetic articulation of natural forms to enhance spaciousness and animation.

CONCLUSION

The landscape and interior scenes of the *Kalila wa Dimna* differ sufficiently—in coloring, scale, and use of space— to have been described as both indebted to Chinese painting and strictly Persian in style. Such observations have bolstered the belief that its paintings were created during different periods and must originally have belonged to different cycles.[19] The exterior and architectural scenes, however, are undeniably similar in fundamental ways. While landscapes are tonally subdued, full of movement, and brilliantly integrated, interiors have a rigid organization that is counteracted by the alternation

of bold patterns and the vivacity of complementary colors; formal considerations, recurring iconography, blending of key figures with their surroundings, and an overall concern with the dramatic image bind the two, however.

More specifically, exterior and interior scenes, both of which use a large format with interlocking L-shaped composition and text block, have a similar monumentality. They also have in common the correspondence of painting and margin through color and theme, conical groupings within larger triangular formations, emphatic weight and bulk through texturing and/or coloring, and comparable development of three-dimensional space held in check by a high horizon or latched door.

Nevertheless, it must be said that the scenes with human characters are sufficiently like other fourteenth-century paintings that they alone would not set this manuscript apart. Rather, it is the treatment of animals and landscape that gives it its unique and sublime character.

Animals

Even taking into consideration the Islamic and Eastern propensity for rendering animals with more sympathy than humans, the animals of the *Kalila wa Dimna* are exceptional for their lifelike force and strength of expression. The Mongols' philosophical beliefs resulted in sensitive and spirited portrayals, their close observation producing unsentimental studies. The delightful variety of birds—the heron (great egret), the crow (red-billed cough), the owl (eagle owl), and the partridge (Persian chukar)—are so perceptively painted that they are easily identifiable. Not surprisingly, for a Near Eastern society, the ubiquitous camel, rendered in a variety of moods, is the most naturalistic animal in the cycle.

Although emotion is conveyed in the 1297 *Manafi*, it is done largely through the interaction of decorative forms rather than by dramatic gestures and facial expression. Closer precedents to the treatment of animals in the Istanbul paintings are to be found in the undated TKS album leaves, "The Man Among the Monkeys" (Figure

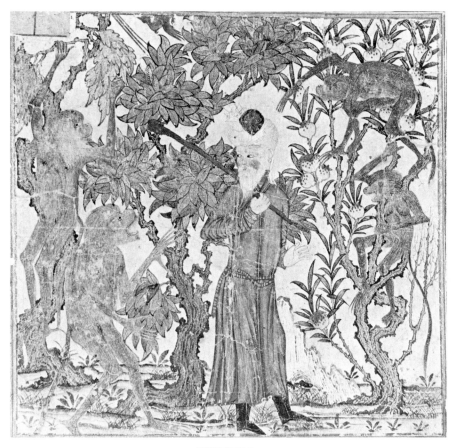

FIGURE 6

6) and "Gayumars, the First King, in the Mountains" (Figure 5). In these paintings, animals are portrayed convincingly in animated poses, but primarily through surface patterning and caricatured gestures. Their decorative richness, attention to texture, and carefully observed mannerisms anticipate the full expression of the dramatically involved and physically compelling characters of the *Kalila wa Dimna*.

The desire to portray action in a three-dimensional landscape led to bold experimentation with the animals' poses. Though shown in conventional three-quarter and profile views, the animals—or some part of them—are tilted upward, downward, and sideways. Their bodies may be angled even when their neighbors' are not. Though their poses may be incongruous, the device contributes to the animals' believability by helping to build internally logical space.[20]

In "Kardana's Deposition" (43), the imminent exile and celibacy of the monkey ruler are presaged by the addition of pairs of younger monkeys who intimately and playfully fondle one another. A pair seated high on the bluff gaze into each other's eyes and lower their heads at 45 degree angles to mimic the viewer's vantage point. The pair in the foreground establish an ascending diagonal aligned with the oblique view of the monkeys above. Kardana is awkwardly tilted forward, his physical isolation reflecting a larger alienation. In "The Owls Attack the Crows" (33), the birds' sizes are not proportional to the degree of spatial recession they demarcate, but the alternation of sizes is used effectively to heighten

the distinction between those in safety and those in the fray.

Tilted poses even accommodate the force of gravity; in "The Old Snake and the Frogs" (42), the crab's escutcheon-shaped shell, tilted diagonally downward, affords a three-quarter view of its back, and the narrowing shell segments convey the strain of treading water. In "Dimna's Death" (26), the unusual view from above emphasizes the jackal's unseemly death; lying on his back, his belly swollen from starvation, Dimna is the victim of his own self-deception.

The artists' anatomical knowledge and sensitive artistry are apparent in the animals' wide range of moods and expressions. Animal characters are fully and masterfully developed, striking a balance between naturalism and their empathic expressions. In "Man's Fate" (6), the camel's nasty and smug demeanor is accentuated by thin black lines—assertive strokes—around his sunken eyes, flared nostrils, and tight, smirking jaw. He is made especially menacing, however, by the distortion of his form, as he is grotesquely compressed. The camel head in the background of "The Monkey Who Tries Carpentry" (10) is more loosely modeled, so that his disdainful mien subtly emerges from the rounded forms of the terrain. This head, like that of the camel at the lower left of "The Fish and the Fisherman" (20), is characterized by skeletal forms, appropriate to its spiritlike nature. Although color is usually of primary importance in enlivening texture, it is sometimes upstaged by bold calligraphic technique, as in the rendering of the varied feathers of the great egret in "The Crab Hears the Heron's Story" (17). The accuracy of the anatomy and the sensitivity to line suggest that the paintings were preceded by detailed life studies similar to those in the Diez album.[21]

Whereas predominantly decorative and stylistic elements suffice to describe the *Manafi* lions, and polyscenic representation depicts movement and dramatic developments in the TKS H.2152 *Kalila wa Dimna,* the Istanbul cycle combines these devices in the dramatic and vital scene "The Battle of the Lion-King and Shanzaba" (22). It is the assimilation of devices—the animated poses, the rendering of the plush fur and sleek

skin, and the potent landscape—that is characteristic of the superiority of the Istanbul cycle as a whole.

Human Figures

In keeping with the high style of Mongol painting and the facility of the artists of this cycle in describing the anatomy and character of animals, it is easy to understand their deftness in focusing on man in action and his emotional responses. Subtleties of human physical and emotional interactions are colored by biting satire, used to heighten animation. Though also satirized, the animals, mocked only by nature spirits, appear more naive in their greed and self-deception.

The dramatic impact of figural scenes is enriched by the strong color and lively patterns of the interiors and by the elaboration of realistic settings, particularly the addition of contemporary artifacts and bountiful gardens. The artists' close observation and attention to the details of everyday life also can be seen in the individualized expressions and animated poses: facial wrinkles, expressive eyebrows, fingernails, the slope or knot of a low-slung belt, and upturned hems add to the figures' convincing corporeality.

Conventional types are quoted, but they are usually invested with new life by a more organic approach to their anatomy and grouping. For the most part, artists relied on models, if not simply on convention, for the poses and compositional arrangements of traditional and seated figures; royalty and courtiers (especially viziers and standard-bearers), judges, and ethnic types are largely derivative. Their sources are varied and innumerable, ranging from specific examples in contemporary painting to pre-Islamic and Mesopotamian models.

The most direct precedents occur in the 1306/7 *World History.* Here, however, the friezelike movement of disparate groups of figures precludes the figures' integration, and their monumentality undercuts the intimacy. It is true that the figures in the *World History* are animated by a larger range of facial expressions,[22] but their stiff, overly attenuated physiques and stilted poses are only individually expressive. The intermediary group of

Shahnama paintings in the TKS album H.2153 is comparatively closer to the *Kalila wa Dimna,* as similar conventional types—predominantly the Turko-Mongol figures—are organized in three-dimensional settings. These paintings dispense with the monumentality of the *World History* and introduce small-scale, close-knit groupings within contemporary settings; in the more assured compositions of the *Kalila wa Dimna,* these elements are synthesized. The Demotte *Shahnama* and *Mirajnama* developed more voluminous figures, whose expressive physicality conveys the drama that in the *Kalila wa Dimna* is infused in the setting.

Its figures, however, are not just additive static quotations, but are individualized emotionally. Conventional types are revitalized, while genre figures and women are introduced, widening the range of characters and expressivity. It is in the portrayal of private interactions that intensity and drama are best realized. These robust, active, and individualized characters anticipate the captivating fifteenth-century genre figures of Behzad.

In keeping with convention, gesture rather than facial features, and the drape of garments rather than anatomical detail, generally express emotion. Explicitly dramatic poses do occur, however, particularly in violent and bloody scenes. Sprawled across the floor, the bloodied thief in "The Clever Merchant and the Gullible Thief" (4) cowers, terrified, with his wide-open eyes, knitted eyebrows, grimacing mouth, and bloodied hair adding pathos to his supplication. In "The Lark and the Blinded Prince" (51), the prince gropes along the floor tiles in a pathetic effort to orient himself. His head is raised and tilted back as he desperately attempts to see.

The few women illustrated in the Istanbul *Kalila wa Dimna* fall into distinct categories. The young wife of the clever merchant (4) embodies a standard poetic ideal of Persian beauty; her oval face, with delicate features, is framed by raven hair, and her willowy body is accentuated by her gown. Only the folds of her kilim coverlet betray her inner agitation, while her expression remains serene. The scheming madam in "The Old Madam and the Young Couple" (14) parodies this ideal of feminine grace, with her coarse features, pendulous, oversized breasts, and humiliating posture. Unlike those of the merchant's wife, her contours are described with a heavy black outline, and she wears garish orange and red clothes with baggy trousers.

Throughout, two principal male types are contrasted—erudite Islamic "men of the pen" and coarser, more physical Turko-Mongols.[23] The Turko-Mongols have animated Oriental features, stocky builds, and Central Asian–style dress; the Muslims are depicted with elongated faces and bodies, pensive expressions, and traditional Islamic garb. Muslims are mostly active in law, philosophy, government, and spiritual matters, whereas the Turko-Mongols hunt and work at trades. They are often satirized by the cleverer, more agile animal characters. In "The Hunter Pursues the Tortoise" (31), for example, the mighty hunter fails to capture the tortoise, whose hind legs mirror the hunter's movements; while the cumbersome tortoise smoothly shifts his weight, the swirling folds around the hunter's knees only accentuate his heavy awkwardness.

Even when positioned in shallow interiors, human characters are effectively arranged to establish the solidity of the figures. Bodies overlap and are spatially interrelated, but their physicality is individualized. When of a dark, solid color, robes are shaded as in the Demotte *Shahnama* to suggest bodily contours; when layered or patterned, they wrap the body and advance through color dynamics. Figures are also spatially defined by ruffled linings, swirling hems, the curved lines of fasteners, and deep pleats. Individualized styles of dress and differentiated figure-types are the building blocks of a cast of characters whose poses and gestures, and humorous or intense interactions, fully invigorate them.

IV. THE PATRON

Extensive attention to the stylistic qualities of the Istanbul *Kalila wa Dimna* has unearthed little more evidence of its date and provenance than is sufficient to situate the cycle in the first third of the fourteenth century, among other works painted in the Tabriz monumental style.[1] Both the Demotte *Shahnama* and the *Mirajnama* share the vigor and robust style of the *Kalila wa Dimna*, and a thorough examination of its courtly manner indicates that it was completed before the weakening and eventual breakup of the IlKhanid empire in 1336. On these grounds, it is possible to say that it postdates the 1306/7 *World History*. However, it falls before the 1343/44 *Kalila wa Dimna* in the Cairo National Library (Adab farsi 61),[2] as discussed below.

1343/44 Kalila wa Dimna *as* Terminus Ante Quem

Of the ninety-two miniatures in the 1343/44 *Kalila wa Dimna,* also based on the text of Nasr Allah, several are iconographically derivative of the Mongol cycle. These 1343/44 compositions are reduced and simplified (a whole page measuring only 24 × 16 cm), and characteristic IlKhanid stylistic features—animated drawing, fullness of form, depth of field, vibrant color, and vigorous texturing—are translated into a decorative, two-dimensional style. The debased and routine character of these paintings is in keeping with the style of the 1353 *Garshaspnama* and other known mid-fourteenth-century painting,[3] confirming their mid-century dating. The 1343/44 *Kalila wa Dimna* is useful as a *terminus ante quem* for the Istanbul cycle. The relationship between it and the later 1343/44 cycle will be seen in the comparisons that follow. It is hoped that these comparisons yield as much in establishing the *terminus ante quem* as in assessing the relationship between an original conception and its perfunctorily executed copy,[4] as in the Rampur *Kalila wa Dimna.*

The 1343/44 version of "The Ascetic Jackal and His Brothers" (52b) illustrates the same moment in the narrative, in a similarly organized composition, that the corresponding scene in the Istanbul cycle does (52a). In both, the vegetarian jackal, from his seat on a rock, is lectured by his brothers, who are ranged opposite on the ground. The foremost carnivore speaks while his neighbor listens with lowered head. But volume is problematic for the 1343/44 artists: the three jackals have been moved farther apart to avoid overlapping, and the rearmost one, moved upward and forward to make him more visible, now actively participates. Mass is predominantly two-dimensional; for example, the animals' tawny ruffs are now black stubble, and their coats are untextured silhouettes. The massive weathered maroon rocks framing the jackals in the Istanbul scene have been replaced by two fire lilies—crude reductions of what formerly enhanced a dramatic mood. The vegetarian jackal's throne, now an ethereal blue, has shrunk in breadth. Consequently, the jackal's asceticism is now described by the throne's height and not its baldachin. His prayerful pose has also been abandoned, but he has gained a string of gold prayer beads. Whereas the Mongol setting dramatizes the jackals' confrontation, the gay, decorative landscape of the 1343/44 version negates the seriousness of the scene.

The 1343/44 painting of "The Owls Attack the Crows" (33b), for which the sole precedent is the Istanbul version, depicts the same dramatic moment, poses, and full array of owls, though the text mentions only the owl-king. The landscape in the 1343/44 scene is again particularly revealing. The mountain forest and starry night, described in the text and prominent in the monumental Istanbul painting, are replaced by a nonspecific, undramatic setting with a small horizontal format. The naturalistic, writhing tree and oppressive rock formations of the Istanbul version have been reduced to a symmetrical and unbending prop. Thus, the setting effectively dulls the ferocity of the owls' attack and diminishes the drama found in the same scene in the Istanbul cycle.

In both versions of "The Lioness Laments Her Dead Cubs" (53a and b) the basic elements of the composition are similar; however, the 1343/44 artists have flattened the depth of the scene, eliminating the dramatic landscape, so that the lioness, jackal, and whelps now occupy a single frontal plane. Whereas the IlKhanid setting heightens the pathos of the narrative, the rigidity and decorativeness of the later painting compromise it.

The rendering of figures in space and the use of color in the Istanbul and Cairo versions of "The Indians" (7a and b) differ significantly. Both paintings have similarly colored, unembellished interiors and depict Dabishlim flanked by the white-haired Bidpai and a guard holding a trident spear. In each, the repetition of orange knits the composition together, though with only moderate success in the latter. Unlike the Istanbul scene, the 1343/44 version has no variegated carpet, orange curtain, or vegetation, and thus lacks the careful integration of figures into their surroundings by color: the orange scarf worn by the standing guard in the 1343/44 version leads the eye out of the scene. The 1343/44 artists' reductionist and two-dimensional approach dictated including fewer characters, which presumably accounts for the gulf of space separating Dabishlim and Bidpai. The parody and wit of the Istanbul scene, in which the Indians' court is mocked for its foreign customs and each figure is individualized, is also absent from the Cairo version.

The prosaic style of the 1343/44 paintings is most evident in their dependence on space-filling devices and the unimaginative coordination of text and image. Though its standard of production is obviously inferior to that of the IlKhanid cycle, it is the lack of invention and the reductive quality that confirm the identification of these paintings as later, derivative works. They are in character with known mid-fourteenth-century provincial Persian painting; they lack evidence of attentive planning by an erudite, wealthy patron and well-trained master artists, who flourished in Tabriz before the breakup of the IlKhanid empire. These circumstances produced the kind of paintings—a Kalila wa Dimna and two other works—that initiated, in the words of Dust Muhammad, the "modern" sixteenth-century style of his time. It was during Abu Said's reign that "the veil was lifted from the face of painting." Does the Istanbul Kalila wa Dimna deserve this acclaim? The characteristics Dust Muhammad would have regarded as "modern"[5] are the full integration of figures into a specific setting at a specific narrative moment; the interweaving of text block, painting, and margin into a complex, individualized format; large, full-page vertical scenes, with an atmosphere of pictorial realism; the suggestion of depth by multiple tipped-up ground planes and partially open doors; lively

genre figures with expressive poses; the orchestration of color; and expressive landscape forms spilling into the margin and mirroring the characters' state of being, all of which prefigure sixteenth-century practice. That Dust Muhammad barely mentions stylistic differences suggests the limits of his interest in Persian painting: his writing is primarily concerned with painters' lineages and the genealogy of their schools. Thus those scenes of the Mirajnama, painted in a varying monumental style, could also have been made in an atelier under Ahmad Musa's directorship.[6] By identifying Ahmad Musa as the "artist" of a Kalila wa Dimna, Dust Muhammad undoubtedly meant that he was the master artist/atelier director who painted its major scenes and supervised its production during the reign of Abu Said. Hardly scientific, Dust Muhammad's comments accurately reflect the indebtedness of later Persian painting to the Istanbul Kalila wa Dimna and other productions of the late IlKhanid court.

IlKhanid Culture and Political Milieu

The atmosphere of realism achieved by the accurate depiction of dress, furnishings, and decorative architectural elements of Persian Azerbaijan in the Istanbul Kalila wa Dimna attests to its artists' conscientious portrayal of the culture around them. Like the Demotte Shahnama, these paintings serve as an inventory of IlKhanid artifacts,[7] which supports an early-fourteenth-century date for the cycle.

The Kalila wa Dimna shares more than just decorative and stylistic features with the Demotte. Both illuminate themes of conflict, death, and fate; both enlarge upon the issues of unbiased ethical standards, reverence for experience, and the peaceful transfer of power; and both give prominence to strong-minded women and prefer Islamic men of letters to the Turko-Mongols.[8] The Kalila wa Dimna and the Demotte Shahnama also emphasize the importance of a court advisor. In the Kalila wa Dimna, this is exemplified by the prominent role given to the royal confidant—the jackal—in the illustrations. These features suggest a similar cultural milieu and the supervision of a patron during the creation of the Istanbul cycle.

As a man of letters, an active patron of the arts, and

a member of the IlKhanid court as chief vizier to both Abu Said and Arpa Khan from 1327 to 1336, Ghiyas al-Din was one of the best-known members of the Persian Islamic elite. It is to him that Grabar and Blair attribute the patronage of the Demotte cycle. The sumptuousness and expansive philosophical interpretation of the Istanbul *Kalila wa Dimna* required a wealthy and learned sponsor, one fully capable of investing himself in such an accomplished work of art. Although Abu Said, himself an acknowledged patron and calligrapher, had the necessary resources, the inclusion and interpretation of certain scenes make it unlikely that he commissioned the work. Abu Said's principal interest lay in architecture, a medium he supported actively. The art of the book was not the means he chose to immortalize his name.[9]

When Abu Said succeeded his father in 1316, he was twelve years old and no match for his Turko-Mongol ministers, who conspired to replace the Persian-style centralized bureaucracy introduced by Ghazan Khan in 1295 with Turko-Mongol feudalism. Within the first eighteen months of Abu Said's reign, Ali Shah, backed by the de facto ruler, the Mongol Amir Chupan, succeeded in plotting against Rashid al-Din, his co-vizier, the illustrious patron and mastermind of Ghazan Khan's economic reforms. In 1318, Rashid al-Din and his young son were falsely accused of having poisoned Abu Said's father, Oljeitu, and both were beheaded. Rashid al-Din left behind twelve other sons, all engaged in public service.

With Abu Said's rule began the irreversible disintegration of the Mongol empire, as one region after another broke with the authority of the central government in Tabriz. Under Amir Chupan and his compatriots, the reins of government were held by the Turko-Mongol military leaders, and the forty-year period of prosperity introduced by Ghazan's reforms was followed by one of insouciant corruption and neglect. The luxury-loving atmosphere of Tabriz at this time is vividly described by the Moroccan traveler Ibn Battuta:

The next morning I entered the town and we came to a great bazaar, called the Ghazan bazaar, one of the finest bazaars I have seen the world over. . . . I passed through the jewelers' bazaar dazzled by the varieties of precious stones I beheld. They were displayed by beautiful slaves wearing rich garments with waist sashes of silk . . . exhibiting the jewels to the wives of the Turks, while the women were buying them in larger quantities and trying to outdo one another.[10]

Challenged by Amir Chupan in 1327, Abu Said finally asserted his own power when he reached maturity; he defeated Amir Chupan and his army and had him put to death. Shortly thereafter, Abu Said made amends for the injuries done to Rashid al-Din and his family. He began by returning his confiscated possessions[11] and then appointed Ghiyas al-Din vizier, the position his father had held. Reflecting the sentiments of his countrymen,

the choice won general approval, and all the emirs agreed unanimously that, among those who claimed this position, Muhammad Ghiyas al-Din prevailed by far because of his parentage, education, and familiarity with affairs of state.[12]

Ghiyas al-Din enjoyed a reputation as an astute diplomat with a generous nature, even toward his enemies. Within months of his appointment as vizier in 1327, he became the virtual head of the government, assuming, among other posts, that of controller-general of finance. He was active in reinstating his father's agricultural and tax reform policies, and thereby helped to raise the standard of living again. But this period of economic growth ended with the murder of Abu Said in 1335.[13] Abu Said left no heir, and it was Ghiyas al-Din who, despite opposing claims, shrewdly put Arpa Khan, a descendant of Genghis Khan, on the throne. In so doing, Ghiyas al-Din briefly secured his position as prime minister. Six months later, however, when civil war broke out, he was arrested and executed. Rashidiya, the city his father had built, which Ghiyas al-Din had enlarged and beautified, and his quarters in Tabriz, were ransacked:

The triumphant party pillaged the goods of the vizier and his entourage in Tabriz. The populace of that city destroyed the Rashid quarter and the homes of those individuals under Ghiyas al-Din's patronage; an immense quantity of coined money, objects adorned with gems, gold and silver vases, precious books and many foreign embassies were plundered at the same time.[14]

Court intrigue, conflict and death, the trouble that befalls a young, inexperienced ruler—all central themes of the *Kalila wa Dimna,* along with the glorification of Islamic "men of the pen" who advise rulers and magna-

minously dispense the laws of the *Sharia*—also marked the years of Ghiyas al-Din's administration.

Raised in his father's court, Ghiyas al-Din inherited an avid appreciation for scholarship and the arts. Known for his excellent calligraphy, he was an active patron of writers and poets, many of whom sang his praises in books dedicated to him.[15] According to one account, Ghiyas al-Din met with learned scholars every Friday evening to discuss literary and scientific subjects.[16] Moreover, he had been exposed to his father's encyclopedic library of "60,000 volumes" that was reputed to include "didactic stories and fables from Iran, Turan, Misr, Maghreb, Rum, Sind, and Hind."[17]

Although few particulars of Ghiyas al-Din's religious background are certain, it is known that he made the hajj and that he was a disciple of the famous Sufi dervish *shaykh*, Safi al-Din of Ardabil.[18] Sufism at this time was an institutional practice the government looked upon favorably. Rashid al-Din, in turn, had made important provisions to encourage Sufism, as found in his endowment deed of Rashidiya. Like most contemporary shrine complexes, a *khanagah*—where resident *shaykh* and Sufis met and lived—was given special prominence.[19] However much Sufi belief shaped this version of the *Kalila wa Dimna*, it would have been perfectly consistent with Ghiyas al-Din's religious convictions.

The Patron

Only a humane patron like Ghiyas al-Din, with strong ethical and spiritual convictions and an appreciation for the subtleties of statecraft, would have undertaken this exceptional version of the *Kalila wa Dimna*. Since Ghiyas al-Din is almost the only known ranking court official who was a member of the Persian literati and had sufficient means to commission such a sumptuous manuscript, one can reasonably hypothesize that he was the mastermind behind this great work.

In "The Father's Advice" (8), a scene for which no precedent exists in earlier versions, an elderly, dignified merchant counsels his attentive sons. This honored figure enjoys several notable attributes: he is allotted half

of the pictorial space and thus is visually preeminent; he wears an Islamic robe with *tiraz* and turban with *dhawaib;* and he is complemented by the tall evergreen in the margin and the rose garden behind him. The son closest to him, the eldest, wears a green robe, signifying piety, and his rapport with his father is underscored by his reciprocal gesture of speech. This sagacious father-figure and his familial relationships call to mind Ghiyas al-Din's relationship with his father, also a successful entrepreneur renowned for his wise counsel. Ghiyas al-Din is said to have received many advice-filled letters from his father, fifty-three of which are thought to have been written while Rashid al-Din was vizier. One includes the kind of moral teaching that shaped the interpretation of these stories, and whose advice is perhaps the subject of this painting.

Take care in picking your friends as well as your enemies.
Always tell the truth, even if it results in bloodshed.
Do not pretend to know a thing unless you are entirely certain of it.
Expand your knowledge to bring glory to this world as well as the next. . . .[20]

Idiosyncratic views on statecraft are revealed in the treatment of powerful characters, including royalty. "The Lark and the Blind Prince" (51) is an unusual portrayal of moral retribution, in which royalty is far from exempt from punishment; for his transgression, the prince is terribly wounded. Similarly, in "The Lioness Laments Her Dead Cubs" (53), the lord of the beasts is herself the victim of aggressive, carnivorous behavior.[21]

The stringent ethics asserted throughout the cycle suitably reflect what we know of Ghiyas al-Din's own values. Particularly noticeable in the illustrations is Ghiyas al-Din's regard for pacifist diplomacy. The cat and the mouse, enemies by nature, work together for their mutual benefit, but revert to wary opposition as soon as they are out of danger: peace is a pragmatic matter. The aversion to needless bloodshed, illustrated in "The Ascetic Jackal and His Brothers" (52), is a concern all too pertinent to the Mongols and to Ghiyas al-Din's own memory of his father's tragic death. A peaceful, spiritual

way of life is advocated by the line appended to Nasr Allah's text: "That in all cases one should observe moderation and follow the commands of the Lawgiver." This implies that the carnivorous jackals should change their behavior and adopt a contemplative Muslim life, following the example set by their pious vegetarian brother.

"The Lioness Laments Her Dead Cubs" (53) follows immediately. Here, the lioness-ruler bemoaning her skinned whelps is counseled against selfish killing by the jackal. Both the lioness and the jackal are repentant, and the cycle is brought full-circle, recalling their initial depiction in the story of Kalila and Dimna.

The jackal, now depicted as repentant and peace-loving, recalls the other jackal character, Dimna, villain of the first two chapters. By showing the jackal reinstated in the last story, and emphasizing his role far beyond its prominence in the text, the artist has restored the jackal's reputation as court advisor. Such a depiction of a court advisor would have appealed to Ghiyas al-Din. The wise lioness in "The Lioness Confronts Dimna" (25) is significantly more prominent than her inexperienced son, the king. She sets straight the affairs he, in his impulsiveness, has muddled; she assumes the position of authority that he relegates to her. Here, an animal figure is invested with all of the traditional attributes of an experienced court advisor.

Further evidence of a respect for experience can be seen in the prominence of the elderly advisor in "The Sasanians" (2) and "The Indians" (7). Yet the portrayal of the ministers flanking the Ghaznavid ruler (1) deviates significantly from this convention. The elderly vizier occupies the honorary position at the right of the ruler, but his figure is partially obscured by the massive throne: leaning quietly on his cane, he is lost in reverie. By comparison, the younger vizier at the foot of the throne stands out. Not only does he occupy the position of honor, at the right, designated for wise advisors throughout the cycle, but his eminence is marked by his position within the perimeter of the throne.

These two viziers are the only Rashidiya-type Islamic sages present. They are obviously men of letters. Their bodies are ascetic, slender, robed in traditional Islamic green, and they may well be son and father. It is not unreasonable to conjecture that they are idealized portraits of Ghiyas al-Din and his father, Rashid al-Din. Furthermore, Nasr Allah's explicit gesture toward the young minister may pay tribute to Ghiyas al-Din's role as vizier-patron of the manuscript.

The stress on court loyalty—also unique to this *Kalila wa Dimna*—would make the cycle a fitting allegory of Ghiyas al-Din's own position at the court of Abu Said. The patron's personal identification with the stories would then explain the unusual way in which the jackal advisor to the lion-rulers is represented, when in the final scene his role is reversed and he is reinstated. The jackal makes three appearances in the cycle. In the first, we see his privilege at court; in the next, his incarceration and death; and finally, in a totally unrelated story, his enlightenment and restitution. The three stages of the jackal's development call to mind the structure of Greek tragedy, in which heroes experience *hamartia* (human frailty), *metabole* (reversal), and *anagnorisis* (self-realization). It is not surprising that this is the strongest evidence for the patron's expression of his personal interests. Refusing to betray his ruler Arpa Khan in 1336, Ghiyas al-Din relied on animal imagery to express his loyalty:

Never would I submit to my enemy, even if he came from heaven. Does the falcon obey the sparrow, and the lion bow his head before the ox?[22]

It is tempting to speculate that Ghiyas al-Din adhered to the lesson taught in the compelling story of the lion-king and Dimna. He was executed, however, shortly thereafter.

On these grounds—as well as stylistic similarity with later IlKhanid painting—a date between 1327 and 1335 is probably plausible for the creation of the cycle. These were the years when Ghiyas al-Din enjoyed full rank and power, and as the inheritor of his father's intellectual legacy, he could have overseen such a philosophical and inspired "mirror for princes." His own introspective disposition was ideally suited for the emphasis on virtue and the beauty of the inner world reflected in this work.

Though the patron has immortalized his interests and taste in this profound interpretation of the *Kalila wa Dimna*, his identity will probably never be known with certainty. The *Kalila wa Dimna*, nonetheless, stands as a permanent monument to the vigorous tradition set by the Persian Mongol court who invested their energy, interests, and fortune in the making of such an exquisite and enduring work.

V. THE ALBUM PAINTINGS

The tales illustrated in the Mongol *Kalila wa Dimna* are translated with reproductions of all the paintings followed by interpretative comments. Of the two-hundred-odd tales that made up the complete fourteenth-century *Kalila wa Dimna* manuscript, about a quarter were chosen to be illustrated. The tales, which were grouped in chapters, open with a prologue. Written by Nasr Allah, the prologue is a eulogy to Persian kings, in particular Bahram Shah, the Ghaznavid ruler who commissioned this translation of the *Kalila wa Dimna*.

The chapters, containing tales within tales, demonstrate specific lessons in diplomacy and statecraft through the adventures of the animal characters. Each chapter is introduced by a brief dialogue between the Brahman sage Bidpai and his Indian ruler, who lay out the principal moral or political lesson to be learned.

The prologue and the eleven chapters that contain the fifty-four painted illustrations are presented here. The first chapter, "Burzuya the Physician," describes the ethical conflicts that led to Burzuya's journey to India, at the behest of the Sasanian monarch Anushirvan, to bring back a copy of the *Pañchatantra*, the ancient collection of animal tales on which the *Kalila wa Dimna* is based. "The Chapter of Kalila and Dimna," the longest in the book, concerns the theme of friendship betrayed by deceit. In the next chapter, "Dimna's Trial," malice is punished. "The Chapter of the Four Friends," which demonstrates the fruits of true friendship, is followed by "The Chapter of the Owls and the Crows," which warns against trusting an enemy. "The Chapter of the Monkey and the Tortoise" tells of the effect of neglecting a hard-won prize. "The Chapter of the Trapped Cat and the Mouse" shows us that even born enemies can cooperate. "The Chapter of the Lark and the Prince" describes the danger of trusting a ruthless adversary. "The Chapter of the Lion-King and the Ascetic Jackal" examines the king's relations with his advisors. "The Chapter of the Lioness and Her Dead Cubs" teaches "Do unto others as you would have them do unto you." And the last chapter, "The Ascetic and His Guest," discusses how confusion and misery befall a person who abandons his inherited tradition and profession.

The English text that follows is a translation freely adapted from Mujtaba Minuvi's reconstruction of Nasr Allah's original text, which was based on various twelfth- and thirteenth-century copies and revisions. For the sake of economy and the modern reader, my rendering, done with the invaluable assistance of Hassan Tehranchian, is intended only as a handmaiden of the accompanying illustrations. Stories are condensed, most poetry is deleted, and the dialogue is greatly abbreviated. Yet it is hoped that some of the original color and wit of the tales are preserved.

Nasr Allah's Prologue

The Ghaznavids

During the 170 years that the Ghaznavid dynasty has ruled, . . . 50,000 male and female pagans have been converted to Islam. The goodness and purity of their conversion benefits not only the Ghaznavid king, Mahmud, but all other kings of his dynasty. Those kings who follow are also virtuous, like Bahram Shah, the Lord of the World, Sovereign of the Universe, the fighting Shahanshah who inherited the kingdom. And other sultans of this government also had many laudable virtues. Each of them was, in policy, in justice, and in kindness, as great as a whole nation. (Minuvi, 13)

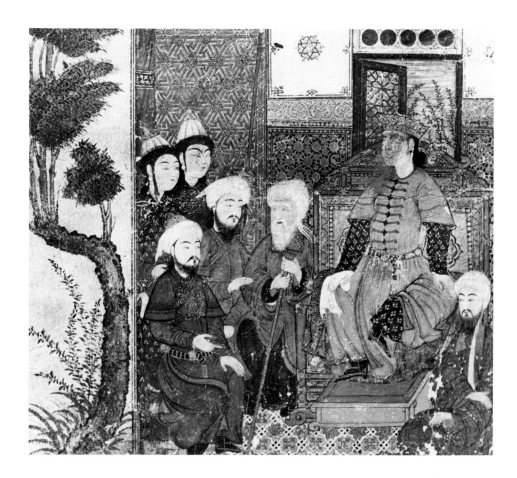

1
"The Ghaznavids"
(IUL f. 22v) 30 × 24.5 cm[1]
(color pl. II)

The first painting in the manuscript appropriately illustrates Bahram Shah, the twelfth-century Ghaznavid ruler who commissioned the Persian text used in this cycle of the *Kalila wa Dimna.* Holding audience with members of his court, he turns toward the gesturing figure in the foreground, who is probably Nasr Allah, the writer commissioned to translate and expand the text. Two viziers—Bahram Shah's closest advisors—occupy positions of honor at his immediate right and left. Clad in green robes,[2] the sacred color of Islam, and depicted with elongated physiques drawn on the model of a sage in the Rashidiya *World History,* they are unlike any of the other courtiers. The idealized vizier (right) may well be the Mongol patron of this manuscript, who, as suggested previously, was probably Ghiyas al-Din, and the older vizier is perhaps his father, Rashid al-Din. Another, lesser courtier is seated behind Nasr Allah, and a pair of guards, also dressed in Central Asian–style robes, stand at the back of the room.

Bahram Shah is an imposing figure. Elevated above his court, he sits in royal isolation, serene and at ease on a golden throne. In his hand is a *mandil* (napkin), a traditional Central Asian symbol of power.[3] Behind him, an open door leads to a garden. In the symbolic vocabulary of this cycle, an interior garden represents the superior state of being of the figure most closely associated with it.

Within the larger triangular configuration of important courtiers that includes Nasr Allah, an inner triangle defines the ruler's inner circle. The younger man on the right must be the chief vizier. All eyes except those of the ruler and the elderly vizier are turned toward him. He seems to be a part of the foundation of the throne itself, and his gaze is fixed steadfastly on things that only he and the ruler can see. He is placed on the right—an empowering position for figures throughout the cycle—and Nasr Allah points at him.[4] Another courtier touches the arm of the elderly vizier, whose eyes appear to be fixed on an inner spiritual world.

The close relationship of the ruler to his viziers is accentuated by vibrant color, which also incorporates the figures into their surroundings. Green brackets the fiery-red robe of the ruler; the play of complementary colors continues throughout this realistic Mongol court setting.[5]

Although remarkably similar in its architecture to the *Shahnama* album pages—for example, "Jamshid Teaches the Crafts" (Figure 7)—this setting has a more specific function as an attribute. The rich blue-tiled dado marks the boundaries of the generous space accorded to the ruler and his intimate advisors, while the minor courtiers are crowded before the red brick (or plaster) passageway at the left. Bahram Shah is framed by a doorway and a flowering rose bush, with which only his crown—his head and body are shielded from the garden by the

throne—is associated. As a symbol of absolute perfection, the roses and the garden celebrate the enduring wisdom of the Ghaznavid dynasty—not the individual figure of the ruler himself.

"The Ghaznavids" introduces several conventions that are adhered to throughout the cycle. In particular, there are three separate but contiguous realms of symbolism: the margin, for the first time in Persian painting, represents the ideal, paradisiacal realm; the interior garden offers access to Nature, the similitude of spiritual perfection; and the central part of the painting represents the physical world.

In contrast with the formality of this arrangement, the naturalistic portrait of the old vizier, presumably Rashid al-Din, is notable. Details like the slump of his body, the grip of his old hands on a supporting cane, and the white,

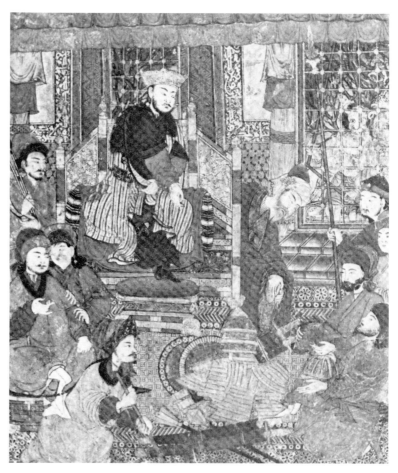

FIGURE 7

silken eyebrows framing wistful eyes—marks of personal expression added to a Rashidiya model of a sage[6]—attest to the artist's descriptive power. Equally sensitive is the portrayal of the trailing end of his turban. Its fine white diaphanous material is rendered with such delicacy that the green robe beneath remains visible. In much the same way, the three principal figures are invigorated by the broad sweep of the evergreen. Thick irregular lines suggest its rough, textured bark, and short impressionistic strokes, the clusters of needles. The tree also balances the layout of the page, its curves acting as counterpoint to the rectilinear architecture. The artist's achievement is to have portrayed in a traditional enthronement scene[7] the power behind the throne. The position of the chief vizier suggests that he is the cornerstone of government. This extolment of and identification with the Ghaznavids is in keeping with the Persian belief "that historical continuity and legitimacy lie in the similarities between past and present."[8]

The Chapter of Burzuya the Physician

The Sasanians

Upon completion of the book, Burzuya was summoned back from India to the court of Anushirvan, who was greatly pleased with the work.

The ruler said, "Take satisfaction in knowing that the work you have done is of great importance to me. Go and rest for a week, and then we will make all the preparations to give the book the reception it deserves." On the seventh day, the ruler ordered the scholars and nobles to gather and summoned Burzuya to read his work aloud.

Everyone was amazed, and thanked Almighty God for having bestowed such a gift. The ruler ordered that the door of his treasury be opened and asked Burzuya to choose without hesitation whatever he wanted. Burzuya replied, "I should like the ruler to order Buzurgmihr [the esteemed vizier] to write a chapter about me, discussing my family, my art, and my religion so that it may be inserted in the book and my name may live on." The ruler happily agreed. (Minuvi, 35–37)

Burzuya, who was commissioned by the ruler Anushirvan to create a Pahlavi version of the *Kalila wa Dimna*, pays homage to the enthroned Sasanian ruler by kneeling and touching his head and outstretched hands to the ground. The figure Burzuya faces is seated within the confines of the throne on the right—

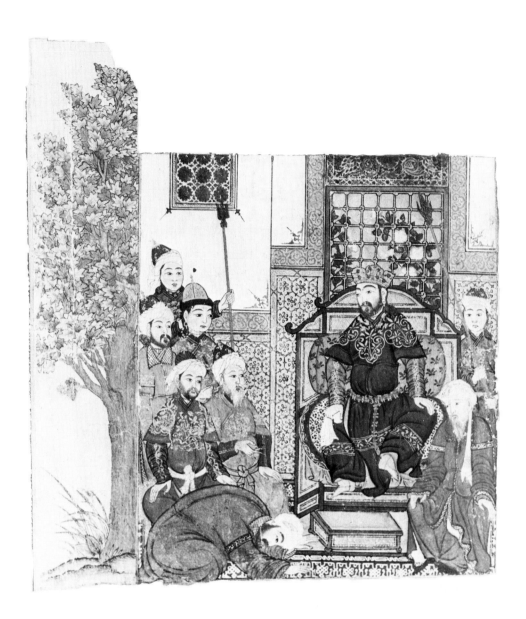

2
"The Sasanians"
(IUL f. 22) 30 × 24.5 cm

the position of honor in this cycle. He must be Buzurgmihr, the vizier commissioned to write his biography. Three other courtiers, a young page (or falconer), and two standard-bearers holding spears[9] are also in attendance.

The large size of the figures, heavy outlining of their facial features, and decorative style of the tree have more in common with paintings in the Demotte *Shahnama* than with paintings in this cycle.[10] This suggests that "The Sasanians" was made by artists who knew the others' work.

The painting shares many features with "The Ghaznavids" (1), which apparently served as its model. But by comparison, this work is static and lacks finesse. The position of one of the viziers is changed—only the elderly man flanks the ruler—and the use of color no longer integrates the figures with their surroundings. The ruler becomes a mere emblem of power, and greater attention is drawn to the role of the older man.

Like Bahram Shah, Anushirvan sits in royal isolation on a golden throne and has the same accouterments of authority. Behind him is a rose garden, and in the margin, a tall *chinar*. To reinforce the ruler's stature, the artist uses several obvious devices: the ruler is larger than Bahram Shah; his robe is royal blue,[11] set off by an enormous red bolster and a leopard skin; and he is more isolated from his court. His dominance, however, is challenged inappropriately by the standard-bearer on his right, who towers above the throne.

Buzurgmihr, like the young vizier in "The Ghaznavids," is visually linked with the throne, and almost all eyes are fixed upon him. Although less individualized than the elderly vizier in the previous scene, this man also looks inward. The attendant standing above him, however, seems to mock his contemplative state with a cross-eyed stare. Burzuya is shown in an unusually awkward pose, with head in profile and body in three-quarter view—like Zal's in "Zal Before Manuchir" from the Demotte *Shahnama*.

The use of color in this scene increases its additive effect. The blue-robed ruler is no longer closely allied with the elderly vizier, who is clad in red and green, and neither one is integrated with his surroundings. The complementary colors of the vizier's Islamic robes call attention to him; the crimson of his surcoat, however, is offset by the fiery red of the ruler's bolster and footstool and the red Central Asian–style robe of a minor official. Burzuya, in his green Islamic robe—incongruous for the period—is only tangentially related to the ruler through color.

The setting designates relationships less subtly than in "The Ghaznavids." Figures are still crowded together at the left, but here there is no doorway and the same tiled dado decorates the wall behind Anushirvan. To separate the ruler, Buzurgmihr, and Burzuya from the lesser courtiers, the dado is symmetrical in design. At its center, a grilled window frames the ruler. His crown, silhouetted against a rose garden and rising above the throne—like Bahram Shah's in "The Ghaznavids"—glorifies not the individual but the dynasty.

The large tree in the margin is as hierarchical as Anushirvan and emphasizes that he is unapproachable. Disproportionately massive, its foliage is too dense to have been incorporated in a fluent, interlocking pattern of text and image, as in the other paintings in the cycle.

3
"The Fool and the Well"
(Rampur, p. 25) 25.5 × 11 cm

The Fool and the Well

Burzuya said, "He who has knowledge and does not use it is like one who knows the dangers of a road but travels it nonetheless, and is robbed. Indeed, he who recognizes evil but still commits a crime earns the scorn of others. Take the example of two men, one blind and one clear-sighted, who each mistook their route, stumbled into a well, and died. Wise men will better understand the blind man's excuse.

46

"The benefits of learning are threefold: self-respect, the glory of the soul, and finally, ability to teach. . . . A wise man knows his destination and maps his route before he sets out; moreover, he sets his destination in the next world. He who prepares himself for life after death will also benefit from this life, while one who sets out to accumulate earthly goods forfeits his spiritual reward." (Minuvi, 40–41)

Judging by its style and thematic content, this scene is likely to have been included in the original Mongol manuscript; it was omitted from the Shah Tahmasp album because its tall vertical format did not, it would appear, conform to the new layout. However, the sixteenth-century Rampur painting is probably a close copy of the discarded original.

In keeping with the didactic tone of the IlKhanid interpretation of the *Kalila wa Dimna*, this scene illustrates the downfall of a traveler who abuses his gift of sight. He lies on top of the hapless blind man at the bottom of a well, a victim of his own failure to use his superior knowledge. This scene may well represent the first stage of the Sufi quest—a journey toward the ultimate goal of total self-awareness and union with the divine. Contrary to tradition, however, it is here portrayed as an unsuccessful first step.

The dark cavity, whose lower depths are shown in section and whose gaping aperture is made visible by its being tilted forward, is like the wells in (6) and (26). Further correlation with the Istanbul paintings is evident in the hill's wrinkled surface, the windswept vegetation,[12] and the discrepancy in size between the painting and the narrower Rampur text.

Dense, black Bukhara coloring and later, Timurid landscape details (small dead tree and rosette in plan) have been added, but the composition retains the vitality and drama integral to the Istanbul cycle.

The Clever Merchant and the Gullible Thief

Burzuya said to Buzurgmihr, "One night a man and his wife were awakened by a band of thieves on the roof of their house. The merchant and his wife discussed ways of protecting themselves and decided that the woman, addressing her husband loudly enough to be overheard by the thieves, should ask him to explain how he had acquired his wealth. She did so, and her husband answered, 'On moonlit nights I used to stand before the houses of the rich and say "Shawlam-Shawlam" seven times and then touch the moonbeam. All at once I would be transported to the

roof, where I would stand before the chimney and repeat "Shawlam-Shawlam." Immediately, I would find myself in the house. The third time I chanted "Shawlam-Shawlam," I would find all of the valuables of the house before me. I took whatever I could carry and, repeating the words, found myself back in the moonlight. Due to the power of the spell, I was never seen and never suspected.'

"The thieves listened with delight. After waiting for some time to let the owners fall asleep, the leader said, 'Shawlam-Shawlam,' stepped into the chimney, and fell head over heels into the house. The merchant grabbed a cane and, beating the thief's shoulders, cried, 'Have I slaved all my life so that you could steal what I have accumulated? Who are you?' The thief replied, 'I am the idiot who let your sweet-talking bring me to ruin!' "(Minuvi, 49–50)

In one of the most poetic paintings of the cycle, the theme of the opposition of the material and spiritual worlds is developed. The moral richness of this scene derives from the merchant's using the thief's method—deception—to capture the malefactor, as well as from the would-be perpetrator's becoming the victim through his own gullibility. In this scene, there is a suggestion of the Sufi "stage of detachment," expressed by the overlay of a lyrical mood. This is achieved by the portrayal of the wife as an ethereal being, and her association with an interior garden that is the reflection of her inner world.

The thief has fallen head-first down the chimney on a silver moonbeam, and, bloodied, is sprawled on the bedroom floor. Grabbing the thief's leg between his knees as a counterweight to his backward movement, the angry merchant prepares to strike the intruder—despite his supplication—with a wooden cane. The etherealized, demure wife looks on from her bed; only her ruffled Turkoman kilim[13] bespeaks her inner agitation. The doors behind her open to an inner garden, representing her virtue and pure soul. She is aloof, almost disengaged from the material world she inhabits. She partakes of the tranquility and harmony of the transcendental realm of the margin and, bending gracefully like a cypress in the wind, embodies the Persian poetic ideal of beauty, described with garden imagery by Firdawsi:

She was like ivory from head to toe, with a face like Paradise and a figure as graceful as a tree. Her cheeks were red as pomegranate blossoms and her lips like its seeds, while two pomegranates grew from her silver breast. Her eyes were like the narcissus in the garden, and her eyebrows stole the blackness from the crow's feathers. She is Paradise to look upon.[14]

The elaboration of setting focuses the action and unifies the composition: the cupboard's Mongol keel arch frames the merchant's upright body; the complementary green of the floor[15] energizes the writhing, bloody thief; and the nar-

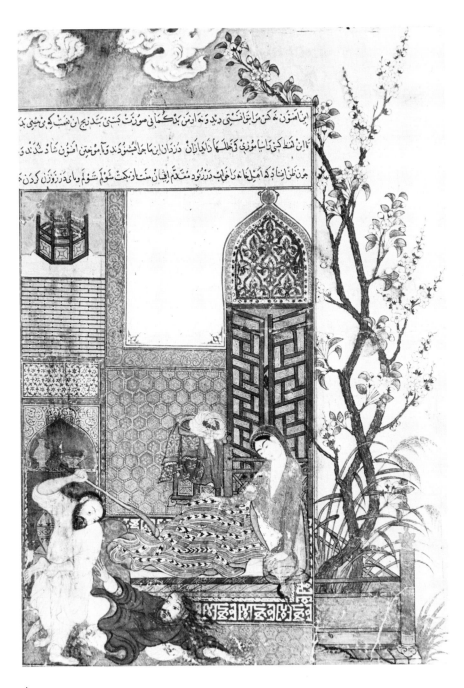

4
"The Clever Merchant and the Gullible Thief"
(IUL f. 24) 33 × 23 cm
small fragment of missing sky (2.2 × 4 cm) found on f. 22; three partial lines of text
(color pl. I)

row portal elongates the figure of the wife, whose sinuous curves are imitated by the intertwined plum trees.[16] The red coloring of the lattice screen and the fence further associate the wife with the paradisiacal garden, while isolating her from the mundane preoccupations of the men. As spectator, she correlates three realms: the ideal, the inner, and the corporeal.

The wife's oblique gaze, however, structures the composition; her field of vision spotlights the combatants, whose interaction—marked by the raised cane, the thief's outstretched arms, and the merchant's upright, foreshortened body— mirrors the endless cycle of greed inherent to the material world.[17] The three lines of text that remain *in situ* were originally appended to a vertical column of text bordering the painting (Figure 2C): the intricate pattern of horizontal and vertical forms that it set off is still discernible.

This highly refined composition is the first of several domestic scenes to appear and is clearly the work of one of the major artists. Its delicacy and smallness of scale and the unusually abstract character of the wife prefigure Jalayirid court painting, but the equilibrium between violence and the metaphysical is a tribute to Mongol expression.

The Greedy Dog and His Bone

Burzuya continued, "One of the rewards of piety is that it enables a man to live without fear of death. Whenever a virtuous man examines this transient world and its pleasures, he realizes its ugliness, and bows to destiny, preparing himself for the next world.

"The more I recognized the rewards of asceticism, the more I desired them. Yet I feared that giving up life's pleasures would be too difficult. If I failed, I would then lose the food of both this world and the next. This is like the dog who found a bone at the edge of a stream. As soon as he had seized the bone, he saw his reflection in the water. Thinking that he saw a second bone, he opened his mouth to grab it and dropped the one he was carrying into the water.

"This fear so confused me that I almost lost the treasures of both worlds. But when I reconsidered this life, I saw that its delights were short-lived and that, as with saltwater, the more one drinks, the more one thirsts." (Minuvi, 52–53)

Although this scene is standard in earlier versions of the *Kalila wa Dimna*, the Mongol compassion for animals and belief in mysticism result in a more fluid

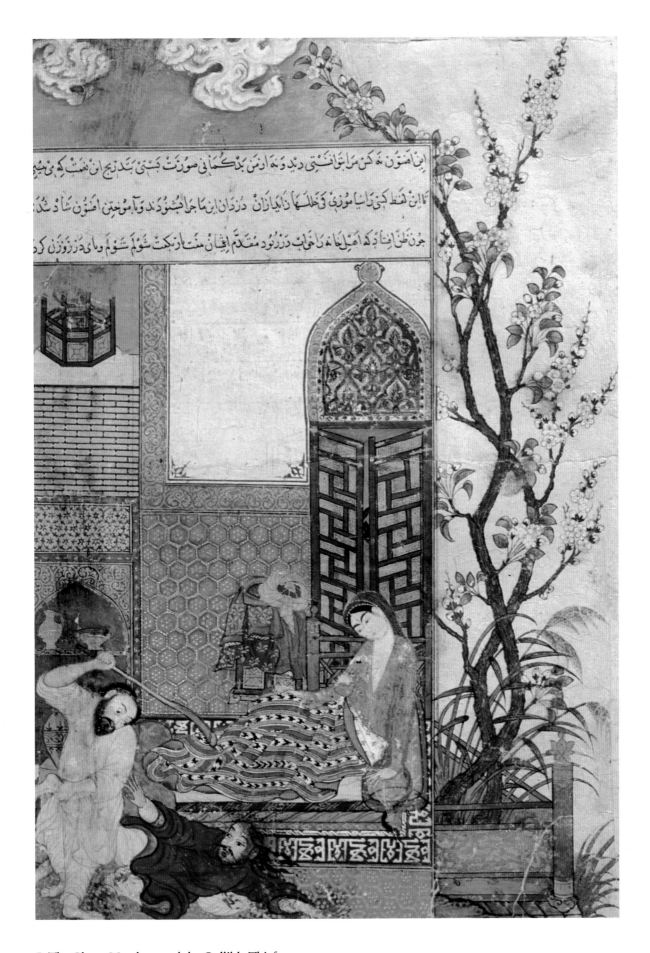

I. The Clever Merchant and the Gullible Thief

II. The Ghaznavids

Facing page
III (*top*). The Indians
IV (*bottom*). The Ascetic's Guest Beats the Mouse

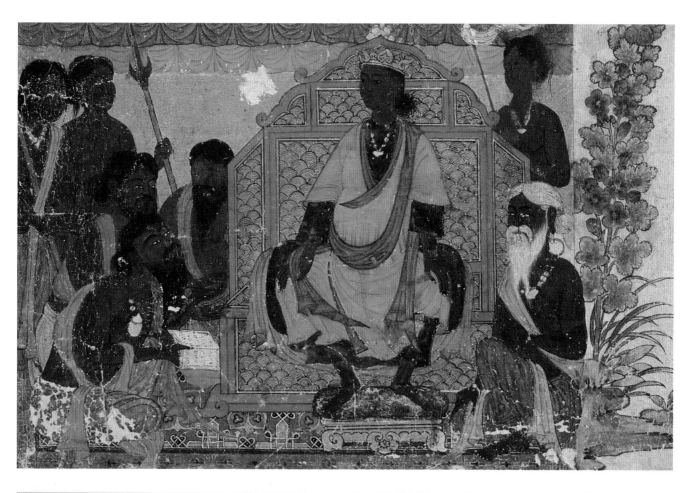

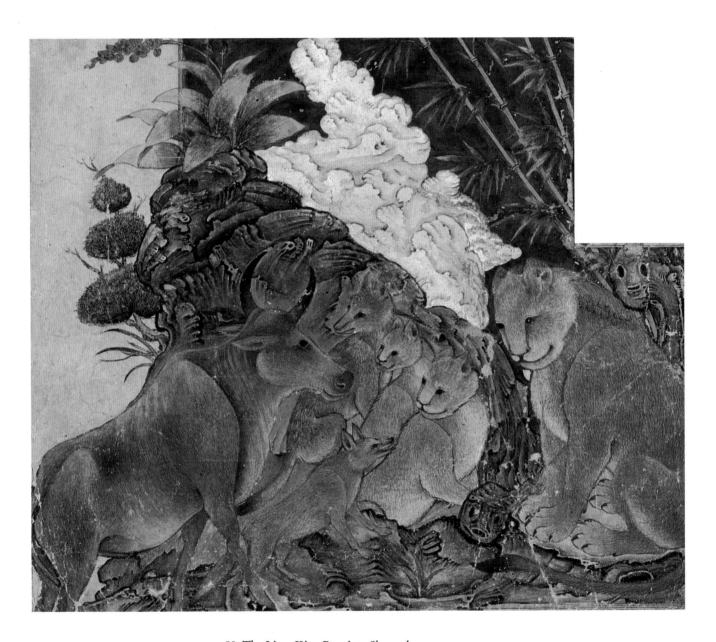

V. The Lion-King Receives Shanzaba

Facing page
VI (*inset*). The Greedy Dog and His Bone
VII. The Battle of the Lion-King and Shanzaba

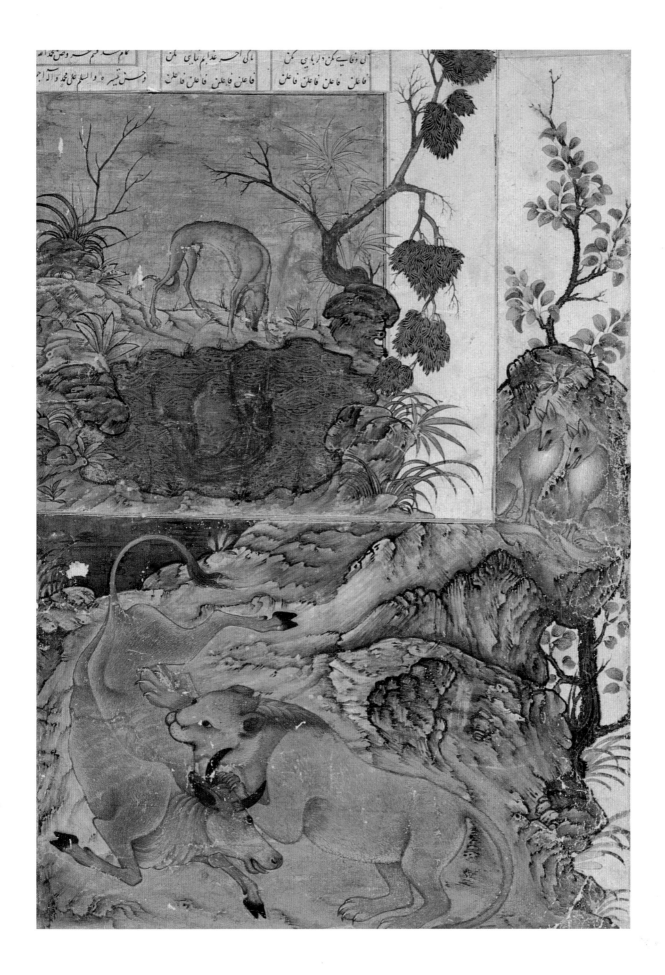

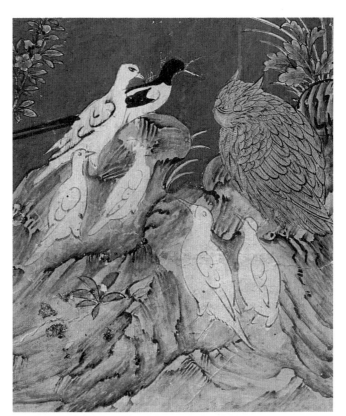

VIII (*right*). The Crow
Insults the Owls

IX (*below*). The Crows
Attack the Owls

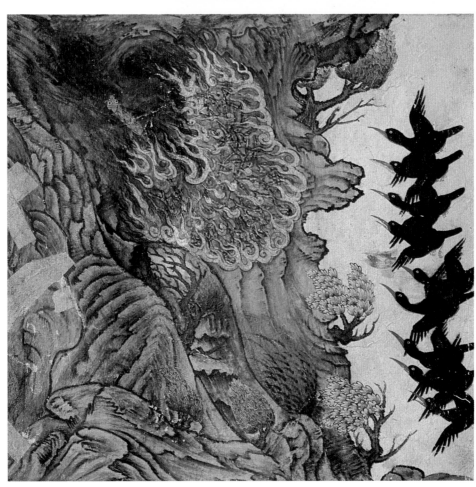

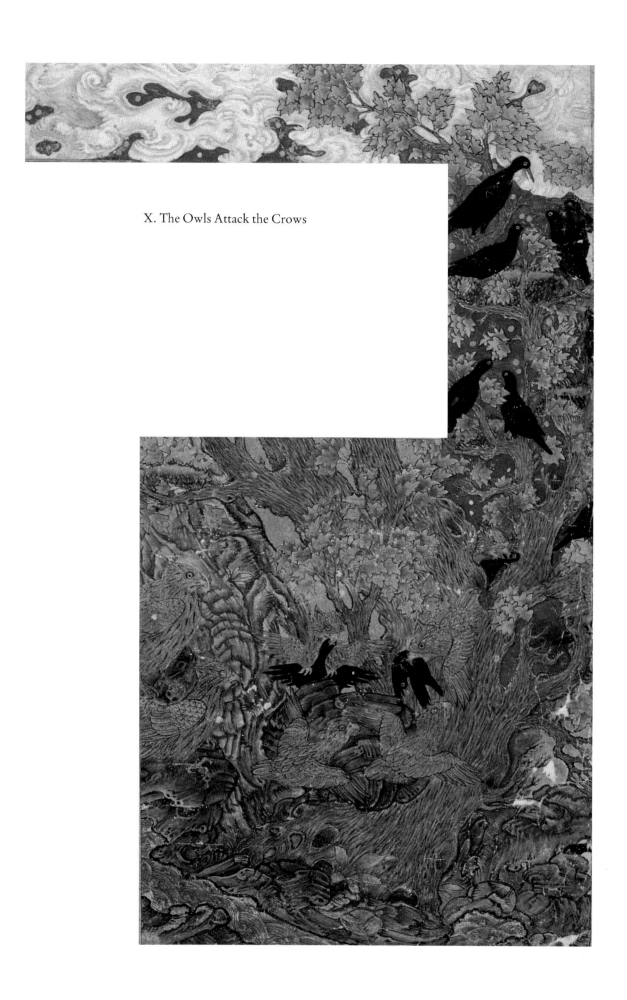

X. The Owls Attack the Crows

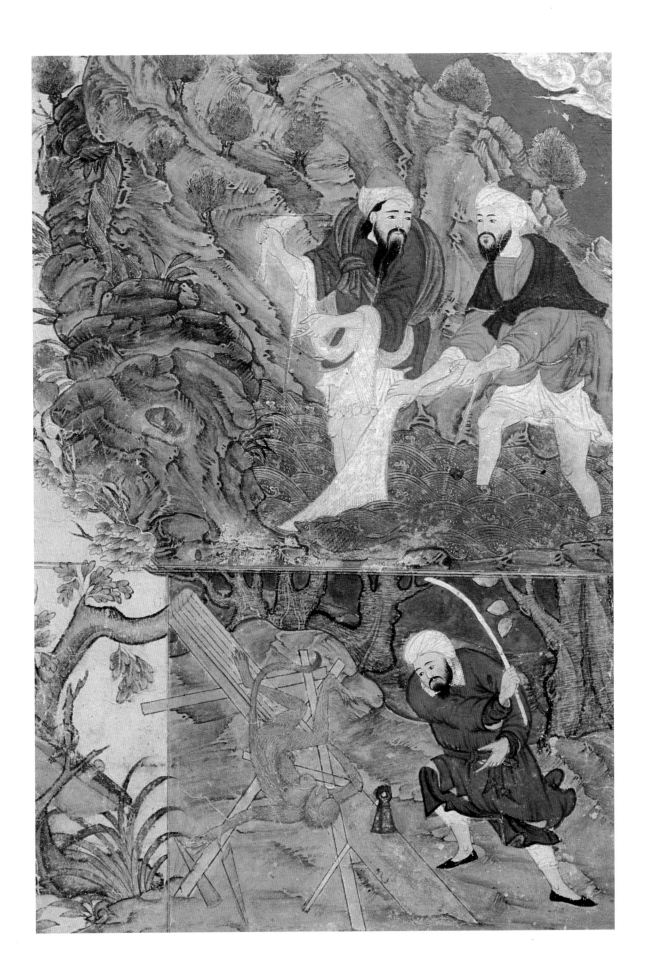

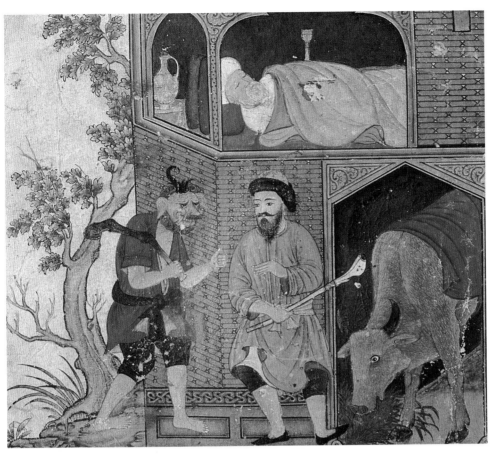

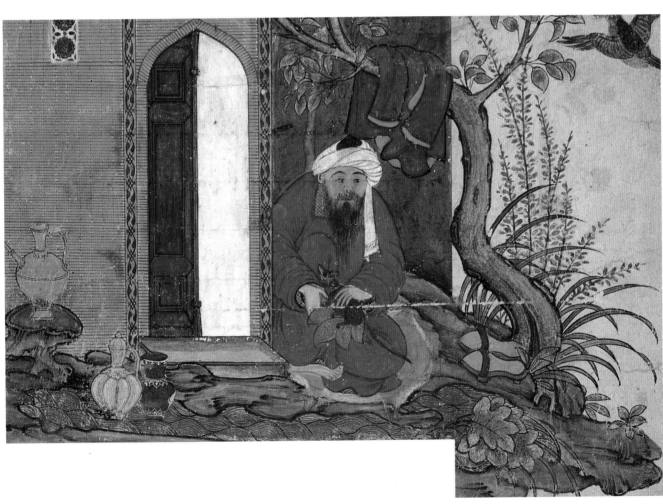

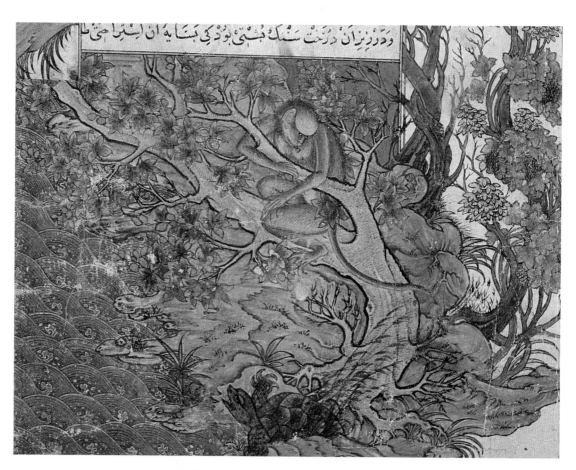

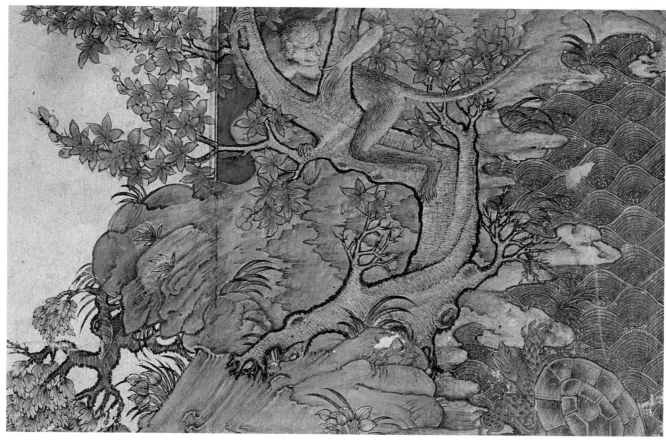

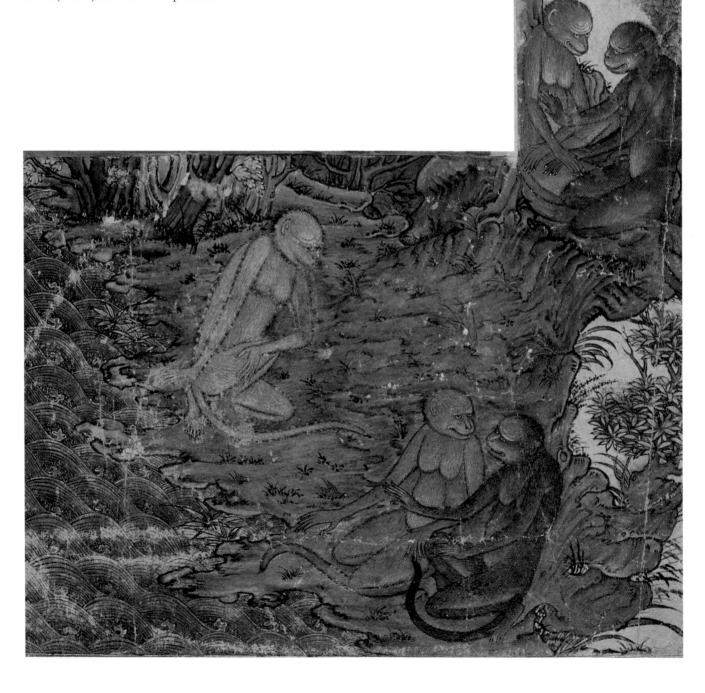

XVIII (*inset*). The Crab Hears the Heron's Story

XIX. The Ass and the Fox En Route to the Lion

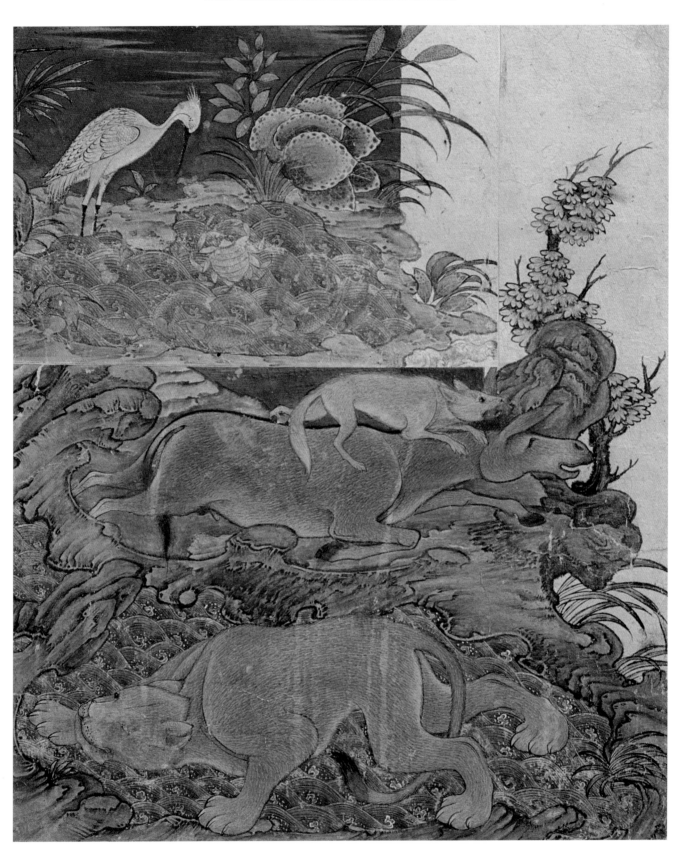

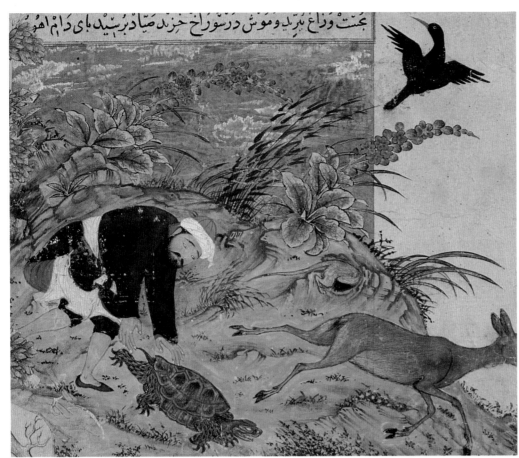

جست وزاغ برید و موش در سوراخ خزند صاد برسید بای دام اهو

XX (left). The Hunter
Pursues the Tortoise

XXI (below). The Fox
Deceives the Ass

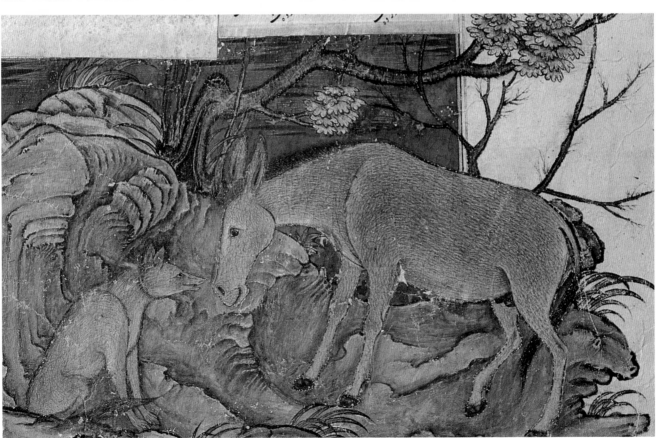

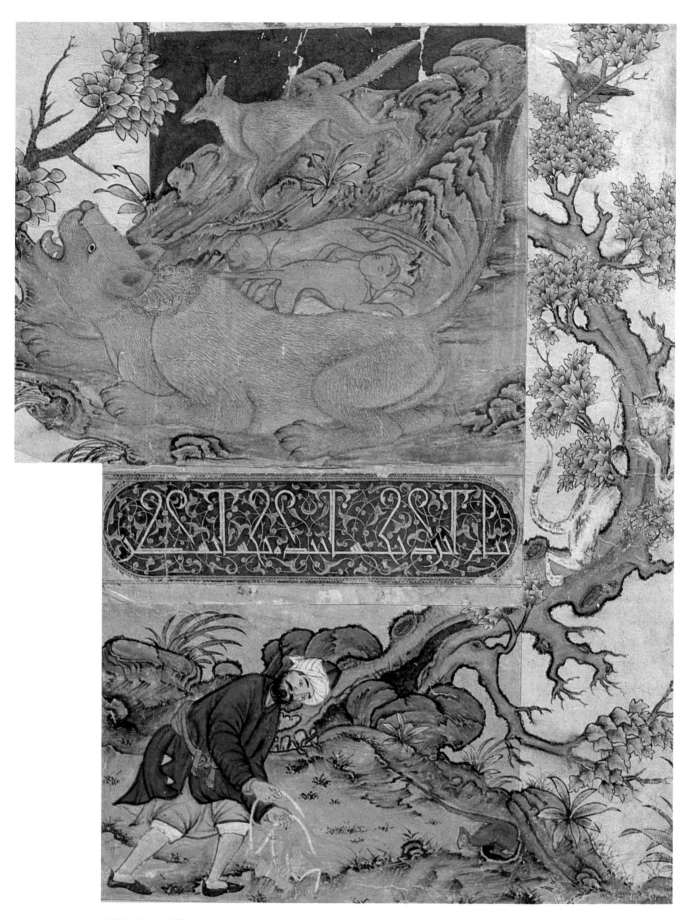

XXII (*inset*). The Lioness Laments Her Dead Cubs
XXIII. The Escape of the Cat and the Mouse

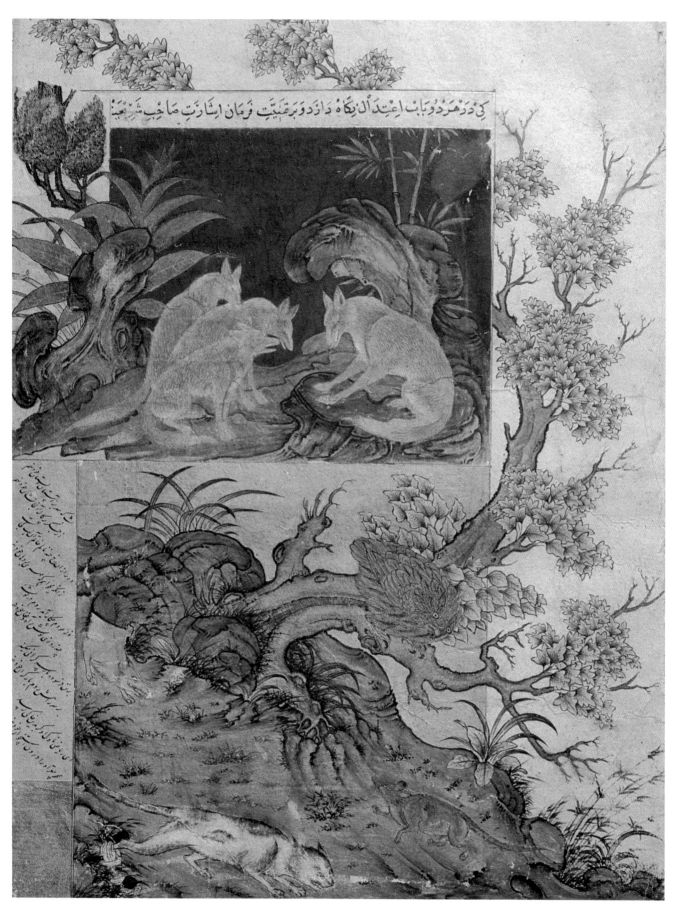

XXIV (*inset*). The Ascetic Jackal and His Brothers
XXV. The Frightened Mouse and the Trapped Cat

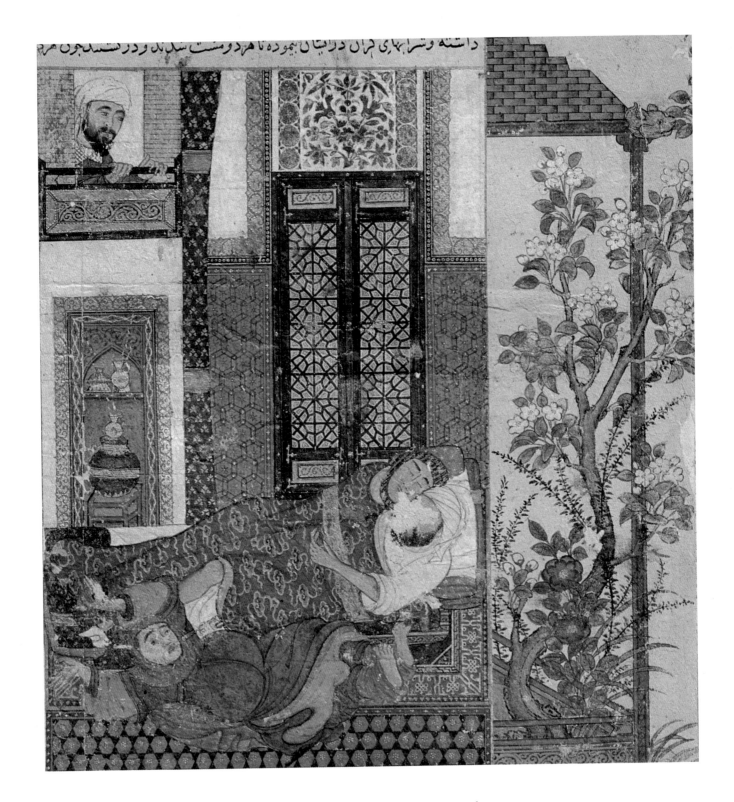

XXVI. The Old Madam and the Young Couple

5
"The Greedy Dog and His Bone"
(IUL f. 6v) 17.5 × 17 cm
bamboo stalks at right a sixteenth-century addition; sky near tree at right
repainted in lavender; as throughout, oxidation of silvery water
(color pl. VI)

and active interpretation. A lean, hungry hound lowers his head to reach in
vain for an illusory bone—the mere reflection of the one he already holds.
Depicted at the moment of temptation, the hound and his reflection exemplify
man's unending greed for the pleasures of his world.[18] The painter's addition
of a red collar signifies the domesticity of the hound and subtly suggests that
his position is analogous to man's.

The slinky, lean hound is realistically depicted; his lanky body also serves to
bridge planes of space gracefully as it curves dramatically to allow a full view
of his lowered head, panting for the object of his greed.

The concentric configuration of the stooped hound and his inverted reflection is repeated in the landscape itself. The river described in the text has been deliberately changed to an oval pool.[19] Windswept grasses and arching dead branches enclose the dog's movement. The margin's eccentric drooping leafage echoes his action and mirrors his fate, creating discord. The pull of the material realm and its grotesque consequences are placed in opposition to the ideal of upward striving, expressed by the tree's vertical foliage.

Man's Fate

Burzuya continued, "A man climbed into a well to escape from a mad camel. He clung to two branches that grew at the mouth of the well and stood on the heads of four snakes. At the bottom of the well, the man saw a dragon waiting with gaping mouth to catch him if he should fall, and above him, a white and a black mouse gnawed at the roots of the branches. He was wondering how to escape when he spotted a beehive filled with honey just within his reach. He tasted some of the honey and became so absorbed in its sweetness that he forgot his predicament. Finally, the mice severed the branches, and the man plunged into the dragon's mouth. So it is that greed may draw a curtain of darkness over a man's wisdom.

"In the following way I compare the world to that dangerous well. The black and white mice represent night and day, furiously devouring life. The four snakes are the four humors sustaining man's body, which become like deadly poisons when disturbed in their desires. I think of the honey as the enjoyment of this ephemeral world, which brings in its wake peril and suffering. And the dragon is like one's inescapable death, for when the Angel of Death summons you, you must go without hope of return.

"Therefore, I accepted my destiny. I lived in hopes of finding salvation for my soul, then I traveled to India and spent my days in study, and returned with several books, among them the *Kalila wa Dimna*." (Minuvi, 56–58)

The painting is an allegory of the human dilemma: a man trapped in a well is so infatuated with the sweetness of the honey within his reach that he becomes oblivious to imminent danger. Open-mouthed and wide-eyed, the man ignores the mice gnawing at his lifeline and the mad, stubborn camel threatening from above. The grimacing, cubistic face fashioned out of the large boulder at the margin may be sneering at the man's short-sightedness and impending fate.

بهتر زنیک نیست خود و بای خود بر سر جهان مازد بد که خار سوراخ بیرون کداسته

6a
"Man's Fate"
(IUL f. 25v) 10.6 × 23.4 cm
lower portion missing;
one line of text *in situ*

6b
(Rampur, p. 25)

As the summation of this chapter—which is chiefly preoccupied with man's blind attachment to the material world—"Man's Fate" relates closely to the three previous paintings. The artist who illustrated the thief in (4) also must have painted this figure. Like that of the thief, the man's wavy auburn hair is parted in strands, and he has a drooping moustache and foreshortened sleeves. His turban also has come unwound, and falls over his shoulders in his struggle to grasp the tamarisk roots and pull himself toward the honey hidden in the cleft of the tree.

The Rampur copy (6b) provides the missing vertical section of this L-shaped composition, showing the dragon at the bottom of the well. That the Rampur artist closely copied the original page format is shown by the similarly placed text—one line above and the rest beneath the camel;[20] the vertical section was removed following the preference of the sixteenth-century album maker for horizontal compositions. The L-shaped painting and text would have dovetailed to form a large rectangle (Figure 2B).

The Chapter of Kalila and Dimna

The Indians

The Raja of India ordered the Brahman, "Tell me the story of two very close friends whose friendship is shattered through the scheming of a cunning individual, as a result of which their love and harmony turn to hatred and enmity." The Brahman replied, "Any time the relationship of two friends is divided by the intrusion of a malicious person, their brotherly feeling will be destroyed. The story of the merchant [and his son's ox] is an example of this." (Minuvi, 59)

This painting of an enthronement is immediately reminiscent of "The Ghaznavids" (1). There are obvious dissimilarities, however, revealing the Mongol appetite for parody. Each scene features a masterly portrait of a venerable old man who advises the ruler. Here the Indian raja, Dabishlim, is listening to Bidpai, the legendary Indian author of the text.

The raja is all but a caricature of the Ghaznavid ruler. Dark-skinned and rotund, he sits incongruously in the relaxed pose of a Bodhisattva, thighs spread wide, belly accentuated by a tautly drawn orange robe, girth framed by a green scarf, and skirt hanging in accentuated folds. A heavy gold necklace replaces

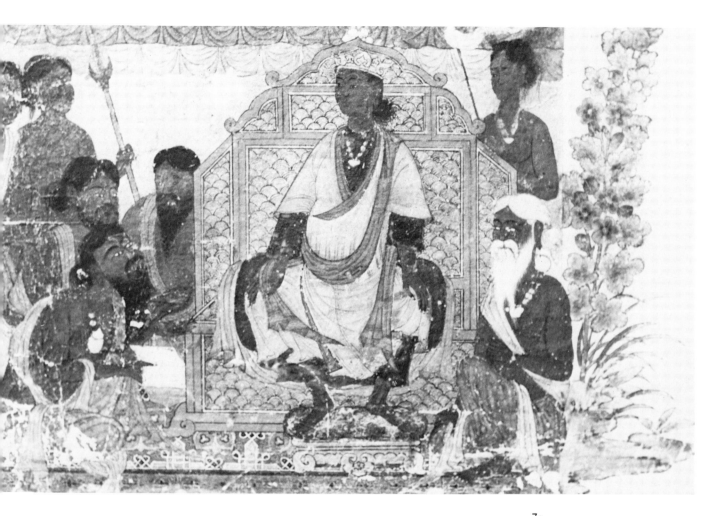

7a
"The Indians"
(IUL f. 6) 15 × 23.5 cm
cropped along top and left side
(color pl. III)

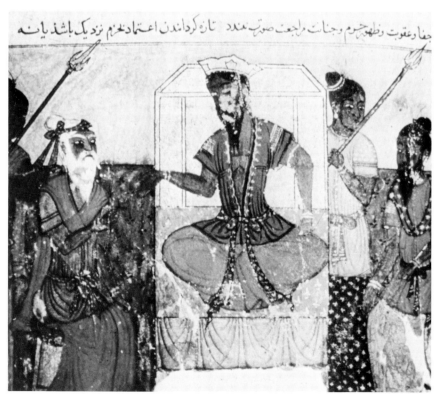

جفاوعقوبت وظلم جرم وجنايت واقعب صورت معدد تاريخ كردماندن اعتماد الحرم نزديك بأشذيانه

7b
(Cairo 1343/44 f. 77)

55

Bahram Shah's delicate brocade; bare feet replace those elegantly shod; and the raja's hair is untidily bunched beneath his crown. He is mundane, not royal or religious.

The Ghaznavid throne has been modified and enlarged; a small Buddhist flaming jewel at the top and a monotonous gold wave pattern camouflage his crown to further diminish the ruler's stature. The raja's marginal attribute is not the conventional tree, but a flowering plant. Simple surroundings, much less elegant than those of the Ghaznavid court, equally demean his position: the only decoration occurs in the richly patterned carpet[21] and the Chinese-style rolled curtains appropriate to a verandah setting and the climate of India. The country's intense heat is evoked by the dense gold background, the characters' scanty attire, and the fly whisk held by the standard-bearer.

The sadhu seated opposite Bidpai also parodies his counterpart in "The Ghaznavids,"[22] with his forked beard, woolly hair, and bushy eyebrows. His necklace and massive hoop earrings only accentuate the scantiness of his dress.

Despite its relative simplicity, this scene is extremely lively, largely because of the rhythms of its vibrant oranges,[23] intensified by the presence of red and maroon—and their play on the dark skin of the Indians. The horizontal format and generous width of the scene require the painting to have been sandwiched between horizontal blocks of text rather than forming the more animated L-shaped configuration. The two standing guards at the left thus replace an area of text to counterbalance the tall plant in the margin.

The Father's Advice

The Brahman continued, "A rich merchant had children who refused to learn any craft or profession but delighted in squandering their father's property. Finally, the merchant was moved to say, 'Oh children, the inhabitants of this world try to gain three things: abundant fortune, respect and high rank, and the reward of the Hereafter. The prerequisites for these are the honest accumulation of wealth, its good use and protection, generosity without harming one's family, and attention to the purity of one's soul. If you disregard any of these achievements, the world will treat you harshly. If you refuse to work and increase your wealth, you will soon find yourselves destitute.' " (Minuvi, 59)

The representation of the mystical "stage of understanding" by the traditional

8
"The Father's Advice"
(IUL f. 20v) 26.2 × 20.5 cm

portrayal of a sage-teacher may explain why this novel and unusually undramatic painting was included in the manuscript.

The audience scene appears in a standard version here; the noncourtly environment and undramatic action required only the hand of a lesser artist. The static figures are enlivened merely by the contrast of color and the interplay of rectangular planes that alternate rhythmically.

The merchant-father reprimands his three sons for their wastefulness, and lectures them on wisdom. The eldest son, who sits closest to his father,[24] is talking, as the gesture of his right hand indicates, while his lowered left hand draws his brothers into the discussion. Reminiscent of previous enthronement scenes, "The Father's Advice" is a domestic scene, portraying the transmission of knowledge within the family rather than in a court.

The text specifies that the father is a successful merchant, but here he is shown as a wise and devout teacher wearing traditional Islamic garb. An asymmetrical composition further stresses his authoritative stature and calls attention to his conventional didactic gesture, embellished by a blooming mallow rose in the garden directly behind. A flower at the top of the painting integrates the figures and their setting: two ascendant diagonals established by the lines of the sons' and father's heads intersect there to form a triangle. The father's relationship with his eldest son is strengthened by the complementary coloring of their robes.

Patterned textiles provide a lively counterpoint to this otherwise somber scene: the Mongol appreciation of bold textiles is accurately reflected. The father is bolstered by large cushions at his back and beneath (the latter Turkoman in design), and his sons sit on a red-and-black zigzag carpet (a Seljuk-type with Kufesque border).

The opening up of the background plane is minimized by the central axis knitting foreground and background, the high railing across the window, and the close view of the mallow rose. The three mature blossoms may be associated with the sons, while the ash trees in the margin—one a sapling, the other mature—may represent the different generations in the family.

"The Father's Advice" is caught between two genres; it displays neither the hierarchical complexities of enthronement scenes nor the dramatic intensity of narrative painting. The figure-types and shallow space are reminiscent of the Rashidiya school: this archaism seems to have kept the artist from attaining the liveliness and originality of the rest of the cycle, but it is in keeping with its didactic moral tone.

Dimna and Kalila Talking

The Brahman continued, "The brothers took their father's advice. The eldest started a trading business and left on a long journey with a caravan that included two oxen, Shanzaba and Nandada. Shanzaba was not fit to travel and was abandoned. With time, he recovered and grew fat and strong on grass and vegetables. Intoxicated by his prosperous circumstances, Shanzaba bellowed loudly and was heard by a lion-king who lived nearby.

"This lion had never seen or heard an ox before. When Shanzaba roared, the lion was beset with fear. Among the king's subjects were two jackals, Dimna and Kalila. Both were intelligent, but Dimna was greedier and more ambitious to improve his position at court. Dimna asked Kalila, 'What do you think of the lion's sad and

9
"Dimna and Kalila Talking"
(IUL f. 10) 10 × 6 cm
only this fragment remains

indolent state?' Kalila replied, 'What does it have to do with you? Though we enjoy hospitality at his court, we do not belong to the worthy class that provides the king's companions and whose words are heard by royalty. Do not meddle in this business, for one who seeks unsuitable gain will suffer the monkey's fate.' "
(Minuvi, 60–61)

The small surviving fragment depicts Dimna and Kalila eagerly engaged in conversation. The jackal on the left can be identified as Dimna by his more ag-

gressive pose, which accords with his cunning nature. In subsequent scenes, he has the same glaring eyes, the same upraised pointed ears, the same snout. Kalila appears more docile. Furthermore, his position at the right is appropriate, since he is the narrator of the following scene. Such positioning is a generally accepted convention throughout the cycle. The animals are set against a backdrop of rough terrain relieved by foliage from an overhanging tree. The conversation scene—a rare occurrence in this cycle—introduces two pivotal characters, and their malicious scheming shapes the course of this central chapter. The Rampur version includes more of the rocky terrain and a complete view of Kalila's body, turned at a three-quarter angle.

The Monkey Who Tries Carpentry

Kalila continued, "The monkey observed a carpenter astride a plank that he was splitting. Two pegs functioned as wedges, lengthening the split in the plank. After the carpenter hit the foremost peg, he pulled out the one behind and reinserted it at the head of the newly lengthened split. When the carpenter left his work for a moment, the monkey sat down in his place to play with the pegs, and pulled out the foremost peg instead of the back one. The split in the plank closed tightly on his dangling testicles and caused him agonizing pain. The carpenter returned and gave the monkey such a beating that he died. That is why it is said, 'Carpentry is not a monkey's business.' " (Minuvi, 61–62)

The monkey suffers the punishment for meddling in another's affairs. Paired with the portrait of Kalila and Dimna, the scene illustrates precisely what Kalila warns Dimna not to do. The monkey's transgression is emphasized by showing him in the throes of a double punishment: caught by his testicles between the sides of the split plank, he endures the carpenter's heavy blows, which have knocked him off his seat and left him dangling upside down. Nearly unconscious from pain, the monkey fixes his eyes in a dazed stare and bares his teeth in a grimace. The confused jumble of boards mirrors his disarray and provides an armature for his predicament.[25]

Leaning forward to deliver another blow with the full weight of his portly body, the enraged carpenter points at the monkey with his left hand; his discursive gesture is realistically portrayed as a hand that clutches his sash at the

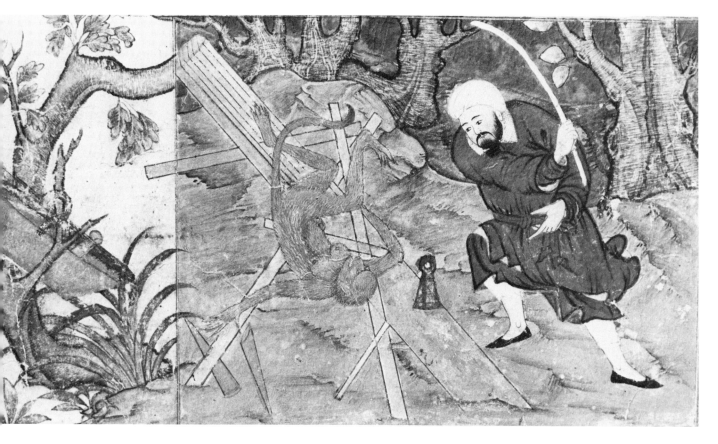

10
"The Monkey Who
Tries Carpentry"
(IUL f. 22) 11 × 20.3 cm
(color pl. XII)

same time. The carpenter, like the hunter pursuing the tortoise (31), anticipates the Timurud artist Behzad's genre figures shown in mid-action, with dynamic poses enunciated by upturned hems fluttering around their weighty bodies.

The composition is bound by the configurations of trees at both left and right: the inwardly curving tree in the margin (and the red-lined tool basket)[26] mirrors the shape of the carpenter's body and switch, bracketing the figure of the monkey. A series of gray striated trunks, marking recession along the high horizon, blocks the dark sky and redirects attention to the fate of the monkey. He is physically entrapped in a series of concentric configurations, the last of which is formed by his writhing body and the camel's face fashioned out of the ground directly behind him. As the spirit of nature, the sneering camel with closed eyes may well be mocking the consequences of unmindful action in the physical world.

11
"The Fox and the Drum"
(IUL f. 10) 25.7 × 16 cm
cropped along right and bottom
edges; fox's head and
ground above it retouched

The Fox and the Drum

As Dimna and the lion became friends, Dimna found an opportunity to ask the lion why he had lost his desire to hunt. Just at that moment, Shanzaba gave a loud bellow, and the lion was compelled to answer, "That mysterious roar causes me fright. If its owner's strength equals his voice, we must leave this region." Crafty Dimna replied, "It is not fitting that a lion should leave his home on account of a strange voice. Not everything that makes a loud noise is fearsome. Let me tell you a story about this.

"There was once a fox who saw a drum lying near a tree. Whenever the wind shook the branches, they beat the drum loudly. When the fox saw the girth of the drum's body and heard its voice, the greedy creature thought its meat would surely equal its volume. He tore it open, but found no more than a small residue of fat. He said to himself that there was no coward but he who has a fat appearance and a loud voice.

"If the King wishes, I will go investigate this sound." (Minuvi, 69–71)

62

This is a small painting, dominated by the gracefully curving tree that sweeps into the margin. Paired with "The Lion-King Receives Shanzaba" (12), the fox's story is told for the benefit of the lion-king; its lesson is immediately applicable.

Grasping the drum between his paws, the fox bites anxiously through its blood-red cloth, only to find that it is not the juicy flesh he had anticipated. His erect tail and flattened ears indicate his surprise.

The landscape is sparse, and the atmosphere stormy. Windswept branches and the pale tree trunk thrown into relief against the dark blue sky (exaggerated by the light underpainting) set the stage for the fox's deception.

The unusual use of foreshortening permits a view of both the drum's white head and its flank. The bright cloth punctuates and anchors the composition, which the leaning trunk would otherwise sweep into the margin. Originally this painting and vertical margin would have been balanced by an L-shaped text. As a straightforward translation of word into image, this is one of the most modest in the cycle.

The Lion-King Receives Shanzaba

Dimna, encouraged by the lion's favorable reception of his offer, went to the ox and declared, "The lion has sent me here to lead you back to him. If you come quickly, he will forgive your outrageous bellowing. If, however, you do not want to serve him, I will return at once with your decision." The ox asked, "Who is this lion?" Dimna replied, "The King of the Wild." At this, the frightened ox told Dimna that if he could promise that the lion would treat him gently, he would come. Dimna gave his assurances, and the two went back to the lion.

The lion invited the ox to stay at his court. The ox praised the lion and willingly became his servant, and the lion admitted him to intimacy and honored him. Day by day, a close friendship grew between them until the ox became the lion's most trusted advisor. (Minuvi, 73)

The first appearance of the lion-king and Shanzaba is aptly composed in what is now a standard audience-scene format. The presentation of the ox to the lion-king unfolds in a dramatic landscape and composition: the newcomers, the ox and Dimna, are diagonally opposed by the stable vertical of the enthroned

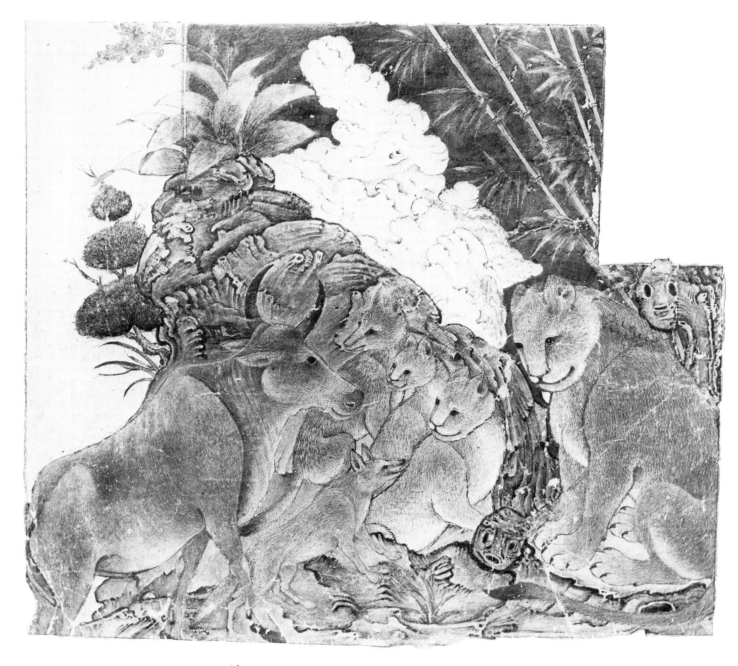

12
"The Lion-King Receives Shanzaba"
(IUL f. 25v) 20.8 × 23 cm
bamboo at right a sixteenth-century decorative addition; black outlining of the face of
the lion and his attendants not original either; right side slightly cropped
(color pl. V)

lion. His three attendants—the lion cubs and Kalila—face their leader and divide the composition: their bodies echo Shanzaba's, while their necks twist to watch the ox's entrance.

Approaching with trepidation, Shanzaba is caught in motion, straddling the margin. In contrast, Dimna, who has already been admitted to the court, holds his ground within the painting between the protagonists. The robust lion, elevated in stature but inexperienced nonetheless, occupies a low rock throne that befits his questionable leadership. He is a young East Asian lion, and his small scalloped ruff[27] betrays his youth. Intent and guarded in a self-protective pose, with his front paws pressed together, he stares down almost timidly: a highly sympathetic portrayal is drawn exactly from these details.

The animals' finely brushed, white furry chests and tawny mottled coats give them rounded physiques that seem even more tactile against the harshness of the rocky wilderness, broken into small, jagged planes; inky outlines and forceful modeling define its pitted, weathered surfaces.[28] The only colorful note is the over-sized, typically Mongol broad-leafed plant with a flowering violet orchis. Landscape effectively designates characters and their relationship: a bluff silhouettes the courtiers and marks their separation from the lion-king. Inhabited by spirits, low coral-like clouds shaped to the lion's head seem to question his authority. At the same time, the adjacent stepping-down of the text isolates and intensifies his part in the confrontation (Figure 2A).

Below the lion's back and at his feet petrified skull faces stare mysteriously with hollow eyes. Like furies, they subtly imply the tragic ending of the story, the unfortunate result of this meeting. It is precisely the infusion of drama, first, into a simple, unembellished narrative, and second, into the characters of the animals and their potent setting, that makes this painting one of the most compelling of the Mongol cycle.

The Fox and the Battling Rams

Observing the exalted position of Shanzaba at the court of the lion-king, Dimna envied him exceedingly and complained to Kalila, "Brother, how stupid I am! I slaved so for the lion that I neglected my own welfare and now have lost my position to the ox." Kalila answered, "The same thing once happened to a pious man." Dimna asked to hear the story.

"A devout man was presented with a robe of honor by the king. One day, an envious rogue approached the man, saying with false sincerity, 'I would like to be

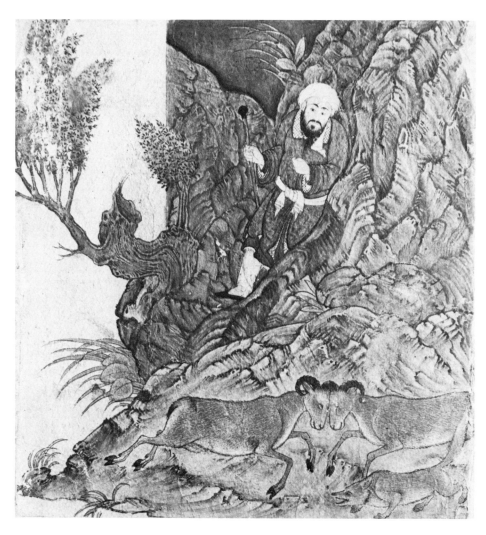

13
"The Fox and the Battling Rams"
(IUL f. 21) 19.5 × 19 cm
right side slightly damaged and cropped

your companion and learn the religious way of life.' The rogue was thus able to
stay with the ascetic until he had the opportunity to steal his robe. When the ascetic
realized that his friend had disappeared with the robe, he set off in pursuit of him.
Along the way, he witnessed several events that revealed life's lessons. The first
was an encounter between a fox and two battling rams. The animals had locked
horns in battle. A greedy fox stood by, lapping up the blood which fell from their

wounds. Suddenly, the rams turned on the fox and killed him. And the devout man continued on his way." (Minuvi, 74–75)

In the first of four illustrations of the ascetic's travels, a greedy fox, unmindful of the harm he will bring to himself, eagerly laps up the blood of two battling rams. The portrayal of the moment before the climax focuses attention on his vice. The bewildered ascetic emerges from a narrow pass above; his alignment with the butting rams draws focus to the animals, and his raised cane freezes the action at a specific moment. The resolution of the story is left in suspense.

Even more than in the painting of the lion-king, the repetition of blue and brown colors and patterns of similar texture integrate the composition: the foreground arena of the animals' action and the background path of the ascetic are correlated. Nonetheless, the protagonists are the central focus of the painting. Although the actions of the four characters appropriately reverberate in the forms around them, the heart-shaped peak of blue ground mirrors the rams' interlocked horns most closely.

In this painting appears the traditional Persian pair of heraldic animals facing the central axis. The scene may even be derived from the *Manafi* illustration "Mountain Rams,"[29] the model of such a convention. Yet because the ram on the right is truncated, he does not mirror his twin; since the axis between their heads is off-center, the central axis is reserved for the figure of the ascetic. The fox and the ascetic also contribute to the painting's asymmetry because, while they are placed at either side of the central axis, their figures are located in different planes, and one is horizontal; the other, vertical. The fox's open snout is aligned diagonally with an old pine whose gnarled trunk changes into a wizard's face, providing a timeless foil for the fox's short-sightedness. Ultimately, the axis suggested by the alignment of the rams' horns with the ascetic's shoulder, though off-center, structures the composition while it knits foreground with background.

The Old Madam and the Young Couple

Kalila continued, "The ascetic arrived in town during the night and looked for a place to sleep. He found a house belonging to a madam who employed young prostitutes. One of them was so beautiful that even the 'virgins in paradise' were envious. The moon stole its lights from her radiance, and the sun knelt in her presence. She was so lovely that only a poem could reveal her true essence.

"As it happened, this young girl fell in love with one of her customers, and

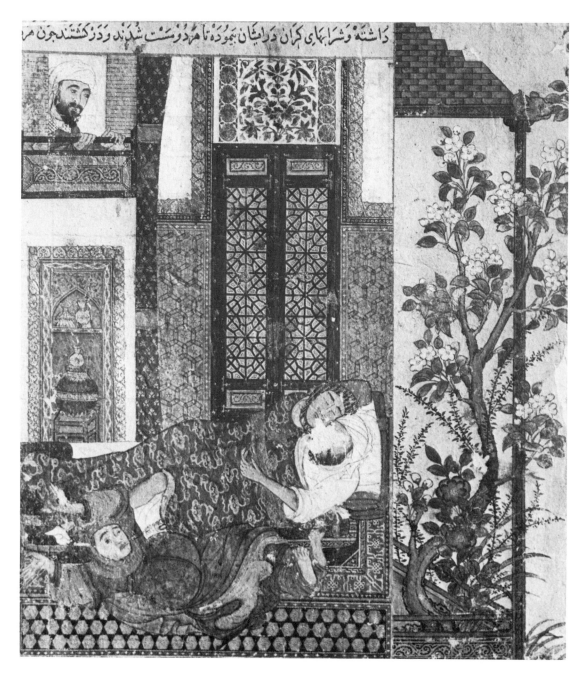

14
"The Old Madam and the Young Couple"
(IUL f. 11v) 23.1 × 20.5 cm
face of young man badly damaged; partial line of text *in situ*
(color pl. XXVI)

because he was jealous, she decided to abandon her profession. The madam was very angry at this loss of income and decided that the only solution was to do away with the young man. The same night that the ascetic arrived, she had given the young couple so much wine to drink that they fell into a drunken sleep. While they slept, the old madam took a hollow reed, filled it with poison, and stuck one end into the young man's behind. As soon as she started to blow the poison into her intended victim, he broke wind. While the ascetic looked on, the poison was forced back into the madam's throat and killed her. When the sun lit up the world, the ascetic escaped from that evil place and sought new lodgings." (Minuvi, 75–76)

Produced by one of the most accomplished artists of the cycle, this scene is notable for its relationship with "The Clever Merchant and the Gullible Thief" (4); they have a similar composition and many of the same conventions. The scene adeptly condenses this off-color story into a large-scale pattern of high-keyed coloring that reflects the bawdiness of the prostitute's world. The two lovers, however, could also exemplify the Sufi stage of the "path of love." Their physical union is portrayed as a bridge between the material world and the eternal realm of divine love.

Having just tasted the poison driven back through her hollow reed pipe, the old woman falls in an ungainly pose, exposing her overblown body and contorted face and the confusion of colored clothing. Only the man's leg, parallel to the reed pipe, suggests his lucky brush with fate. The innocent young couple lies in a deep, wine-induced sleep (their jug stands in the nearby cupboard). The doors of the inner garden are sealed, but the couple's love is consecrated by the abundant garden in the margin.

The charged interaction between the madam and the man is framed by the ascetic's field of vision; the three recumbent figures are spotlighted from above. Attention is concentrated on the grotesque particulars of the frustrated murder: on a white sheet, the murder weapon is framed by the madam's face, the man's exposed leg, the cover's ruffled lining, and the madam's oversized breasts (the probable consequences of her trade).

The idealized garden plays a vital role in the composition of the whole. Its open, brick-roofed pavilion filled with luxurious vegetation would have balanced the opposing column of text. In addition, its sinuous plum tree ingeniously corresponds to the nature of the characters. Its gnarled lowest curve reflects the madam's overblown body, while its undulating middle part brackets the lovers. The upper vertical section parallels the ascetic's height, and the two crimson roses symbolize the spiritual union of the young lovers. The appreciation for humor found throughout the cycle is exemplified by the lion-headed

gargoyle—a counterpart of animated nature spirits—nibbling leaves at the upper right.

Realistic, intimate details personalize the melodrama in exciting, aesthetic terms. Vibrant colors and muted tones, undulating curves and rigid planes, and tile patterns and plane surfaces are boldly orchestrated. The array of textiles is significant:[30] the lovers' dreamy state is echoed by their Yüan cloud-design coverlet and star-studded pillow, while the madam's orange and red clothing aptly twists into the shape of a mandrake root. Technical virtuosity distinguishes this scene from its prototype—the TKS H.363 version—as well as from a bedroom scene in the contemporary Demotte *Shahnama*, "Gulnar Coming to Ardashir's Pillow and Sleeping by His Side."[31] It is the degree to which setting is integrated and the extent to which metaphysical concerns inform such an organic composition that set the Istanbul *Kalila wa Dimna* apart from similar works.

The Go-Between and the Shoemaker

Kalila went on, "The ascetic found new lodgings with a shoemaker. The shoemaker's wife sent for her lover through the wife of a barber, as she was accustomed to doing. The go-between asked the lover to await his mistress at her door. Just as the lover arrived, the shoemaker returned from a banquet, drunk. Enraged, he struck at his wife and tied her to a pillar before falling asleep. During the night, the go-between crept in and agreed to exchange places with the unlucky woman. The shoemaker woke up and called his wife. Receiving no answer, he became doubly angry and cut off the woman's nose, saying, 'Send this gift to your lover.'

"When the shoemaker's wife returned, she begged forgiveness from her miserable friend and set her free. She then bound herself to the pillar and once again began to pray aloud, 'Oh God, if I am innocent, restore my nose.' Her husband lit a lamp and, seeing his wife's face unscarred, resolved never to pass hasty judgment again." (Minuvi, 76–77)

No extant Istanbul scene corresponds to this Rampur painting. However, a fragment remains of what probably was the margin's garden;[32] this and the compositional and narrative correlations with the preceeding painting suggest its original inclusion in the cycle. The rest of the IlKhanid original has been lost or discarded.

The go-between is bound to a pillar near the shoemaker's bed. Her figure, rendered with the realism of Behzad, is limp with exhaustion. With a blue-tiled dado, cupboard, and inaccessible garden, the interior closely resembles the old madam's bedroom, and the position of the shoemaker recalls that of the sleep-

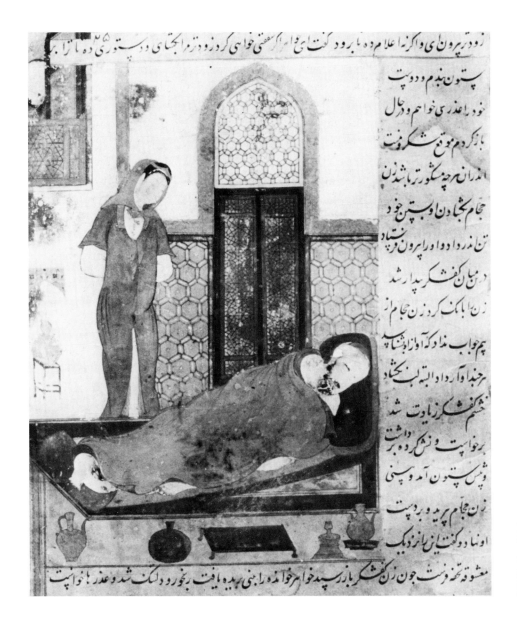

15
"The Go-Between and
the Shoemaker"
(Rampur, p. 51)
21.9 × 14.3 cm

ing young couple. Again, the ascetic observes from a second-story balcony, and in so doing unifies the composition.

The poor alignment of text and image in the Rampur copy hints at the original position of the garden—a decorated margin with a red lacquered fence common to these interiors—and suggests that the artist was unable to reproduce the larger, tightly woven Mongol composition in a smaller format.

The Fate of the Go-Between

Kalila concluded, "In the meantime, the barber's wife took her severed nose home, wondering how she would explain the injury to her husband. When she arrived, the barber asked her to bring his utensils so he could leave for work. She hesitated, and then brought only his knife. Angry, he threw the blade at her in the darkness. She collapsed, crying, 'Oh my nose, my nose,' and the barber blamed himself for the accident.

"When the sun brightened the day, the woman's relatives led the barber to the judge. The barber was unable to defend himself, and the judge ordered him to be punished. Just then the ascetic, who was standing in the background, called out, 'Judge, do not act hastily, for it is one's own nature that is to blame for one's calamities. If I had not desired followers, my robe would not have been stolen. If the fox had not been greedy, he would not have been killed by the rams; if the madam had not tried to take advantage of the young man, she would not have lost her life; and if the barber's wife had not meddled in clandestine affairs, she would not have lost her nose. We all bring on our own ruin.' " (Minuvi, 77–79)

The subtle drama of poses, gestures, and colors enhances the visual richness, while focusing attention on the revered figure of the cadi. Crowded into a doorway, the go-between, her husband and relatives, and the ascetic present their case to the judge. Standing next to her veiled relative, the exposed bloody-faced woman extends her hands imploringly toward the judge and the ascetic, who has just stepped forward to bear witness to the truth of the story and to proclaim his wisdom; that is, we are responsible for the ruin we bring upon ourselves.

The two assistants are evidence of the judge's prestige, and only he enjoys the imposing dais. The screen woven with Allah's name, like the cadi's green robe and venerable turban, makes it clear that he is dispensing the *Sharia*. In fact, his elongated physique and majestic pose call to mind the depiction of Muhammad in the 1306/7 *World History*.[33] By contrast, the two assistants appear lifeless, their pincushion physiques accentuated by cascading tubular folds.

As in "The Lion-King Receives Shanzaba" (12), the newcomers and the judges oppose one another along diagonal and vertical axes reinforced by the arrangement of floral elements. And, like the audience hall in "The Ghaznavids" (1), the audience of petitioners is crowded into the narrow doorway, while the judges sit in an orderly row in a broad, tiled chamber. The three wall ornaments above measure the more limited space of the two assistants against the expansive setting of the judge. His preeminence and the ascetic's prominence

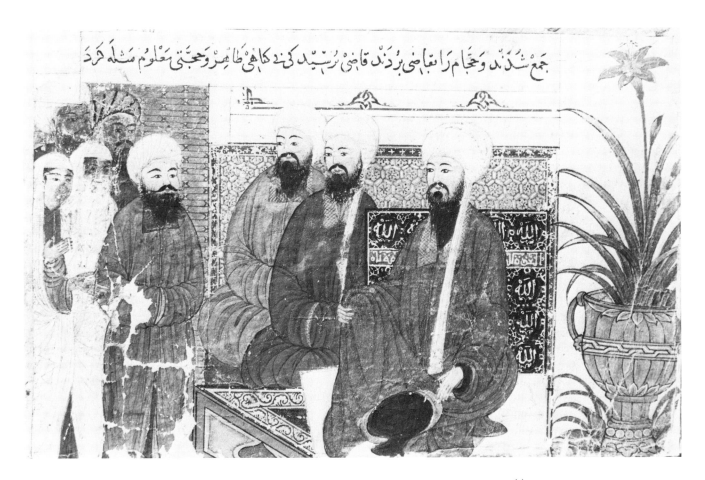

جمع شُدَنْد وَحَجّامْ رَا نِقَاضِى بُرْدَنْد قَاضِى رَسِيْد كُنَدْ كَاضِى طَامِرْ وَحُجَّتِى مَعْلُوْم مَثْلُهُ كَرَدْ

16
"The Fate of the Go-Between"
(IUL f. 21) 12.2 × 19 cm
one line of original text
remains above the painting

are underscored by an interweaving of color and line. The red brick wall draws attention to the ascetic, who is silhouetted against it, while the cadi's red lacquer dais does the same, its receding diagonal further linking the two. In addition, the elongated stem, magnificent blossom, and gracefully curving leaves of the adjacent fire lily (or Turk's cap)[34] celebrate the cadi's wisdom.

This court scene accurately reflects contemporary Mongol legal practice: in accordance with the *Sharia*, instituted by Ghazan Khan in 1295 with his conversion to Islam, the populace was able to present cases directly to the judge without a legal intermediary; also, women enjoyed exceptional freedom for an Islamic urban society and were no longer entirely bound to their domestic setting. Here, as the barber's wife approaches the cadi, she is accompanied by a female relative whose presence enhances her privilege.

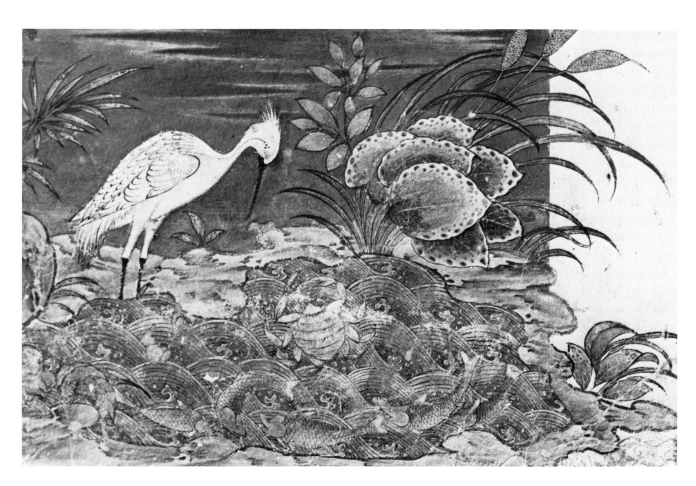

17
"The Crab Hears the
Heron's Story"
(IUL f. 25) 10 × 15 cm
central vertical plant later
addition or retouched
(color pl. XVIII)

The Crab Hears the Heron's Story

Dimna said to Kalila, "There is only one way to regain my position at court. I plan to destroy the ox by trickery, which often succeeds where strength would fail, as in the story of the crow and the snake." This tale within a tale includes the story of the heron's fate, as a warning of the punishment suffered by those who wish to destroy others.

"A heron lived a contented life by a well-stocked stream until old age left him too feeble to fish any longer. Sadly, he told himself, 'Since life has left me nothing to experience, I will have to procure my future livelihood through deceit.' When a crab approached and asked why he looked distressed, the heron replied, 'In my straits anyone would feel depressed. I used to catch one or two fish daily without

74

depleting the supply, but today I overheard two passing fishermen say that they planned to return and catch all the fish in our river basin.' The crab said to himself, 'If they do that, I too will starve to death.' He summoned the fish, and together they addressed the heron.

"The leader of the fish said, 'A wise one does not refuse advice, even from an enemy, especially when it can benefit him. What do you think we should do?' The heron replied, 'I cannot tell you how to stop the fishermen, but I do know of a nearby river where the water is clearer than a lover's tears. From above you can see the eggs of its fish and its sandy bed. There you would be safe and comfortable.' The fish replied, 'But we cannot go there without your help.' The heron promised to take the fish, and added that they must make haste to avoid the fishermen." (Minuvi, 81–82)

The story of the crow's revenge on the snake, which Dimna cites as an example of how deceit can be used to dispose of an enemy, is not illustrated. Instead, the parenthetical tale of the heron and the crab, in which the heron is killed by his own trickery, illustrates retribution for deceit. This story assumes particular prominence: two paintings were devoted to it (the second survives only in the Rampur copy).

Wading in a pool at the river's edge, the heron engages the crab in conversation; straining to tread water, the crab tilts his shell diagonally and extends all his limbs. The action of his pincers indicates he is speaking—it mimics the discursive gesture of humans with an open thumb and elongated index finger—and hints at the denouement, when these pincers will strangle the heron. The heron's fan-shaped crest and eye markings draw attention to his lowered shiny bill, eagerly awaiting satisfaction. In reaction to the news of the fishermen's imminent return, a school of fish leaps above the waves. Their arc-like formation reaches to the heron, foreshadowing their fatal interaction and creating a concentric configuration around the crab, who, as protagonist and hero, is central to the plot's unfolding.

Echoing the heron's curved body and markings, the Mongol red-speckled ovoid-leafed plant, arching knobby cattails, and scalloped waves (a pattern of parallel convex lines and tri-lobed spray)[35] animate the field of action. Varied brush strokes add to the realistic depiction of the heron, identifiable as a great egret: glossy, black, tapering lines render the cartilage of his legs and bill; thin, curving brush strokes differentiate the tufted feathers; wide, oval strokes define the sturdy wing feathers; and a feathery texture fills his tall crown.

18a
"The Crab Kills the Heron"
(Rampur, p. 56) 24 × 10.3 cm

18b
(TKS H.363 f. 53v)

The Crab Kills the Heron

Dimna continued, "Each day the heron carried one of the fish to a hillside and ate it while the others competed among themselves to be next. The heron viewed their mistake through the eyes of experience, telling himself that one who places confidence in an enemy deserves the consequences.

"Several days later, the crab also asked to be taken to the river, so the heron took him on his back and headed for the hillside. When the crab saw the bones of the fish in the distance, he understood the situation. He told himself that if a wise man recognizes an enemy, he must take action or suffer the consequences. Thereupon, he seized the heron's throat with his pincers and strangled him. The crab then crawled back to the river to reveal to the remaining fish the fate of their friends and of the heron. They rejoiced over the death of the heron, taking it as the start of a new life for themselves." (Minuvi, 82–84)

The death of the heron—the concluding scene of this story—survives in a Rampur copy of the Mongol painting. The original was probably left out of the cycle when it was remounted, because of the painting's vertical format.

This is among the most successful of the Rampur animal scenes, with unusually expressive coloring and modeling. The crab has succeeded in choking the heron with his pincers, for the bird's red beak gapes and his legs and wings hang limply. A tree bends upside down to show the reversal of fate, and typically Turkoman bird- and sheep-like faces animate the gray and blue rocks (the pigment has deteriorated to reveal much of the mauve underpainting).

The text bites into the painting at the point where the crab is strangling the heron, partially obscuring the action. The awkward arrangement allows the text to intrude on the focal point; the Rampur artist apparently reproduced the fourteenth-century version, though in a reduced format. The stepping down of the text for dramatic effect appears in the TKS H.363 version (f. 53v) (see 18b) and may have directly influenced the Mongol scene and its subsequent Rampur copy.

As seen throughout the Mongol cycle, punishment for avarice and duplicity—especially involving another's death—is chosen for illustration.

Dimna Deceives the Lion-King

Kalila said to Dimna, "You should kill the ox only if you can do it in such a way that the lion does not suffer; a wise person never sacrifices his master's interests for his own desires."

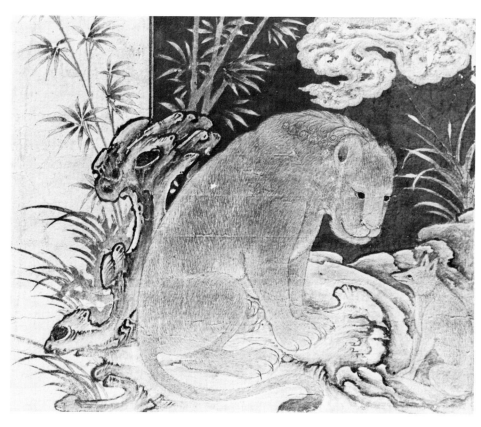

19
"Dimna Deceives the Lion-King"
(IUL f. 18v) 14.5 × 16.5 cm
bamboo stalks a sixteenth-century addition; approximately 1 cm
cropped from top, bottom, and right side

Dimna seized an opportunity for a private interview with the lion. Affecting a gloomy countenance, Dimna said, "It grieves me to tell you this, but Shanzaba has been holding conferences with the generals of the guard on the king's points of weakness. Though I know the king has cherished this outsider, it seems that evil has entered his heart, and he is planning a revolt. You must act quickly and resolutely to cure this sickness before it reaches you. If you examine him as he presents himself, I think you will not fail to see his agitation: his color will be altered; his feet will tremble; he will turn from right to left; he will act as though about to deliver blows with his horns. You must make haste." (Minuvi, 88–89)

Against Kalila's warnings, Dimna resolves to deceive the lion-king. Dimna occupies the superior position on the right, from which he gravely relates the story "The Fish and the Fishermen" (20) to the lion-king. Though the lion has enormous stature and power and is master of his environment, Dimna has succeeded in backing him into a corner.

The two form a semicircular configuration reinforced by the arrangement of the landscape. Seated on bumpy ground, the lion is restricted by a deformed, skull-like spongy rock and is compressed by the swirling clouds above; the animated setting is in keeping with the thoughts churning in his head. The lion's unfurled tail suggests that he has been switching it back and forth, agitated by Dimna's grievous tidings.

The compositional emphasis on the lion and the expressive rendering of his distress accentuate his predicament, rather than Dimna's role in perpetuating the deception. The lion and landscape appear lighter than they originally did because of the surfacing of the lighter underpainting.

The Fish and the Fishermen

Dimna continued speaking to the lion-king: "It is said that people are of two types: the cautious and the weak. The story of the three fish will help explain these classifications.

"Three fish lived in a remote pool in a river, safe from most passers-by. Two of the fish were cautious by nature, while the third was foolish. One day two fishermen happened on the pool, and, seeing the fish, decided to return with their nets. The most cautious fish, who was quite experienced in the ways of the world, escaped at once through the mouth of the river. When the fishermen arrived, they blocked the sides of the pool. The second fish said to himself, 'I neglected to act in time, but regret will not help in time of disaster. A wise one should not hesitate to counter his enemy's cleverness. Now is the time for me to act cleverly and decisively.' And so he floated belly up on the surface of the water. Taking him for dead, the fishermen picked him up and threw him aside. The fish then found his way back to the river and so saved his life. The third and witless fish was overcome with fear and began to toss from right to left, upward and downward, until he was caught."

Once Dimna was convinced that the lion was ready to attack the ox, he went to the ox to arouse him against the king. (Minuvi, 89–92)

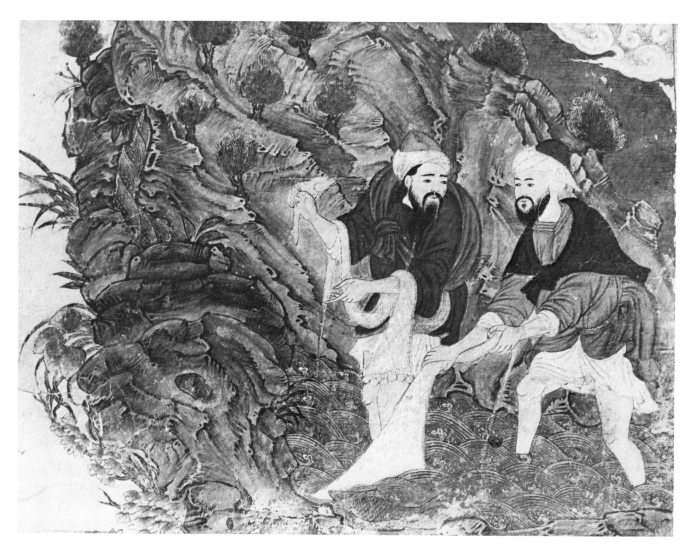

20
"The Fish and
the Fishermen"
(IUL f. 22)
16 × 20.5 cm
red-speckled leaves
at right belong to
another painting
(color pl. XI)

To prepare the lion-king for the upcoming confrontation with Shanzaba, Dimna relates an allegory on the merits of action in the face of danger—the story of the fish and their hunters. The fisherman on the left has just lifted the clever fish, who, on finding himself trapped, feigns death—aptly signified by his colorless body. Deceived by the fish's ruse, the fisherman holds up his limp catch for his friend's inspection; he prepares to throw it aside and thus unwittingly to spare the fish's life. The foolish fish remains in the pool and swims dangerously near the net, approaching his fate. The most cautious fish has already escaped and is nowhere to be seen.

Wading with his robes raised above his knees, the fisherman on the right leans forward awkwardly to steady his net; his bent legs suggest the uneven distribution of weight. The fishermen's movements are accentuated by loops of cloth around their necks (to hold the day's catch), the swirling folds of their hiked robes, and the coordinated colors of their fire-red, scarlet, and maroon attire. The folds of the nets draw attention to the fish: the cork-fringe focuses on the limp fish, while the triangular-shaped net draws the eye to the active fish, soon to be caught.

The influence of the Chinese blue-and-green landscape style is evident in the color and treatment of the mountainous terrain,[36] choreographed to highlight the figures. Nearly blocking the horizon, the mountain's winding, segmented ridges converge near the fishermen; the pines radiate from their heads to mark depth; and the disproportionately large figures are surrounded by gray-green cliffs and vivid brown and blue boulders. The ribbonlike waterfall and scalloped waves limply animate the fish's actions. Faces hidden in the rocks, including the blue cubistic camel facing the margin, though aloof, contribute an eternal quality.

The artist has effectively encapsulated the story—one replete with irony as well as drama. The quick-thinking fish is pictured during his brief captivity, while his less provident companion still swims freely.

The Stars' Reflections and the Bird's Illusions

Shanzaba said to Dimna, "It was not right for the king to change the love he has for me. I have not committed any offense. The lion has probably fallen for the deceitful stories of mischief-makers and made the same mistake that a certain duck made. The duck saw the reflection of a star in the water and mistook it for a fish. He tried several times to catch it but failed and forgot about it. On another occasion, the duck saw a fish, but, thinking it was only a reflection, made no effort to catch it and went hungry. One should never be too quick in judgment and always wary of deceit." (Minuvi, 102)

A pair of snow-white swans represents the duck described in the text; the depiction of their opposite responses to the same situation strengthens the moral. The swan with greedy bulging eyes, twisting neck, and gaping bill is ready to

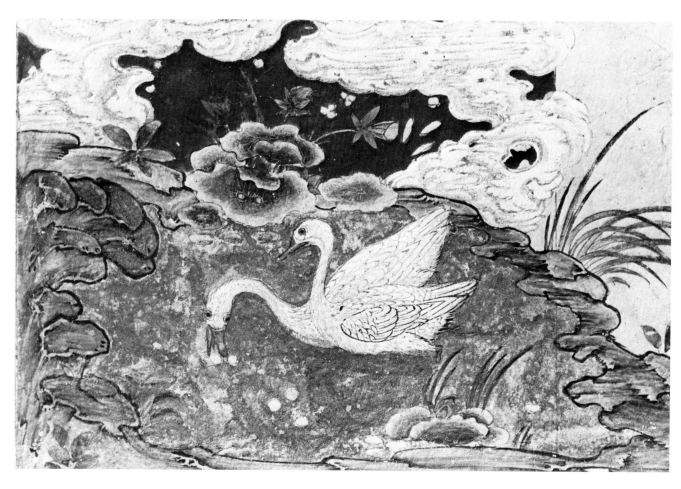

21
"The Stars' Reflections
and the Bird's Illusions"
(IUL f. 28) 10.5 × 15.5 cm
upper edge cropped

snap up what he takes to be a fish; unable to distinguish between appearance and reality, he is deceived by the star's reflection. His open orange beak is shown in profile, making his greed explicit. The wiser companion holds his head erect, unmoved by the glimmering light.

In contrast to the swan's awkward movement in a rugged environment, the billowy, semicircular cloud canopy gracefully embraces the dark, starry night, fringed at the horizon by a radiant orchid and an Indian lotus.

This tale, told by Shanzaba to Dimna, foreshadows the following scene, in which, like the foolish bird, the lion-king is deceived by his inability to differentiate between illusion and reality.

The Battle of the Lion-King and Shanzaba

Shanzaba then said to Dimna, "I will not be so foolish as to attack the lion."
Dimna replied, "When you visit him, you will see the signs of his anger. He will
be sitting erect with his chest puffed out, pounding the ground with his tail."
Shanzaba said, "If he acts in so menacing a fashion, I will not doubt his intention."
When Dimna heard this, he was happy with the success of his deceitful plan to set
the ox and the lion against each other, and he ran to tell Kalila.

Dimna and Kalila arrived at the lion's abode at the same time as the ox. When
the lion saw Shanzaba, he sat up and roared, twisting his tail like a snake. Shanzaba
was convinced that the lion intended to attack him. By repeating to himself that
"the servant of a king has always to be on guard," he prepared himself for battle.
The lion, who watched him, recognized the signs of which Dimna had spoken. He
leaped on the ox, and the two engaged in a desperate battle, during which blood
poured from their bodies.

Watchful Kalila said to Dimna, "Oh stupid one, think of the dangerous future
that will result from your treachery. The consequences of this event will reverberate
for the next two hundred years." (Minuvi, 113–14)

This is one of the most poignant scenes of the cycle. The ferocity of the battle
is admirably conveyed by the ox's violently contorted body and the centrifu-
gally expanding blue landscape. Anchoring his feet to the ground, the lion clasps
Shanzaba with heavy paws and bites his flanks. The force of the lion's pounce
has caused the ox's haunches to fly through the air;[37] an inveterate predator,
his movements are more coordinated than those of the domesticated ox. Two
profiles of Shanzaba are combined: a right profile for his frontal half and the
opposite for the rear, arranged along a descending diagonal, according to Dim-
na's perspective atop the hill.

Observing from his safe perch in the margin, Dimna, to the right of Kalila
and in the traditional position of authority in this cycle, follows the struggle
most keenly. Dimna's chest and forelegs are in partial frontal view, while his
head is turned slightly to the side. Its downward movement makes visible his
open snout, dark gloating eyes, and erect ears and the raised hairs on his neck.
The plush ruff and head movement cleverly disguise this abrupt transition be-
tween alternate views. Kalila's representation is similar to Dimna's, but his
expression is less aggressive.

The violent movement of the ox's loose-jointed structure is accentuated by
black outlining and the quick rhythm of light and dark alternation. The slack
skin of his neck is effectively rendered with shaded parallel planes that, al-

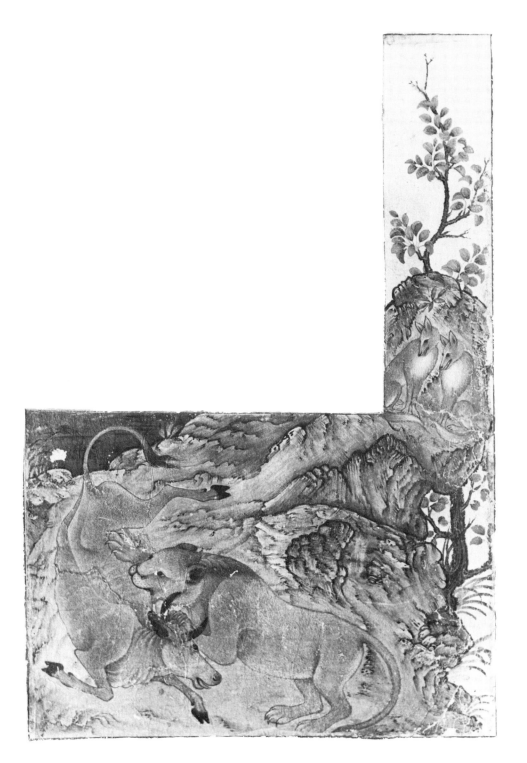

22
"The Battle of the Lion-King
and Shanzaba"
(IUL f. 6v) 32.5×23.3 cm
trimmed at bottom; additional
outlining of lion's mouth
(color pl. VII)

though heavily stylized, as in Central Asian painting, suggest familiarity with
the animal's anatomy.

The combatants are spotlighted at the base of a conical ray—a recurring de-
vice in the cycle—in the scheming jackal's oblique field of vision. The ox's
curvilinear tail mirrors that of the lion to create a continuous helical movement
appropriate to this fateful entanglement.

The sweeping, mottled landscape complements the dramatic tone as the precipitous incline radiates from the combatants' field of action. Only the spirit faces fashioned from the cliff remain unmoved. The text block originally interlocked to counterbalance the radiating force and to add weight to the embroilment.

The Weasel and the Deceitful Frog

Kalila said to Dimna, "You never take advice, either, and you will regret it later when your scheming brings on your own ruin, as happened to the rogue in the following story. There were once two partners in trading, one smart, the other foolish. One day they found some gold, and the rogue said, 'Instead of dividing it, we should take a portion now for our immediate expenses and hide the rest in a safe spot. We can come back for more as we need it.' They buried the larger portion of it under a tree.

"Later, when the rogue and the simpleton went to retrieve their loot, the rogue blamed the simpleton for its disappearance. The poor man swore that he knew nothing about it, but the rogue took him to the cadi and told his story, claiming that the tree itself would attest to the truth of his claim. The judge was amazed but decided to hear the tree's testimony before he delivered his verdict.

"The rogue went home and asked his father for help. He explained to the old man his scheme of hiding in the tree to answer the cadi's questions. The father told him the story of the frog and the snake who had eaten all of the frog's young. The frog plotted to trick a weasel into killing the snake, but when the weasel grew hungry, he devoured the frog itself. The son said to his father, 'Oh enough of your story. This little job will bring us great profit.' So the father agreed to hide in the tree." (Minuvi, 117–20)

The moral of the story Kalila addresses to Dimna—that employing deceit will bring about one's downfall—is strongly emphasized by this illustration. Strikingly perpendicular to his prey, the weasel draws attention to the demise of his victim, the half-eaten frog who is otherwise barely visible. With limbs extended, a second frog, dangerously close and swimming for his life, intensifies the drama and broadens the ramifications of his companion's trickery. The effect of deceitful behavior is a common preoccupation of the Istanbul cycle.

The terrain surrounding the weasel is modeled and striated, as is his body,

23a
"The Weasel and the Deceitful Frog"
(IUL f. 23) 12.7 × 14.5 cm; 5.3 × 7.5 cm
incomplete; two fragments survive;
bamboo stalks a sixteenth-century addition

23b
(Rampur, p. 80)

while the blue rocks and sky silhouette his dramatic pose and excited tail. Once more, nature—in the forms of windswept sedge, flowering red lotus, wispy clouds, and hidden spirit faces—invigorates the scene.

The faithful Rampur copy is complete, but these two fragments provide the essentials of the Mongol original.[38]

The Rogue and the Simpleton

Kalila continued, "The next day, the judge went to the tree, and many people gathered around. When he questioned the tree, a voice answered, 'The simpleton has taken the gold.' Astonished, the judge approached the tree and realized that someone was hiding in it.

"The judge ordered that some logs be piled around the trunk of the tree and that it be set afire. Only after an hour did the thief's father make himself known, begging forgiveness. The judge cursed him but ordered his rescue, whereupon the old man disclosed the treachery of his son and the honesty of the simpleton. He was awarded the comfort of absolution but died nevertheless, and his son, after being punished, was sent home with his father's body. The simpleton went home with the gold, in reward for his honesty. And so you see, Dimna, that there is no future in deceit: it ends only in dishonor." (Minuvi, 120)

Engulfed by leaping flames, the rogue's father emerges from the rotted cleft of an old *chinar* tree to implore the judge to save him. The rogue and the simpleton above him turn to gesture toward the old man while keeping their eyes fixed on the cadi. A lozenge configuration—the cadi and the father occupying the ends of its longer axis—locks the four central figures in an undramatic composition. The father's status and imminent death are presaged by his location in the margin.

Like the figure grouping, the treatment of the landscape is unsubtle. The dense yellow foliage forms a canopy over the heads of the cadi and the simpleton, while the twigs, many of which are dead, reach out like the old man's fingers. The barren terrain sprouts grasses only at the feet of the cadi.

As in "The Fate of the Go-Between" (16), the elongated stature of the Rashidiya-type judge makes him an impressive figure. His green cloak *(tarha)* and the trailing turban-end complement his ethereal nature, which is strengthened

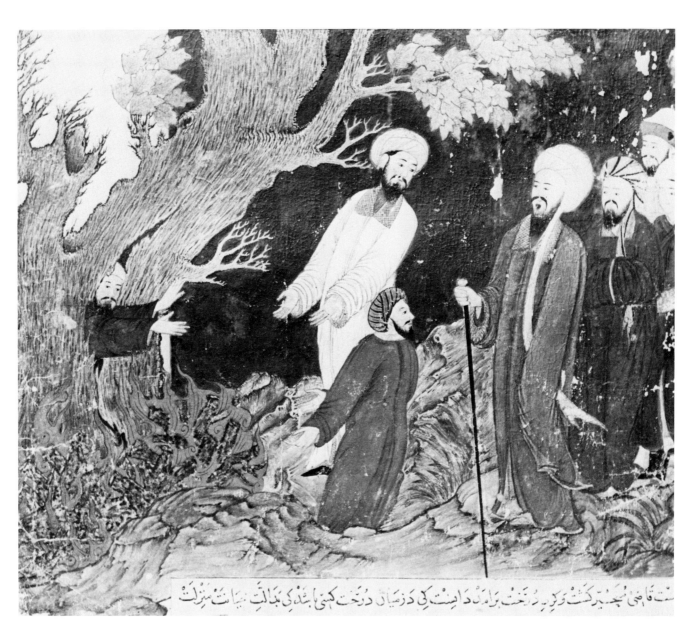

24
"The Rogue and the Simpleton"
(IUL f. 28v) 20.3 × 23.3 cm
approximately 4 cm cropped at right; partial line of text *in situ*

by the contrast with his stocky assistant. Holding his hands in deference to the judge, the maroon-clad attendant and the figure behind establish a pattern of color that unifies the page. The Rampur copy shows that originally there was one other figure in the crowd.

As the final illustration of the chapter, the trial scene is a legal, societal condemnation of deceit. Whether punishment is brought about by one's self or by the law, deceit will ruin those who practice it. The similarity of figures in this scene to those in "The Fate of the Go-Between" suggests that they are by the same artist.

The Chapter of Dimna's Trial

The Lioness Confronts Dimna

The lion's mother counseled her anguished son, the king: "Forgiveness and charity are important, but not when exonerating evil may encourage further evil. The king's mistakes in judgment, if uncorrected, may incite more of his people to treason. Dimna must be punished."

The lion-king summoned his garrison and ordered that Dimna be brought before the court. Turning his face from the culprit, he began to think. When Dimna saw that he was trapped, he asked one of his friends, sotto voce, "What has happened to the king? Why is he so pensive? And why are you all gathered here?" The lion's mother overheard and answered, "Your treachery is the cause. For the lies you fabricated about Shanzaba, the king's honorable companion, the king should not allow you to live another day." (Minuvi, 131–32)

In what is clearly a reversal of the scene in which Dimna proudly leads Shanzaba to the lion-king's court,[39] the jackal now approaches the court for trial, creeping low with trepidation. In typical Mongol humor, a burly Asiatic black bear is added as the strongman who escorts Dimna from jail. The prominent leopard, behind the bear, is probably the one who overheard Dimna's fatal confession to Kalila, and he importantly confides this to the lion's mother. Distinguished by his full ruff and swishing tail, the lion-king looks imploringly at his mother, whose size and right-hand position befit her seniority. The lioness's pensive eyes suggest her awareness that Dimna has preyed on her son's inexperience. A hyena and a feline creature stand guard, alert and concerned,

25
"The Lioness Confronts Dimna"
(IUL f. 18v) 18.5 × 23.7 cm
the lions' and bear's heavy black facial features are the result of later retouching;
bamboo and branch adjacent to the margin are later additions; right side and bottom
cropped approximately 1 cm

beneath the throne. The sleeping cub, who is not mentioned in the text, represents the first of the "three ages of man": the innocent cub lies unperturbed; the king, though mature, is still inexperienced; and the old lioness, wisest in the ways of the world, takes charge. As in other illustrations, her unusual prominence probably reflects the patron's concern for wisdom cultivated with experience.[40]

The sleeping lion cub is closely modeled on an attendant leopard in a *Shah-*

nama portrait of "Gayumars, the First King, in the Mountains" (Figure 5). The pose, sense of weight, and location are identical in both pictures, but here the artist modulates color and refines his textures with greater skill, creating a life-like presence that far surpasses the simple decorative pattern of shading in "Gayumars."

Dimna's Death

A wild beast who had been sleeping near Dimna's cell committed to memory all that Kalila and Dimna had talked about. The next day, the lion's mother reminded

26
"Dimna's Death"
(IUL f. 11) 16 × 13 cm
trimmed at top,
bottom, and left
margin

her son that one who keeps a criminal alive shares his guilt. The king agreed and decided to try the case quickly. The other animals remained silent, fearful of becoming involved in the intrigue. Finally, Dimna spoke out, suggesting that their silence corroborated his innocence, but urging the animals to give their evidence.

After hearing the testimony of the eavesdropping wild beast, the lion was convinced of Dimna's guilt. Dimna was brought from jail, convicted, and sentenced to death by starvation. Such is the destiny of the deceitful and those who meddle in the affairs of others. (Minuvi, 155–56)

Punished by starvation, Dimna lies on his back, his body swollen, his mouth rigid and open; the fate of the unjust is explicit. A stringent morality is typical of these illustrations, and here, the unusual angle of the jackal's representation permits a full view of his unseemly death.

As is common, side and frontal views have been combined; the cave parallels the slope of the hillside, and both the cave's entranceway and its cross section are shown. Pale, swollen Dimna is silhouetted against the somber black cavity that entombs his body. The graceful curvature of the vegetation dotting the hillside contrasts with the stiff, lifeless pose of Dimna, now made more noticeable by the dominant white underpainting.

The Chapter of the Four Friends

The Mouse Frees the Doves

The Raja said to the Brahman, "I have well understood the lessons of the story of the two friends who are separated by the malice of a third person. Now tell me the story of true friends who enjoy the fruit of their forthright relationship."

The Brahman began, "The story of the ringdove, crow, mouse, tortoise, and gazelle is of that kind. It is said that in Kashmir there was a beautiful field that was home to many wild animals, who, in turn, attracted hunters. When one day a flock of ringdoves was lured into a hunter's trap, a crow watched them save themselves. By their united efforts, they lifted themselves up in the net and flew away to seek the help of a mouse. The crow followed the doves so that he could profit from their lesson.

"The mouse, whose name was Zirak, was wise and experienced, and had burrowed hundreds of interconnected tunnels to escape in case of danger. The leader

27
"The Mouse Frees the Doves"
(IUL f. 24v) 26.5 × 19.8 cm

of the ringdoves called into one of them, and Zirak rushed out, weeping at his friend's predicament.

"The mouse began to gnaw the threads that bound the flock's leader, but the dove said, 'My friend, would it not be better to begin with my companions? You must not question me, for I accepted their leadership and with their loyalty we escaped from the hunter.' Zirak agreed and gnawed all the other threads of the net first, and the ringdove and his friends flew home safely." (Minuvi, 157–61)

This is the first of six illustrations emphasizing the fruitful rewards of friendship rather than the consequences of deceit stressed in the previous images. Grasping the net tightly and gnawing through its mesh, the crouching mouse works eagerly to free the doves. The flock's entrapment is conveyed by the birds' crowded V-shaped configuration and straining necks. Their leader is distinguished by his size and commanding position. The crow, who has followed the doves to learn from their experience, cranes his neck to watch from the margin.

Only a thin red outline describes the animals; painted in reserve on brown terrain, it gives them a somewhat ghostly appearance. Yet their well-articulated, expressive surroundings convey their excitement and expectation. The contrast between the kinetic quality of nature and the indistinct character of the animals gives the painting its mysterious air. In conjunction with the birds' straining bodies, the rising terrain is segmented into narrow planes and animated by holes and furrows[41] that mirror their projecting heads. The diligent mouse enjoys smoother terrain. Arching grasses curve toward the mouse and draw attention to the watchful crow.

The lifeless tree in the margin and its entwined green vine balance the contiguous text-block. The tree is reminiscent of the doves' close encounter with death, while the ivy is emblematic of the life-giving power of friendship. This marginal flora also pertains to the role of the crow—safely perched in the tree—in the following illustration.

The Crow and the Mouse in Transit

A crow who had witnessed the mouse's chivalrous act in saving the doves decided to make friends with the mouse should he, too, need help one day. The mouse, peering out from his hole, said to the crow, "How can a predator befriend his prey? The ways of friendship are closed to us, just as one cannot hope to sail a boat on land, or ride a horse on the sea." The crow replied, "But what would I gain from eating you when you would hardly make a mouthful? Your friendship has far more value to me." After much discussion, the mouse emerged and the two became friends. After several days, the mouse asked, "Why don't you bring your family to stay permanently?" The crow replied, "This field borders on a well-traveled path, and we may get hurt by some passer-by. It is nice here, but I know another beautiful field, filled with flowers and fruit, where my friend the tortoise lives. If you are willing, I will take you there." The mouse agreed, explaining, "I did not come here of my own will. It's a long and strange story that I will tell you

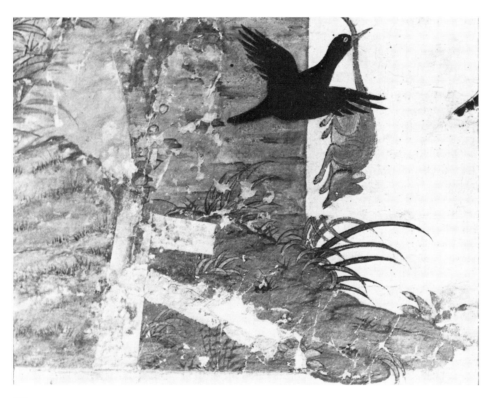

28
"The Crow and the Mouse in Transit"
(IUL f. 18) 10 × 11.5 cm
cropped along left and upper edges

when we have some time." The crow took the mouse by the tail and flew toward the field. (Minuvi, 162–70)

Off to make a new home in the fertile land of the tortoise, the crow, depicted here as a magpie, carries the mouse firmly in his beak. The diagonal angle of the bird's body indicates that he has just taken flight, as does his position on the threshold of the unconfined space of the margin. The crow's wings are set parallel to the sloping ground as the animals leave behind nearly barren hillside. The only prominent foliage is in the margin.

The modest size of this scene is in keeping with the simplicity of what it illustrates. The painting is in poor condition; it has been taped together in the lower center, and the sedge has been severely pruned in cropping.

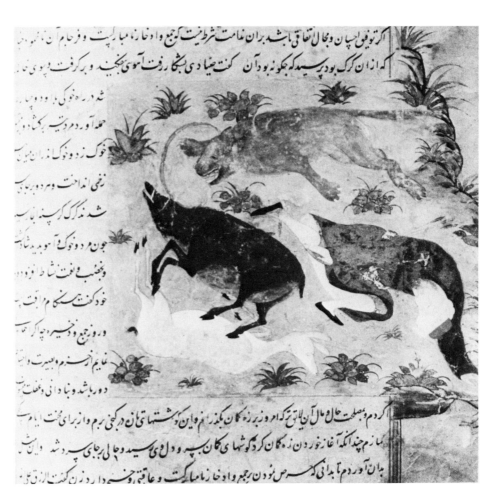

29
"The Dead Hunter and the Wolf"
(Rampur, p. 114) 13.7 × 12.8 cm (excluding margin)

The Dead Hunter and the Wolf

When they arrived at the field, the mouse told the crow the story he had promised to tell to explain why one should appreciate what one has at a given moment.

"One day a hunter, who had killed a gazelle, was on his way home when a wild boar charged at him. He tried to kill the boar with an arrow, but both the boar and the hunter wounded each other and died. A hungry wolf passed by and rejoiced over the quantity of food he had found. Reasoning to himself, 'It is wiser to eat only the string of the bow now, and to store the fresh meat for days of hardship,'

he attacked the bow. It snapped violently and knocked him dead. He who hoards wealth comes quickly to ruin." (Minuvi, 170–72)

Paired with "The Ascetic's Guest Beats the Mouse" (30), this painting also explicates the theme of retribution for intemperance. The hunter, boar, and gazelle lie strewn across a hillside; they died in rapid succession and are arranged according to the times of their death. The gazelle, the first to die, rests upside down; the hunter, wearing a frozen, pained expression, shares a slightly higher register with the boar. The wolf (whose rounded snout and large body are more like those of a bear), the last of the quartet to die, is above the others, snarling as he charges the bowstring to meet his death.

This Rampur painting appears to be based on a Mongol painting which no longer exists. Typically, the scene depicts the wolf at the point of death, receiving the punishment due him in keeping with the consistent emphasis of the Istanbul cycle. The composition of a larger painting has also been truncated to suit the smaller Rampur format; the absence of a horizon is uncharacteristic of sixteenth-century painting. The crowded arrangement of the characters and the awkward continuation of the hillside into the upper margin also suggest that this painting is based on a Mongol original.

In accordance with later artistic conventions, a flat ground plane has been substituted for the Mongol highly textured terrain, over which are now scattered stylized East Timurid plants.

The Ascetic's Guest Beats the Mouse

The mouse continued, "I used to live in the city in the house of an unmarried ascetic whose disciple brought his food every day. The ascetic would put his dinner aside and go out, whereupon I would eat what I could and feed the rest to the other mice. The man tried various tricks to protect the food, even hanging it from the ceiling, but, of course, I would reach it there too. One night a guest came to the ascetic's house and wanted to find the reason for my courage. The guest said to the ascetic, 'Bring me an axe, and I will open and search the mouse's hole.' Although I was then in another hole, listening to the guest's stories, I knew that in my own were thousands of dinars. I had no idea who had put them there, but they made me happy. The guest discovered the gold and said to the ascetic, 'There will be no more theft from this mouse.' As I heard his words, I felt weakness overcome

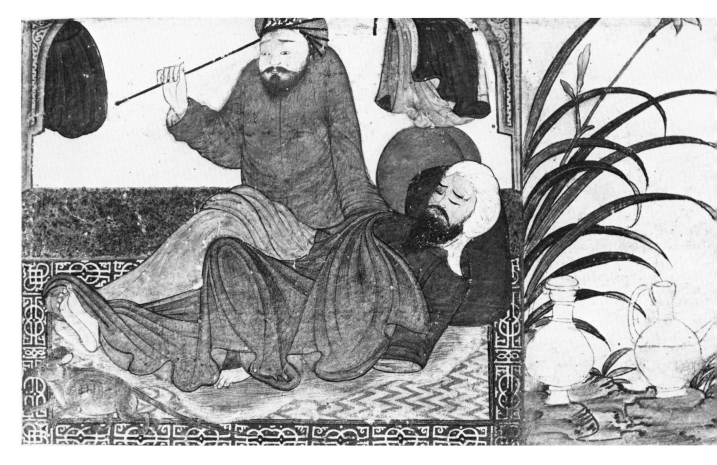

30
"The Ascetic's Guest Beats
the Mouse"
(IUL f. 7) 10.2 × 18 cm
arch cut along the top
(color pl. IV)

me. I realized that without my wealth the other mice would now despise me, and I told myself that one who is poor has no friends.

"I watched the men divide the gold, and the ascetic put his portion in a bag which he concealed under his pillow. I hoped to retrieve some of it in order to restore my power and status. When the ascetic fell asleep, I ran toward the bag, but the guest awoke and beat me with a wooden stick. I limped back to my hole and crept in on my stomach. Once the pain of the beating had subsided, greed compelled me to make another try. This time, the watchful guest hit my head so hard that I collapsed, unconscious. And thus I learned that greed leads to disaster and that all people are subject to its power. A poor man has no friends. This is why I had to leave the ascetic's house and go to live in the fields." (Minuvi, 173–76)

In attempting to reach the gold beneath the ascetic's maroon pillow, the mouse awakens the ascetic's guest. Brandishing the cane he has just used to beat the mouse, the guest sits upright in bed, knitting his brow in concentration. Frightened and in pain, the mouse, dragging his exaggerated tail, runs to hide. His anguish is voiced mainly by the rising and cascading folds of the ascetic's covers. The ascetic's conventional sleeping pose, common in the thirteenth-century Arabe 3465 *Kalila wa Dimna*,[42] is here infused with emotion.

The use of setting to convey drama and movement, as in "The Father's Advice" (8), is evident in the pattern and arrangement of textiles: the undulating curves of the ascetic's animal-skin rug[43] and swirling covers, the red pillows, and the yellow and orange zigzag carpet lining the field of action are prominent examples. These textiles contrast with the simplicity appropriate to an ascetic's dwelling, with its unadorned wall and brown dado. And while the garments hanging on the right are colorful, the one on the left is dark and oval, reminiscent of the opening of the hole that offers the mouse refuge. (The mouse's greed does not allow him to escape into the freedom of the margin.) A single day lily bedecks the modest garden in which sit an undecorated water bottle and ewer.

The figures are arranged in a triangular, active composition. The limping mouse occupies the lower angle, and the men's faces mark the opposite vertices to focus attention on the protagonist. The ascetic's bare foot, behind the mouse, points to the thief and serves as a foil for the mouse's furry, scurrying body. Throughout, the mouse's gigantic size is in keeping with its narrational importance.

The Hunter Pursues the Tortoise

The crow and the mouse not only became great friends, but also befriended a tortoise and a gazelle, with whom they shared the marsh. One day, the gazelle got caught in a trap a hunter had set in the reeds. The animals turned to the mouse, who alone seemed able to help; he could chew the cord holding the gazelle. The mouse ran to his friend, crying, "Oh brother, how were you caught despite your wisdom?" The gazelle replied, "When faced with our heavenly fate, of what avail is knowledge?"

At this moment, the tortoise arrived. The gazelle cried anxiously, "Friend, your desire to help me has created a more serious problem than my own predicament, for by the time the hunter arrives, the mouse will have freed me. I can then run; the crow can fly; the mouse can dive into a hole; but you are unable to protect

yourself." The tortoise replied, "What joy is left in life without friendship? Coming to the aid of one's friends when they are in distress eases one's mind. For if something happens to a friend, you suffer as much as he does."

So spoke the tortoise as the hunter returned. The mouse had just finished gnawing through the trap. The gazelle leaped away, the crow flew overhead, and the mouse escaped into a hole. The hunter discovered the empty trap and was amazed. He looked to the right and to the left, and, spotting the tortoise, caught him and bound him tightly. Later, as the animals searched for their missing friend, it became clear to them that he had been captured. (Minuvi, 183–85)

Upon the return of the hunter to check his trap, the four friends attempt to flee. The valiant tortoise, whose sacrifice leads to his capture, embodies the chapter's theme of friendship; his dramatic portrayal is achieved by the integrated dynamism of this painting.

In an amusing parody of the flight of the lithe gazelle, the tortoise has stretched his squat body to its full length. Threatened by the hunter's grasp, his mouth is agape and his nostrils are flared in fear and desperation. Sweeping, dark lines and highlights shape his wrinkled face; thick white illuminates his glaring eyes; and his segmented shell reflects his forward movement.

The fleet gazelle's extended neck and flying legs swiftly propel him to the safety of the margin. Echoing the gazelle's outstretched leg, the attenuated tail of the mouse draws attention to his own escape into the margin, while above the crow turns to watch the drama unfold.

Despite his determination and strength, the hunter has not succeeded in capturing the cumbersome tortoise, whom he stoops to snatch. The hunter's alienation in the animal world is evident from his awkward movement, accentuated by the reciprocal poses of the tortoise and gazelle. Hindered by his bulky body and layered red-lined dark clothing swirling around his knees, the hunter, a Turko-Mongol, is revealed as a comical figure. His rendering anticipates Behzad's animated figures, who are painted with accentuated humor and verve.

The heightened sense of movement toward the margin—and freedom—further emphasizes the hunter's encumbered, hunched pose. The curved spine of the hill echoes his rounded back and constricts his movement while intensifying his threat to the tortoise. In contrast, the hill's decline, invigorated by tufted grasses[44] and arching flower stalks, accelerates the release into the margin.

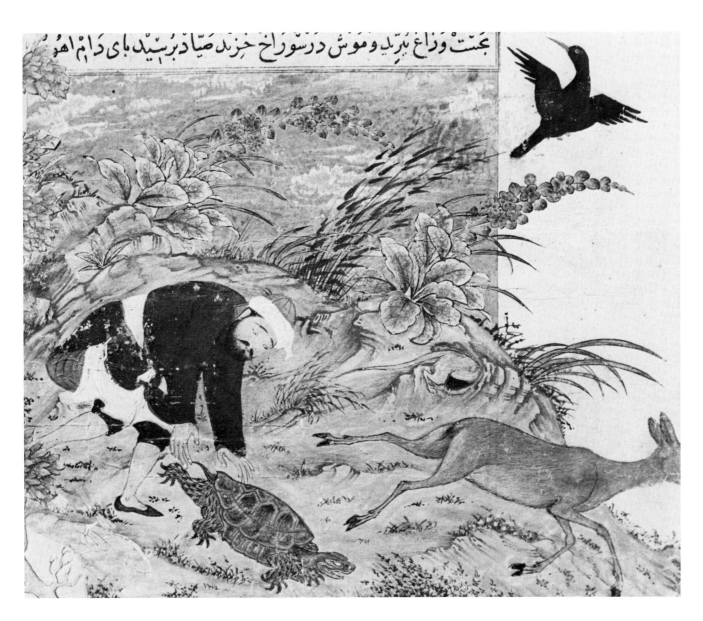

31
"The Hunter Pursues the Tortoise"
(IUL f. 10) 17.5 × 18.5 cm
one line of text; gazelle's head cropped, and bulrushes on the horizon added; left side
and bottom cropped
(color pl. XX)

The Hunter Pursues the Gazelle

The mouse told his friend the gazelle, "Run out into the open where the hunter will see you, and pretend that you are wounded. The crow will sit on your back as though ready to attack you. No doubt when the hunter sees you, he will leave the tortoise and follow you. You must limp along slowly so as to lead him on. Meanwhile, I will gnaw through the trap and release the tortoise."

The gazelle succeeded in exhausting the hunter in the chase. When the hunter finally returned to find his trap destroyed and the tortoise escaped, his skin turned the color of saffron, and he thought only of escaping from the land of sorcerers.

As the Brahman had said, "Friendship exists even among those who are remote from one another. In tranquility, true friends share each other's company, and in times of misery, they show their devotion." (Minuvi, 185–88)

The dramatic irony in this scene, the second half of this pair, makes the hunter's predicament as the victim of his own foibles humorous. The hunter wields his knife in pursuit of the gazelle, who feigns a limp. The crow, already in the margin, perches on the gazelle's back; spreading his wings, he opens his beak in a mock attack. Unknown to the hunter, the mouse eagerly gnaws the cord binding the valiant tortoise, whose body is enshrouded in a black cloth.

Fists clenched and lips pursed, the hunter chases the gazelle with hopeless determination. Though slimmer than in the previous painting, he still runs with a heavy stride and cumbersome clothes, which the speed of the light-footed gazelle mocks. Such devices are not so effectively employed here as in the previous painting, the product of a more accomplished artist.

Despite variations in size, sky color, and dramatic tone, this hillside is clearly derived from that in the previous scene.[45] Though clumsily retouched, the bamboo stalks direct the eye toward, and echo, the general movement of the animals escaping into the margin. Like the "wounded leg" the gazelle feigns, one of the stalks is appropriately bent and broken.

The Chapter of the Owls and the Crows

The Owls Attack the Crows

The Raja said to the Brahman, "You described to me friends who were as close as brothers. Now tell me about the enemy of whom one should be wary; that is, one

102

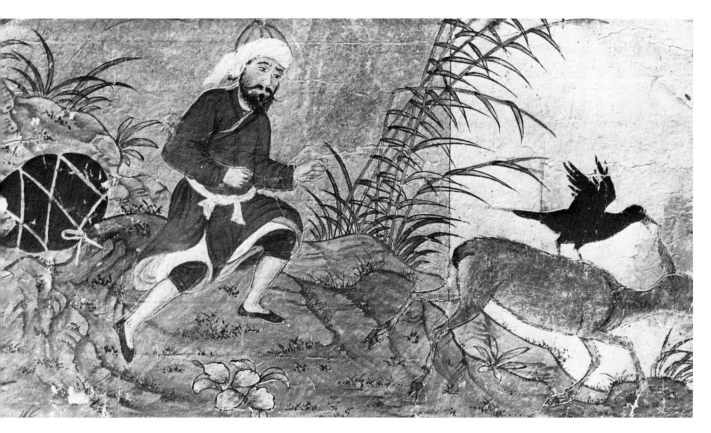

32
"The Hunter Pursues the Gazelle"
(IUL f. 28v) 11.5 × 21.3 cm
gazelle's nose cropped; bamboo retouched; left side trimmed

who feigns submission but later proves not to be what he seems, and is treacherous."
The Brahman replied, "A wise man does not heed the words of an enemy, nor is
he deceived by his tricks. For if, by a sign of weakness, he gives the enemy the
advantage, he will not even have the time to regret his mistake. Such was the sad
fate of the owls at the hands of the crows.

"At the top of a mountain stood an enormous tree. Among its numerous branches
and lush foliage were the nests of thousands of crows, who obeyed a king taken
from among their race. One night, the king of the owls, driven by the hate that his
subjects felt toward the crows, decided to launch a campaign against them. The

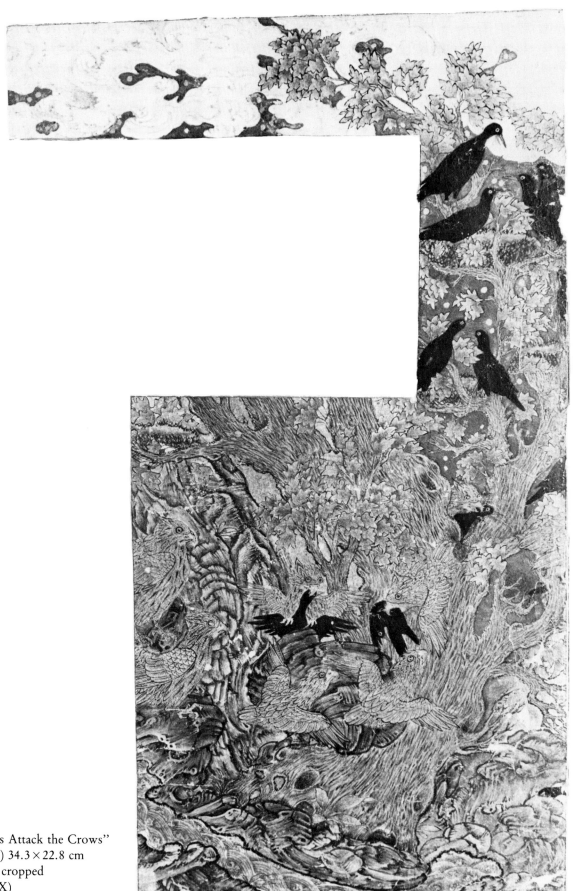

33a
"The Owls Attack the Crows"
(IUL f. 18) 34.3 × 22.8 cm
right edge cropped
(color pl. X)

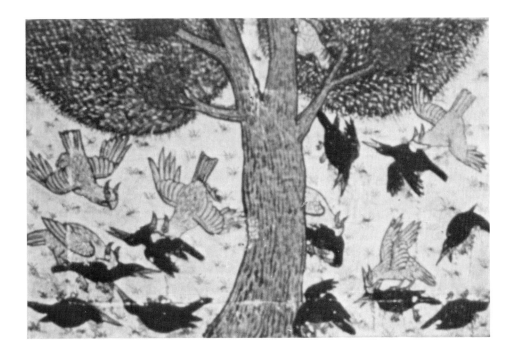

33b
(Cairo 1343/44 f. 49v)

owl-king fell upon the crows, killing and wounding a great many." (Minuvi, 191–92)

This Van Gogh–like tapestry of forms and movement aptly re-creates the terror of the owls' nocturnal attack on the crows. Swooping down on barbed wings in a surprise maneuver, a group of owls (eagle owls)—not just the owl-king of the text—fly through the dense forest in a low formation, camouflaged by the massive *chinar*. At the center, three owls are devouring three crows (red-billed choughs): two cry out as they are clutched in the owls' talons, while the third hangs limply from his attacker's beak. The crows have been dragged from their nest, which lies vacant on the left. Another three pairs of crows sit high up in the tree and look on with terror; the two owls opposite them await their turn in the battle. Regardless of their location, all the birds in safety are depicted as larger than those in combat; this heightens the difference between those who live in freedom and those who struggle.

The violence and sinister quality of the attack are reflected by the setting. Writhing, tortured forms predominate: rugged, barren cliffs; a choppy stream; agitated clouds punctuating the starry night; and a gnarled tree whose roots twist into a howling face. Like the detailed feathering of the owls, the entire

surface of the painting is textured: the boldly outlined rocks are weathered in striated layers; the tree's bark has short parallel strokes bounded by heavy outlining; and the turbulent clouds are animated by swirling lines.

A sense of depth is created by the birds' poses, surface texture, gradations of individual colors, and low horizon. Even so, the tree interferes, screening out a distant view. Though the *chinar* is depicted with Mongol mannerisms, it is more organic and realistic than its prototypes, and more skillfully knits planes of space above and behind. And though the composition may appear to be asymmetrically oriented by the sweeping tree, equilibrium is achieved by the cliff opposite it and by the original counterbalancing of the L-shaped text (Figure 2D). The artist cleverly animates the traditional Persian device of animal pairs flanking a central tree.

Birds in the throes of death or silently observing the scene fill the margin. The background, a blue and gold starry night, differs from those in the rest of the cycle; nonetheless, the margin remains a separate realm.

The charged atmosphere—a Mongol preference—makes this one of the most exciting scenes of the cycle. Nothing is static in this primeval forest with its primordial struggle.

The Crow Insults the Owls

Having heard the varied counsel of the first four ministers, the king of the crows addressed the fifth. Among other questions, the king asked if he knew the cause for the hatred between the owls and the crows. "It is said," answered the minister, "that a group of birds without a king once gathered to discuss choosing a leader from among the owls. In the midst of their conference, a crow appeared, and several birds proposed that they ask his advice, for a community exists only in unanimity. This crow said, 'The owl is the ugliest, the meanest, and the most vengeful of birds. Do not forget that he is blind in the daytime, and that he is a poor and unapproachable administrator. If you feel compelled to have him, allow him to be king only in name.' " (Minuvi, 201–202)

As the second scene of this chapter, this painting explains the cause of the battle. The congregation of birds and the rising ground form a pyramid that culminates in the crow, who caws his objection to the election of an owl-king. Sitting slightly below, though in the premier position at the right,[46] the owl

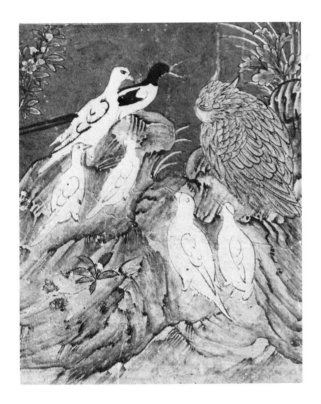

34
"The Crow Insults the Owls"
(IUL f. 10v) 12 × 10 cm
cropped on all four sides
(color pl. VIII)

raises his ears attentively and, chagrined by his verbal assault, turns his head away from the crow.

Only the crow and the owl are rendered in significant detail; the other birds—save for their dark red outlines—are left unpainted, like the doves in "The Mouse Frees the Doves" (27). The dark ominous sky nearly obliterates the crow's black head and open orange beak. But the rising, segmented ground and arching grasses enthroning the owl-king reinforce his unwieldy physicality, and call into question his wavering in the face of slander.

The success of the crow's attempt to humble the owl is foreshadowed by his superior position; likewise, the owl's isolation—only he sits alone, while the other birds are paired with mates[47]—suggests his coming rejection.

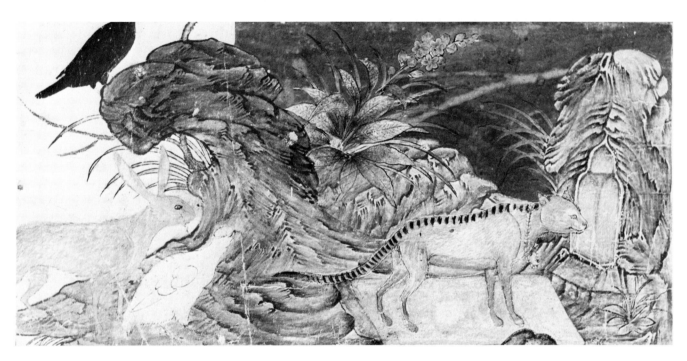

35
"The Ascetic Cat and
His Prey"
(IUL f. 7v) 9.5 × 19.8 cm
left side, top, and
bottom cropped

The Ascetic Cat and His Prey

The minister continued, " 'I have not yet told you everything,' said the crow to the assembled birds. 'The worst of kings is the one who, like the owl, will place you in the position of the partridge and the hare, who referred their dispute to a treacherous cat. This partridge and hare fell into an argument, and decided to bring it before a judge. The partridge recommended presenting their case to a cat who lived nearby and was renowned for his asceticism.

" 'When the cat saw the hare and partridge approaching, he rose and faced the mihrab, an act which greatly impressed the hare. When he had finished his prayers, the animals paid their respects and, somewhat fearfully, begged his advice. The cat replied, "Old age has weakened my hearing. You must come nearer and speak up." They moved closer and repeated their story. The two animals were captivated by the wisdom with which the cat offered his advice, recounting instances of morality and friendship. They moved closer and closer to him, until all at once, he leaped on them and killed them both.'

"After hearing all the crow had to say, the birds decided against choosing one of the owls as their leader." (Minuvi, 205–207)

Aware of the presence of the hare and partridge, the hypocritical cat assumes a praying posture. With his eyes closed and head lowered, he stands on a yellow (felt?) prayer carpet before a rock-hewn mihrab;[48] its grotesque and bewhiskered carved face perhaps mocks the feigned piety of the cat, whose flattened ears betray more aggressive intentions. The cautious hare and partridge are ranged at a safe distance from the cat,[49] and the crow, who has come merely to observe, is perched in the margin.

The landscape is unusually fragmented in this painting, one of the least successful of the cycle: abrupt changes in color, texture, and unintegrated flora create a patchwork effect. Even the animals themselves are less expressive than usual. Their bodies are flat and untextured, caused, in part, by paint deterioration. The dark markings along the cat's spine could signify emaciation—appropriate to his asceticism—but are more of a decorative flourish, continuing along his tail.

A degree of cohesiveness is imposed by the maroon rock and orchis plant. They are arranged centrally so that their curved forms mirror each other and bracket the animals below.

This scene, unlike its TKS H.363 counterpart, illustrates only the moment preceding the murder of the innocent animals, and the rewards of deceit are intentionally uncelebrated.

The Crow Spy

After hearing his minister's story of how this crow had insulted the owls, the king of the crows said, "Now I understand why the owls attacked us. How do you think we can save ourselves?" His minister replied, "I think we must employ deceit; many have triumphed through cleverness rather than battle. The king should order me to be beaten publicly and thrown under a tree. Then all the other crows should take shelter and wait." The king did as his minister recommended.

The following night, the owls returned, but they could not find the crows. At first they did not notice the single crow who had stayed behind as a spy. Then he began to groan quietly, pretending to be wounded.

The crow explained, "My master doubted my counsel. After you attacked us, the king ordered his ministers to consider the best response. I said that since we could not match the owls' bravery and strength, we should send an emissary and sue for peace. The other crows accused me of siding with the owls, and the king ordered me to be beaten and exiled. I understand they are now preparing themselves

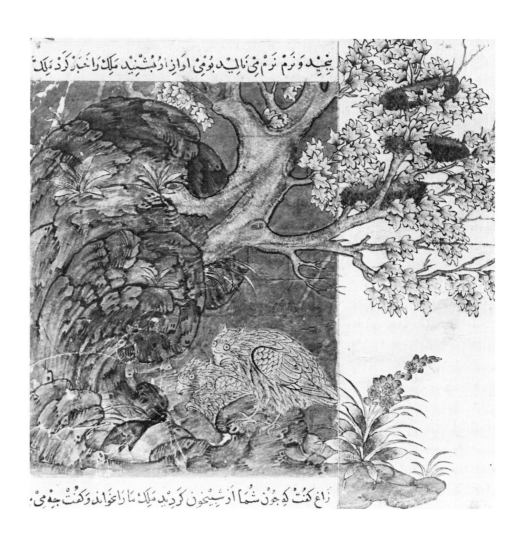

36
"The Crow Spy"
(IUL f. 6) 19 × 19 cm
two lines of extant text

for war." The owl-king turned to his ministers and asked if he should believe the crow's story. (Minuvi, 211–12)

The invading owls find the crows' territory and nests abandoned; a single crow, beaten and pretending to have been rejected by his peers, remains. The crow-spy assumes an abject posture, cowering with back hunched and wings hugged to his body. Occupying a prominent position above the two owl-ministers,[50] the owl-king stands on guard, holding his talons in readiness.

The setting is particularly successful in intensifying the drama and intimating

the dire consequences of the fateful interaction. The imminent danger for both crows and owls is reflected in the precarious, overhanging rock and asymmetrical tree,[51] made more menacing through surface patterning and rugged outlining. A vigorous interplay of texturing in the weathered rocks with jagged striations and stippling,[52] the silvery tree's knotted bark, and the delicately veined orchis leaves contrast with the feathery plumage of the owls. The orchis is a direct reference to the preceding painting, reinforcing both a thematic and a visual continuity in the sequence of paintings that illustrate this story.

The arching cliff, whose curves grow more emphatic as it rises, echoes the crow's hunched body, protecting his seemingly vulnerable position. The owls' position reveals (as will the story's denouement) that their powers are restricted, for they are menaced by the cliff towering above them and confined by the low branches of the *chinar* hanging over their heads. The empty crows' nests filling the branches are an ominous reminder of the crow-spy's nearby compatriots.

The Ascetic, the Thief, and the Demon

The king of the owls then turned to a minister and asked his advice. He replied, "I feel that we should treat the crow well; he may give the king valuable counsel. Good sense dictates that one consider discord among one's enemies a handsome victory. Such was the case with the ascetic who was saved by a quarrel between a demon and a thief who had come to rob him while he was asleep. The thief had seen the ascetic accept a cow from one of his disciples, and followed him home. A demon, taking human form, approached the thief and explained, 'I am a demon who hopes to find an opportunity to kill the ascetic. Who are you?' The thief answered, 'I am a swindler and am thinking of stealing the ascetic's cow.'

"The thief said to himself, 'If the demon first tries to kill him, the ascetic may cry out and alarm the neighbors, who will come before I can steal the cow.' The demon thought, 'If the thief acts first, his noise may awaken the ascetic and I will lose the chance.' And so he said to the thief, 'First let me do away with the ascetic, and then you will be free to take the cow.' The thief answered, 'I would prefer that you wait until I have gone; then the ascetic will be all yours.' Such an argument arose between them that the thief finally called out to the demon, 'Murderer!' while the demon shouted, 'Thief!' The noise awakened the ascetic and his neighbors, who arrived only after the two had escaped, but without harming the ascetic or his possessions." (Minuvi, 214–15)

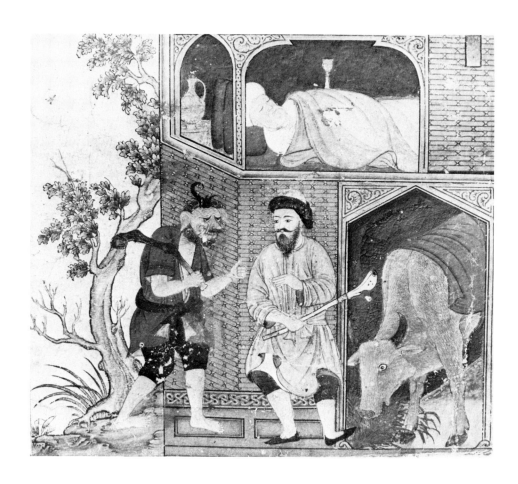

37
"The Ascetic, the Thief,
and the Demon"
(IUL f. 7) 18.5 × 20.5 cm
trimmed
(color pl. XIII)

It is discord between the ascetic's enemies that saves his life and his cow. Accordingly, the argument between the wily thief and the demon is the subject of this illustration.

Arguing over whose scheme will be carried out, the thief and the demon stand beneath the ascetic's window, beside the cow. The ascetic sleeps soundly through the din suggested by the hand gestures and swinging clubs of the intruder and demon. With his stick and his left shoe, the thief points to the object of his desire, the cow. The demon approaches from the margin—which, like his physiognomy, indicates a half-spirit, half-human nature. Contrasted with the well-groomed thief, the demon's every feature is satirized: his boar's snout and tusks, glowering eyes, flap ears, rough beard, forked horn, shaman animal club, pink skin, and bare feet are animalistic counterparts to the thief's bright eyes, cropped beard, trim Mongol cap, ivory cane, pale complexion, and slip-

pered feet. Such a demon is common to Buddhist, Taoist, and Tantric im-agery,[53] and his juxtaposition with the fashionably appointed Mongol figure lends a humorous air to both characters.

The architectural façade, one of two in the Istanbul album, is composed of Mongol-style arches whose diverse dimensions are crudely related, arranged solely to frame the characters. The rhythmic repetition of primary colors—especially bright yellow—eases the rigid compartmentalization of the setting and integrates an otherwise additive composition.[54]

The Cuckolded Carpenter

The first minister, who favored killing the crow, said, "I can see that this crow, with his artful humility, has made you abandon your caution. This situation reminds me of the carpenter who loved his wife but had been told that she had taken a lover. To find out about this, he told her that he was going away on a trip for several days, but instead crept back into his house that night. The carpenter waited until the couple fell asleep and then hid himself under their bed. When his wife awoke, she saw his foot protruding from under the bed and realized the danger. She whispered to her lover, 'Ask me loudly, "Do you like me better or your husband?" Be insistent.' He obeyed, and she replied, with reluctance, 'Out of weakness and lust, women fall into this sort of wrongdoing, but they choose lovers whose families they do not respect. Once their lust is satisfied, these men seem to them like strangers, while their husbands always occupy the place of a father, or a brother or a child. May the woman who does not devote her life and soul to her husband's comfort never find happiness.'

"When he heard these words, the carpenter's heart softened, and he thought, 'I have sinned in my suspicions. If my poor, loving wife unwittingly errs, I should take no notice. None of us is beyond reproach.' " (Minuvi, 217–19)

The carpenter's wife, aware of her husband's presence, has awakened her lover so that he can question her about her matrimonial devotion. The carpenter lies under the bed and anxiously follows the lovers' conversation. He has apparently retracted the foot which caught his wife's attention. The wife's modesty is respected, and her bedcovers are pulled high around her neck, although a single lock of hair snakes down her cheek from beneath her kerchief. Her lover's bare chest is visible from under the red-and-white checked sheet,[55] though

38a
"The Cuckolded Carpenter"
(IUL f. 23v) 20 × 20.5 cm

38b
(TKS H.363 f. 136)

more suggestive is the array of discarded clothing and shoes. A potted amaranth in the margin is meager embellishment for this illicit love, the wrongness of which is reiterated by the denied access to the inner garden.

The artist has included a Chinese-red lacquer bed so that the carpenter can hide comfortably; all the other figures sleep in Eastern custom on mattresses directly on the floor. Although the room is animated by pattern and color, this composition is less fluid than other bedroom scenes. The bedcover's vegetal pattern and encircling band are probably derived from the TKS H.363 version (see 38b), but their reinterpretation—in combination with the upturned lining—makes the lovers' bodies more explicit.

The "moral"—don't believe what you hear, but rather trust what you see—is illustrated in a composition rigorously structured to underscore the complexity of the love triangle. The wife's divided alliances are subtly depicted in the tierlike arrangement of figures; she and her lover are joined by location and by the cover's diagonal pattern, and an ornamental band simultaneously draws the eye toward the carpenter, thereby linking husband and wife. In addition, the heads of the married couple lie along a single vertical axis, while the lover's head projects beyond it. The placement of husband and wife makes clear that the wife (literally) occupies a position superior to that of her entrapped husband.[56] Such a portrayal is in keeping with the independence Mongol women enjoyed. The corner of a window that appears beyond the curtained doorway suggests an additional plane; the effect, however, is minimized because the window occupies a peripheral position, and the wall is the same color as the one in front of it.

The Ascetic and the Adopted Mouse

Eventually, the crow came to be respected by the owls. Sometime later, the crow told the king that in order to take revenge on the king of the crows, he wanted to disguise himself as an owl. A suspicious minister said, "Even if you look like an owl, your nature will be unchanged, just as in the story of the ascetic and the mouse.

"One day an ascetic who had always had his prayers answered sat beside a stream. Suddenly, a kite set a baby mouse before him. The ascetic took pity on it, and wrapped it in a leaf. He wondered whether it would live a good life as a mouse, and prayed to God for help. Thereupon the mouse was transformed into a ravishing young girl, so beautiful that the sun of her face set fire to water and the darkness of her hair caused the moon to believe it was night. When she came of age, the

ascetic said to her, 'You are now old enough to marry. You must choose between angels and men for your husband.' The girl answered that she only wanted a powerful husband, so the ascetic suggested the sun.

"The sun replied, 'I will show you one who is more powerful than I: he is able to eclipse my light and hide my face from the world. It is the cloud you want.' The ascetic went at once to the cloud and repeated his request. The cloud answered, 'The wind is much more powerful; I am a pawn in its hands.' The wind, in turn, told the ascetic to talk to the mountain, which blocks its path, but the mountain said, 'You must talk to the mouse, who makes his house in my body despite my strength.' When the girl heard that the mouse insisted on a wife from his own species, she implored the ascetic to pray to God that she become a mouse. His prayers were answered, and the mice were wed." (Minuvi, 224–26)

As an illustration of the impossibility of changing one's nature, this scene prefigures the final confrontation between the owls and the crows. Seated beside a stream, the ascetic holds in his lap the mouse delivered into his care as the kite flies away in the margin. The mouse raises its head from a bed of pear-tree leaves enquiringly. The ascetic's trancelike expression and herculean size convey his involvement with miraculous transformations.

The ascetic is depicted in a pose typical of Chinese scholars. His massive, frontal face, exaggerated by the disproportionate pug nose, the sweeping curve of his knees, and his bulky, hunched shoulders emphasize unusual power that would be appropriate to the "path of astonishment." His pose[57] and quizzical countenance anticipate a later fifteenth-century Behzadian figure of an ascetic.[58]

The mouse occupies a liminal position, beside the carefully drawn threshold and half-open doorway, suggesting that its transformation is about to occur. The ascetic's position between the architecture, the blue horizon, and the margin links him to these three realms—as do the young lovers (14) and the etherealized wife (4).

Unlike those of the pious ascetics in other paintings, the fantastic powers of this figure justify not only his monumental size, but also his more refined possessions: the brass and silver vessels and a splendid *lajawardine* ewer are in the style of the finest work of the period.

The robe blowing in the wind suggests that it—although now much too large—is the garment that the girl will wear once the mouse is miraculously transformed.

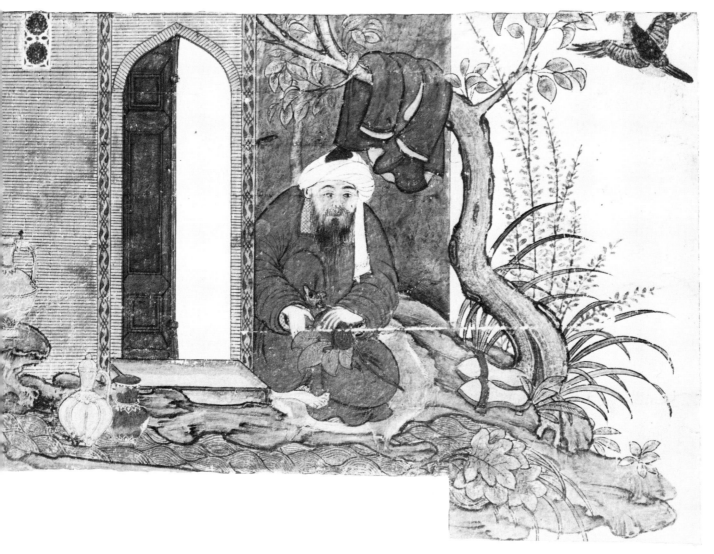

39
"The Ascetic and the Adopted Mouse"
(IUL f. 23v) 17 × 21 cm
partially cropped at the right and upper margin, which necessitated gluing the bird
lower down than it originally was
(color pl. XIV)

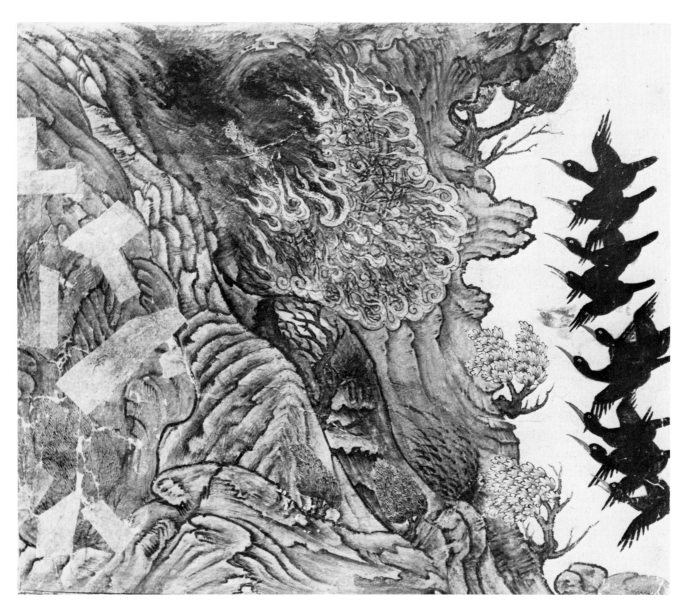

40
"The Crows Attack the Owls"
(IUL f. 7v) 17 × 19.8 cm
cropped at bottom;
paint smudged in margin;
bulrushes and dead tree
later additions
(color pl. IX)

The Crows Attack the Owls

Neither the king nor the owls paid attention to the suspicious minister's fable; on the contrary, they honored the crow all the more. Meanwhile, he learned all that he wanted to know about the owls. Then, in secret, he went to find the crows.

When the crow saw his king, he cried, "I have good news: I have fulfilled my

mission, and we can now avenge ourselves." The king responded, "We are at your command." The crow explained, "During the day, all the owls gather in a cave on a wooded mountainside. The crows can easily set a bonfire at the cave's entrance. Then the king must order the crows to fan the flames with their wings; the owls who try to escape will be burned, and those who remain will suffocate."

The crows carried out this plan, and all the owls were killed. The victorious crows went home in peace. The king and his soldiers lavished praise on the minister, but the minister praised the king, saying, "It is the king's destiny that brought us victory. The owl-king was overbearing, foolish, and careless. I saw the good omen on the day of the owls' attack." (Minuvi, 229–30)

In formation, the crows execute a planned attack from the freedom and safety of the margin; they fan the fire with outstretched wings to suffocate the owls trapped inside their mountain cave. As the fire rages, three pairs of eyes are discernible through the black smoke: their number recalls the trio of owls present at the original battle (33) and at the fateful meeting with the crow-spy (36).

Although neither the crows nor the owls are expressive in themselves, the drama of the deadly confrontation is effective. The phalanx of crows, menacing in number, stands sternly opposed to the confusion and uproar of the owls' cliffside. The threatening mountain, its precipitousness, jagged profile, and scarred, twisted rocks voice the danger. In the somber terrain, a prominent grotesque closes its eyes, lending a timeless quality to the ensuing confrontation. The mountain's enormous bulk blocks the horizon, and space is constricted, as it is for the owls, who are trapped and suffocating inside their cave. The leaping, claw-shaped tongues of the Chinese-style flames[59] and gnarled, windswept trees intensify the atmosphere of this final confrontation between the owls and the crows.[60]

The Old Snake

The king of the crows said to his minister, "You have suffered hardships in order to appear humble to the enemy." The crow answered, "One resigns oneself to such suffering, for ultimately it works to one's advantage, as with the snake who resigned himself to serving a frog. This snake had grown so old and feeble that he could no longer hunt, yet even so, he wished his life might never end. He crept along until he found a deep pool." (Minuvi, 229)

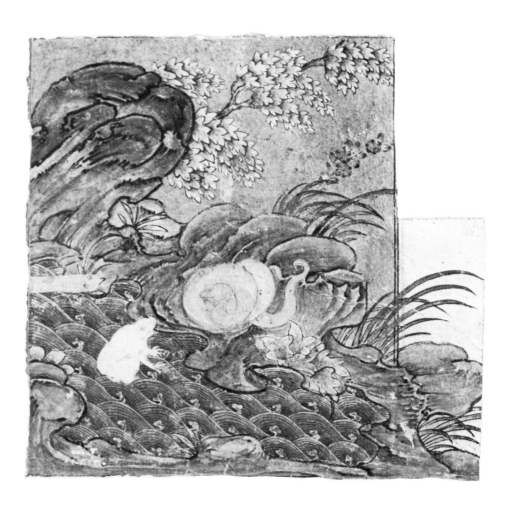

41
"The Old Snake"
(IUL f. 23) 12.8 × 13.7 cm
white frog later addition

More than likely, this painting was originally placed opposite the following illustration; as the final pair of this chapter, these small images illuminate its central theme of naiveté and the king's gullibility before his enemy. Ultimately, the snake, here sympathetically portrayed, will hoodwink the frog-king; like the crow-spy before him, he feigns submission.

Too weak to hunt for his sustenance, the old snake lies tightly coiled at the stream's edge. The white frog, not yet mentioned in the narrative, is painted in a later, more decorative style and in a pose derived from the following scene.

The thrusting movement of the landscape is appropriate to the situation of the old and helpless snake. The downward-flowing stream, its diagonal shoreline, and the arching vegetation and weathered rocks forcefully suggest the inevitability of old age and the transience of life.[61] In this scene, found nowhere else in the tradition, the old snake is defenseless before the forces of nature—

only deceitful flattery can help him to procure his needs from a naive and vain king.

The Old Snake and the Frogs

The crow continued, "The snake went to a stream where the frogs lived with their king, and appeared very sad. He explained to a solicitous frog, 'I used to live by hunting frogs, but now, even if I caught one, I would not dare to eat it.' The frog

42
"The Old Snake and the Frogs"
(IUL f. 20v) 10.5 × 14.2 cm
bottom and top trimmed

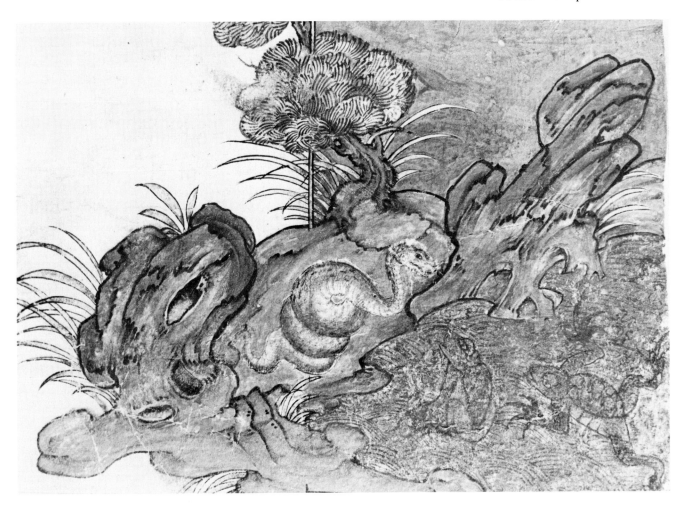

reported this to his king, who came to ask the serpent, 'How did this misfortune befall you?'

"The snake replied, 'On my hunt, I chased a frog into the house of a hermit, but in the darkness, I bit the little finger of the hermit's son instead of the frog. The hermit cursed me, saying, "I beseech God to make you the carrier of the king of the frogs, and that you be able to eat only those frogs that the king allows you." Now, I have come to ask the king to ride on my back.'

"The king found great honor in riding his new vehicle. After some time, the snake pleaded for some food so he could renew his strength, and the king allotted him two frogs per day. Thus the snake practiced humility to retain his status and to preserve his life." (Minuvi, 230–32)

The old snake approaches two swimming frogs, the frog-king and his companion, to relate his false tale. Uncoiled at the edge of the stream, the snake wears a crafty look—this and the mischievous face peering out from the overhanging rock betray his hypocrisy as he addresses the credulous frogs; they listen keenly with heads raised and mouths agape, their submissive postures suggesting their gullibility.

The snake's position in the landscape reflects the constraints of old age and his inability to hunt. Brown rocks sandwich his body, while the pine tree and stream at his sides restrict his space.

The composition is divided into two prominent triangles—the snake, rocks, and embankment form the first, while the frogs and the stream occupy the adjacent one—and opposing diagonals cross to link the frog-king and the snake's head.

This illustration is significant for the choice of the specific moment: while the text makes clear that the snake's ruse eventually is successful, the scene portrays a moment when his fate is still uncertain.

The Chapter of the Monkey and the Tortoise

Kardana's Deposition

The Raja said, "Now tell me the story of one who obtains something by great effort but then neglects it until it is lost." The Brahman replied, "It is easier to obtain something than it is to keep it; fortune helps us to obtain what we need,

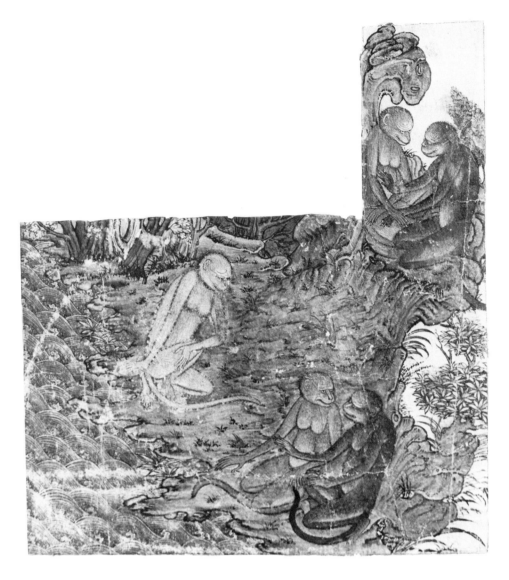

43
"Kardana's Deposition"
(IUL f. 23) 21.8 × 19.5 cm
cropped along the bottom
(color pl. XVII)

but keeping it requires wisdom and caution. Once there were many monkeys living
on an island under the wise and righteous rule of a king named Kardana. In time,
this king's youth, which is the spring of life and the season of happiness, passed.
Old age arrived to weaken his body and spirit, and because of this, his kingdom
declined. A cunning young relative arrived in the kingdom and, by flattering all the
renowned and cultivating the friendship of the king's army, was soon able to
overthrow the old monarch and seize power." (Minuvi, 238–40)

The first of a series of four—a sequence marked by its expansive display of
talent, cohesiveness, and subtly varied expression, as well as by its length—this
scene introduces the theme of losing one's acquisitions through neglect. It also
focuses on particular interests of the Mongols: the peaceful transfer of power[62]
and the ephemeral nature of life, both of which hardly figure in the text.

Isolated and alone, the deposed ruler, wearing a resigned expression, leans
toward his fellow monkeys to seek recognition. His loneliness and celibacy are

accentuated by the intimacy of the pairs of younger monkeys and the addition of the females who are seductively fondled by their mates. While the younger males have rich dark coats and the females tawny ones, Kardana's advanced age explains his lighter mottled coloring (made even more emphatic now through the surfacing of the light underpainting). The new young king imitates Kardana's pose, but he has assumed the right-hand position. Kardana is at the odd angle of the isosceles triangle formed by the grouping of monkeys and by the compression of space around him. His placement at the shoreline also underscores his marginal status—he is neither king nor, yet, exiled—and anticipates the following episodes, all of which involve the same river and shore.

The variation of the monkeys' tilted poses establishes a sense of depth within the stilted ground plane of the modeled, wrinkled terrain. Bits of grass, segmented planes, and a cantilevered rock with an empathic face overlooking a pair of amorous monkeys punctuate the landscape. Throughout the "Kardana series," landscape and the use of space are particularly successful in reinforcing the emotional state of the protagonist: here the landscape's barrenness and claustrophobic atmosphere aptly convey Kardana's desolation.

Kardana and the Tortoise Become Friends

The Brahman continued, "Forced into exile, Kardana moved to a coastal region where there was much fruit, and settled in a fig tree near the shore. One day a tortoise sat down under the tree to relax in its shade. The monkey, who was eating figs, dropped one into the sea. Delighted by the sound, he dropped more and more, which the tortoise devoured, thinking they were thrown for his enjoyment. He called out to offer his friendship, hoping to discover why the monkey was being so generous. The monkey responded with kindness. They soon became such close friends that it seemed one soul breathed in the two bodies and one heart beat in both breasts. The monkey no longer feared loneliness, and the tortoise's life was filled with happiness." (Minuvi, 238–40)

In the second scene, Kardana, leaving his fellow monkeys in a stark environment, has moved upstream to a lush landscape set for the ripening of his newfound friendship. Entwined in the branches of a fruit tree, dropping figs that look more like pomegranates, Kardana is sad, his expression revealing that he is still unaware of the tortoise. Their approaching union seems to have inspired

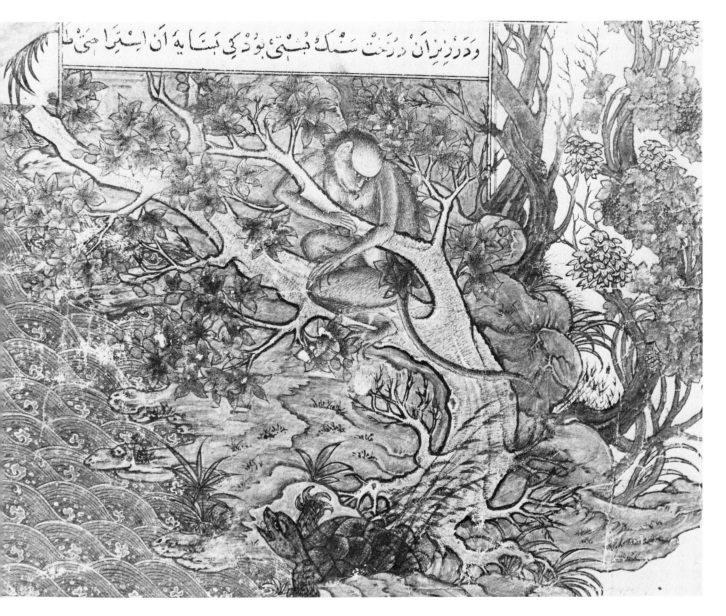

وددرزران درخت سنك نبشتی بودکی نسایه ان اسرا می طا

44
"Kardana and the Tortoise
Become Friends"
(IUL f. 19v) 20.3 × 19.7 cm
one line of text; 4 cm of shore-
line cropped at the bottom;
foliage at upper left pasted on
(color pl. XV)

in this scene a sense of the Sufi "stage of unity." Intertwined fruit trees, an arching central tree running parallel to the coastline, gently lapping waves with playful spray, and luxurious terrain create a joyful mood. The margin's contrasting pairs of intertwined trees, one pair festooned with a lush grapevine and the other composed of two dead fruit trees, signify the animals' friendship— soon to ripen and link their fates, and later to perish.

The trunk of the central tree curves upward to link the eager tortoise (who is consuming the fallen fruit) with the monkey, effectively unifying the composition. The tree's prominence—in position and function—is thematically appropriate, for its fruit nourishes the animals' closeness. The alignment of the tortoise and the monkey along a vertical (and central) axis also bonds their incipient relationship.

The Tortoise Ferries Kardana

The Brahman continued, "It happened that the tortoise stayed away from home for a long time, and his wife grew anxious over his long absence. She confided in a friend, who told her, 'He has befriended a monkey and soothes his desire for you by constant companionship.' The wife and her friend decided that there was no alternative but to kill the monkey. The wife sent for her husband on the pretense that she was sick.

"When the tortoise arrived, he found his wife sick in bed and mute. Her friend explained, 'When one is incurably ill, how can one speak?' The friend then explained that his wife suffered from a pain in the womb which midwives cured with the heart of a monkey. The tortoise pondered the situation. He believed the neighbor but was horrified at the thought of betraying his friend. At last, his love for his wife proved stronger, and he decided to fetch the monkey.

"He returned to the monkey and said, 'I was so sad at being parted from you that I could not enjoy my family's company. I thought I would ask you to come back with me.' The monkey answered, 'Although I am far from my own home and family, I have found happiness here with you. If in the past I could have imagined such a blissful life, I would not have been so preoccupied with directing the affairs of my country.' The monkey accepted his friend's invitation and, because he could not swim, straddled the back of the tortoise, and they set off across the water.

"As he carried Kardana, the tortoise began to be tortured by his conscience. Kardana sensed his uneasiness and became alarmed. He asked the tortoise what was disturbing him, and the tortoise replied, 'It is my wife's illness.' The monkey said, 'You told me this before; we should find her a cure.' The tortoise replied, 'Doctors suggest a monkey's heart.' The monkey's eyes grew dark as he realized his friend's designs, and he said, 'If you had told me earlier, I would have brought mine along. When we visit a friend, we usually leave our hearts behind, because we consider them a source of sadness and suffering which we do not want to inflict on our hosts. Let us return to the fig tree.' " (Minuvi, 241–47)

126

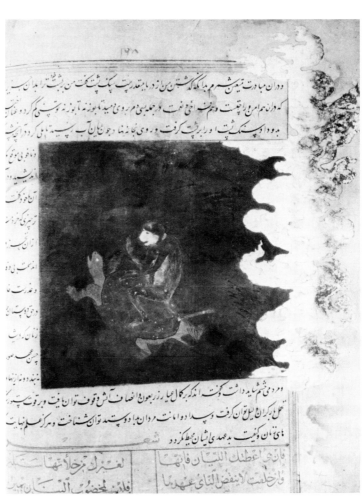

45b
(Rampur, p. 74)

45a
"The Tortoise Ferries Kardana"
(IUL f. 22v) 24 × 4 cm
only a fragment and two partial lines of text remain

This painting fragment, extant text,[63] and the Rampur copy provide evidence that the original Mongol painting—the third in the series—illustrated the tortoise ferrying Kardana home on his back. The Rampur scene furnishes the missing details of pose and position; sitting astride the tortoise equestrian-style, Kardana is busily talking with the tortoise and they are as yet not far from land. The Mongol fragment shows only the shoreline, bordered by marsh plants and covered by an embankment of dense, swirling clouds.

As in other paintings of this series, the expressionistic treatment of landscape reflects the characters' emotions; the insistent choppy water and low, turbulent clouds with flamelike projections presage the animals' stormy course. Unlike those in the previous painting, which break against one another at irregular angles, the high waves, rendered with longer calligraphic lines, ebb without playful spray.

Kardana's Escape

The Brahman concluded,"The tortoise turned around at once and brought the monkey back to the shore, believing that he would return with his heart. The monkey quickly climbed the tree and said to the tortoise, 'I have been a king and have had much experience in the world, but only now have my eyes been opened to good and evil. Today, the world has snatched from me its gifts.'

"The tortoise replied, 'I have wounded you so grievously that your heart will never again be open to me. My malice has been stamped indelibly on my countenance. There is nothing to gain from regret or sorrow. I must learn to bear our separation.' " (Minuvi, 247–59)

The same gifted hand of "Kardana and the Tortoise Become Friends" (44) has imparted to this scene, by equally limited but effective means, a variety of moods and expressions: a profound comprehension of the conventions of this cycle invigorates both paintings.

The severed friendship of the monkey and the tortoise is poignantly expressed in their poses, in the empathic landscape, and in the compressed space. Climbing along the branches of the grotesquely contorted tree, Kardana contorts his body, his flaccid breasts dangling as he glares at his former companion. The friends are no longer vertically aligned, and Kardana even extends and lifts his tail to expose his backside to the deceitful tortoise.[64] Grasping the shore

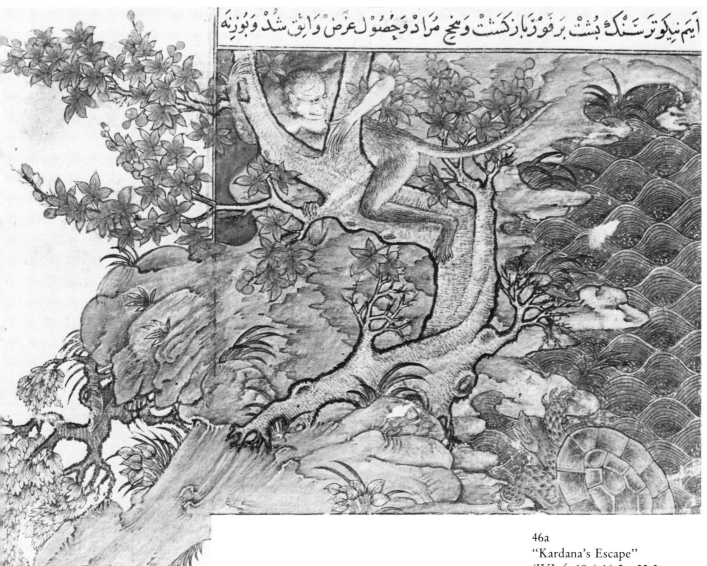

أَيَمْ نِيكُوتَرْسَنْكَ بُشْ بَرْفَوْزْبَازْكَشْتُ وَبَنْج مَرَادْوَحُصُوْلَ عَرَضْ وَايَقْ شُدْ وَبُوزِنَهْ

46a
"Kardana's Escape"
(IUL f. 19v) 16.5 × 20.3 cm
line of text above the painting;
bottom margin cropped
(color pl. XVI)

46b
(TKS H.363 f. 151)

with outstretched claws and tilting his body, the tortoise desperately appeals to Kardana to return.

The landscape is awash with dynamic forms: the central tree, angular and twisting;[65] the steeply descending shoreline and Chinese-style fingerlike projections; the flecks of spray; the ground's serpentine planes cutting a corner of sky; and the precariously balanced rocks jutting into the margin reflect the disarray of the ruptured friendship. A reversal of the natural order is signified by the tree in the margin growing upside down among angular, cascading forms.

The animals have retreated to their respective natural habitats. The monkey's mottled gray coloring, parallel striations, and twisted limbs blend with the central tree. The head and claws of the tortoise are echoed by jagged inlets; the feathery brush strokes of his scaly body mirror the aqueous spray; and his segmented shell continues the patterning of the shoreline.

Whereas Kardana and the tortoise were aligned along a stable vertical axis in their first meeting, a strong diagonal emphasizes the instability of their present relationship. Careful planning of this pair of paintings resulted in a clever juxtaposition: although the orientation of the central tree is maintained, the shift in the shore's location underscores the reversal of both composition and sentiment. The continuity of this sequence is so thoroughly and artfully realized that this pair must be celebrated as the work of a single artist and a highlight of the whole. The contrast between the two paintings emphasizes the harmony attainable only by following the "path of unity."

The Fox Deceives the Ass

Kardana then told the tortoise the story of the fox, the lion, and the ass: "Do not mistake me for the ass whom the fox said lacked heart and ears. This fox served a lion who suffered so severely from mange that he could not hunt. Since the fox lived on the carrion left by the lion, he was eager for his master's recovery. When the lion said that his cure required the heart and ears of an ass, the fox answered, 'I can help you. I know of an ass who grazes near a stream while his master washes. I will convince the ass to come back with me if the king will promise to eat only the ass's heart and ears.' The king agreed.

"The fox went to the ass and asked him why he was so weak and sickly. When the ass described how he was mistreated, the fox urged him to escape. 'If you will trust me, I will take you to a pasture which is like a shop filled with jewels, where the air has a scent of a perfumery filled with musk.' Finally, the fox convinced the ass to accompany him, and the two set off." (Minuvi, 252–53)

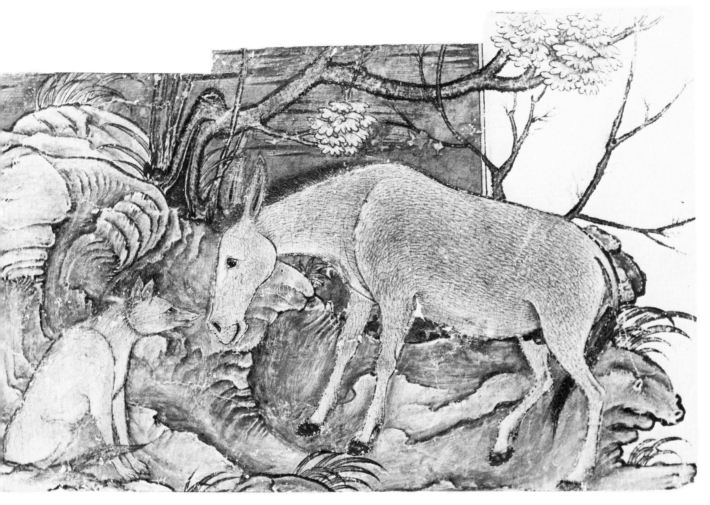

47
"The Fox Deceives the Ass"
(IUL f. 11) 12 × 19 cm
cropped at top and upper right; missing portion corresponds to extant fragment
at upper right
(color pl. XXI)

The gullible ass raises his ears, wide-eyed with interest, and cranes his neck to
listen to the fox's fabricated story. The ass's stupidity is indicated by the rela-
tive disequilibrium of his stance; although he is the larger and stronger of the
two animals, he gropes for sure footing on uneven terrain. The artist admirably
succeeded in rendering a naturalistic portrait of the donkey, complete with white
markings, wiry hair, and the mat finish of his hooves. The gender of the ass is
made unusually explicit. This may allude to a ploy the fox has in store—using
a she-ass as temptress. Together, the two animals' silhouettes form the Il-

Khanid keel arch found throughout this cycle: the shoulders of the ass form the apex, which draws further attention to his weakness.

Although the ass occupies two-thirds of the composition (he extends into the margin, but only for reasons of limited space), the fox dominates. The crafty fox is animated by similarly colored rugged rocks rising above him; a spirit's face in the ledge appears to smirk at the earth-bound creatures. The oddly contorted tree echoing the donkey's irregular contour reiterates his clumsy stance, while also unifying space by extending the central axis. Relieved only by this flawed tree, the barren scenery helps to explain why the ass is eager for the Elysian fields with which the fox tempts him.

The Ass and the Fox En Route to the Lion

Kardana concluded, "On the way to the promised pasture, the lion attacked, but with so little force that the ass escaped. The fox was amazed, but the lion only said, 'Servants are unable to understand their masters' actions. Find a way to entice him back.' The fox returned to the ass and explained, 'The beast who attacked you was only a she-ass who desires your company. If you had stayed, you could have become friends.' And so the fox tricked the ass, who had never before seen a lion, into returning.

"The lion befriended the ass, who grew so relaxed that he became easy prey. When the lion had killed him, he told the fox, 'I am going to wash; then I will be back for the heart and the ears. Guard the body of the ass while I am gone.' Instead, in the lion's absence, the fox ate the heart and ears. When the lion returned, the fox said, 'Oh king, if the ass had a heart, which is the seat of the brain, or ears, which are the center of hearing, he would not have walked into his own grave.' "

When the monkey finished, he said to the tortoise, "I tell you this story so you will understand that I had the heart and ears to discover your treachery."

Thus "fortune helps us to obtain what we need, but keeping it requires wisdom and caution." (Minuvi, 245–57)

Clutching the ass's neck, the sly fox crouches low to steady himself; as a further precaution against falling, he holds the ear of the ass in his mouth to steer him (this alludes to the denouement, when he robs the lion of his choice morsel). Oblivious to the impending danger, the ass lopes through the countryside, eyes closed, nostrils flared, and mouth agape. The forward thrust of his ear, like his thoughts, tends toward the paradise to which he believes the fox is leading him. Hiding behind a rock beside a river, the lion crouches, ready to spring. His predatory nature contrasts markedly with the trusting naiveté of the ass.

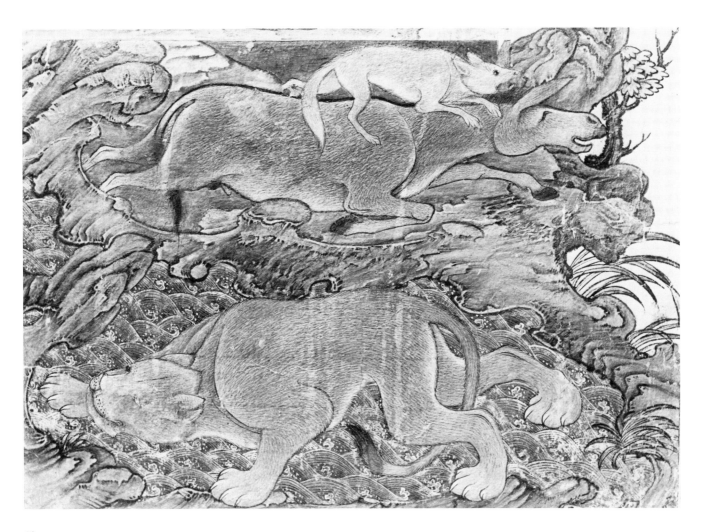

48
"The Ass and the Fox En Route to the Lion"
(IUL f. 25) 21 × 20.4 cm
(color pl. XIX)

The landscape is arranged according to the ancient compositional device of superimposed registers where the figures themselves define the horizontal planes. Headed in opposite directions, the animals are nevertheless engaged in a circular patterning of forms: suspense is maintained, but the repetition of semicircular motifs makes their meeting imminent.

The alternating browns and grays integrate the figures and draw attention to the fox. The ass moves through a barren, earth-toned landscape, while the tawny

lion haunts the more mottled riverscape that makes reference to the later unillustrated passages of the story. The small crouching fox stands out boldly, and is silhouetted against a dark sliver of sky that accentuates his aggressive nature. His pointed snout is reiterated by the sharp corner of the text block above.

Although the landscape is arranged in registers, the design is invigorated by the profusion of modeled, fragmented planes, the animated texturing, and the repetition of color. Foreground and background are also subtly connected by an implied central axis formed by the tip of the lion's tail and the line running between the hoof of the ass and the fox's rear; the circular motion of the animals revolves around this axis.

By portraying the moment before the climax, when the lion has yet to make his deadly assault and the fox to enjoy his meal, the artist visually deprives the fox of his reward for double deception.

The Chapter of the Trapped Cat and the Mouse

The Frightened Mouse and the Trapped Cat

The Raja said, "Tell me now the story of one surrounded by enemies; how should one placate them, if not with friendship? Teach me the meaning of peace, and how it is won." The Brahman answered, "There are many long-time friendships that suddenly turn to hostility. In the same way, old hostilities and inherited feuds may disappear in a moment of kindness. Thus one may protect himself from harm by accepting an enemy's request for reconciliation, as happened in the case of the mouse and the cat.

"Under a tree were two holes, the homes of a cat and a mouse. One day the cat caught himself in a trap set near the tree. When he saw the cat ensnared, the mouse rejoiced, but suddenly looked to one side and saw a weasel stalking him. When he looked back at his hole under the tree, he noticed an owl about to swoop down and carry him off.

"The mouse realized that if he retreated, the weasel would attack him; if he stood still, the owl would catch him; and if he continued on his way, he would encounter the cat. Despairing, he decided that his best option was to make a truce with the cat, so he called out, 'Ordinarily, I would rejoice at your difficulties, but today I share your predicament, and I think your salvation depends on mine. You see the weasel and the owl, who prey on me; they are afraid of you. If I gnaw your trap open and free you, will you promise me safety?' The cat responded happily, 'Your words are just, and I accept the exchange of aid.' Watching this scene, the weasel and owl realized that they had lost their prey and left." (Minuvi, 266–68)

134

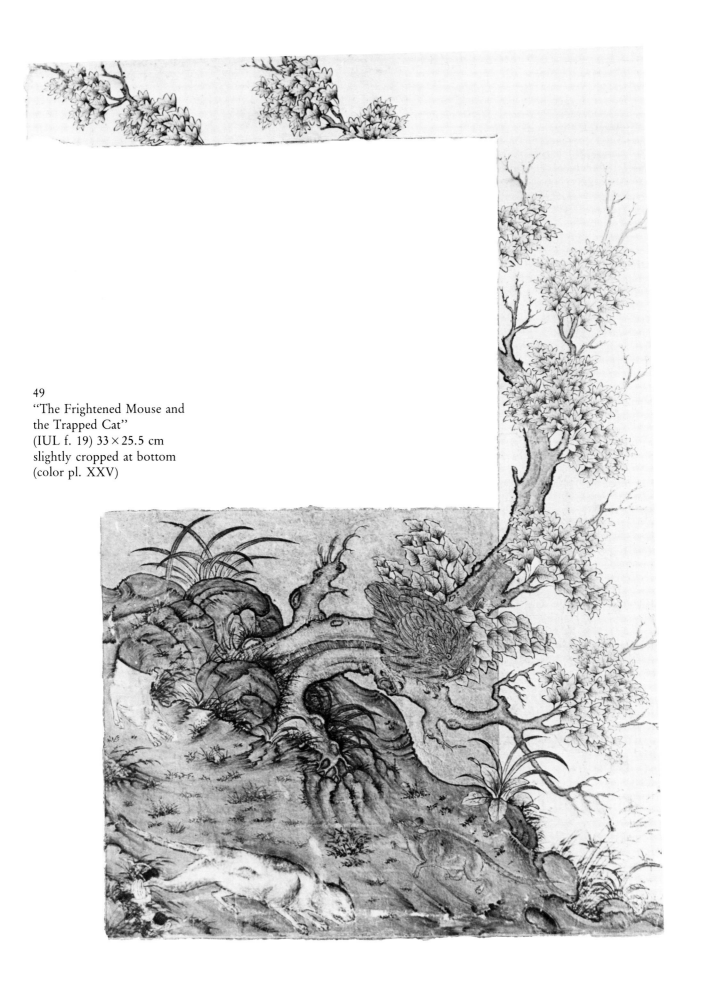

49
"The Frightened Mouse and
the Trapped Cat"
(IUL f. 19) 33 × 25.5 cm
slightly cropped at bottom
(color pl. XXV)

This pair of scenes illustrates the mutual benefit of reconciliation with one's enemy—but makes the warning clear not to confuse reconciliation with friendship. Transfixed with fear, the mouse crouches above the opening of his hole. Menaced by the predatory owl, perched directly above, and by the weasel (a poorly painted, phantomlike creature emerging from a cluster of rocks), the mouse is oblivious to his natural enemy, the cat. Ironically, it is the rodent's traditional enemy who presents no immediate threat, for the cat's eyes are turned not on the mouse (as are the eyes of the others), but in the direction of escape as he lunges to free himself from the trap.

The figures are ingeniously grouped to intensify the drama and focus on specific relationships. The four animals form a conventional square—the two enemies mark the top register, and the two soon-to-be allies the bottom.[66] Within this square, however, the threatened mouse faces his enemies diagonally: the mouse, weasel, and owl form an inner triangle, reinforced by the diagonal of the cat, that reflects their charged interaction. These configurations help to unify and dramatize a composition in which each of the figures occupies a modified, even personalized setting: the pale weasel takes shape from the curvature of the intensely colored blue rocks; the owl is perched among leafage whose texture and pattern mirror his wings; the outstretched spotted cat moves on an elongated patch of semé ground; and the mouse is confined by the contours of the landscape. Behind him, the hole—and safety—is inaccessible; before him are the menacing, clawlike roots of the old plane tree.

Despite a diversity of landscape elements, the painting as a whole is unified. Blue rocks and windswept grasses, which might fragment the space, merely punctuate the single earth-colored ground plane. On the steep hill, a towering bent *chinar* depicted with Chinese mannerisms[67]—grasping roots, a prominent cleft trunk (split by a boulder), and an oppressive overhanging branch—dominates the action and intensifies the mouse's peril.

The sweep of the curved tree gives the painting an asymmetrical format. Yet the design is perfectly balanced, achieved by the tree's rise into the upper margin and the shape of the text block.

The Escape of the Cat and the Mouse

The Brahman continued, "The wise consider the works of the Prophet in these circumstances: to love one's friend but with caution, lest one day he becomes an enemy, and to treat one's enemy with respect, lest one day he becomes a friend.

50
"The Escape of the Cat and the Mouse"
(IUL f. 20) 35 × 20 cm
trimmed
(color pl. XXIII)

"The mouse began to gnaw at the trap, but so slowly that the cat said, 'I thought you were eager to help me, but now that you are safe you have grown defensive. Our agreement has put an end to the hostility between us; make haste to fulfill your promise.' The mouse replied, 'To one who violates an oath, I wish the worst. But the clever help their friends with a measure of caution. To ensure my safety, I will gnaw all the cords but one; I will free that last knot when your mind is on something other than me.'

"The cat agreed, and they stayed together throughout the night. When morning came, the hunter appeared. Then the mouse freed the cat, who fled up the trunk of the tree, while the mouse ran into his hole. The hunter found the open trap and left in despair.

"The cat from his perch in the tree said, 'Why can't we be friends?' The mouse replied, 'We were friends only as long as it suited us both. Now we must go back to our natural state, that of enemies.' " (Minuvi, 268–73)

Now freed, the cat flees up a tree; wrapping his body around its trunk, he turns to watch the hunter from the safety of the margin. Directly below, the resourceful mouse burrows his way to freedom in the margin. The perplexed hunter bends over his empty trap, turning his head in disappointment as he retrieves the animal bone he used as bait and the gnawed cord.

The setting is strikingly similar to the previous one, which portrays an earlier moment in the story. Though slight, the differences between them are significant. In (49), where both the cat and the mouse are in danger, the landscape has an agitated, threatening character; in the sequel, the flattened profile of the hill and smoother terrain evoke a calmer, more auspicious mood. Chirping high in the margin, the blue songbird, an addition to the text, is also emblematic of the ending, when prudent behavior leads to the joy of freedom.

The composition, too, is simpler and more harmonious. Where intersecting diagonals structure the preceding painting, here the inclined body of the hunter is aligned with the bent tree to form a single, strident diagonal. However, the hunter's red coat and awkward movements accentuate his disharmony with nature and with the white cat and gray mouse, who blend into their surroundings.

These two paintings are paired to form a single chapter; the conclusion, when natural enemies under duress cooperate for mutual benefit (not included in any previous versions), must have had particular appeal during the tumultuous years of the late IlKhanid period.

The Chapter of the Lark and the Prince

The Lark and the Blinded Prince

The Raja said, "Now tell me the story of two individuals who were vengeful and become mistrustful of each other. Is it better to shun the ruthless man or to befriend him if he asks for our friendship?" The Brahman answered, "A lark's chick and a queen's baby were raised together as playmates inside the palace. One day, while its mother was absent, the young lark hurt the prince. Forgetting their friendship, the prince threw the bird to the ground, killing it. When the lark's mother returned, she cried out, 'Woe to him who befriends the ruthless. Such faithless friends punish one's smallest error, while ignoring their own faults. I will have my revenge.' The mother lark blinded the prince.

"When the king learned of the incident, he wept with anger and was resolved to cage the lark. The king thought that the lark, imprisoned, would surely die like the fool who fails to anticipate the consequences of his actions. The king called to the lark and promised her amnesty. She answered, 'Wrath, when it reigns in the heart, leaves no place for harmony and engenders more disaster. It is impossible for me to come to you because you have made me lose what is most dear to my heart. Circumstances have separated us beyond reconciliation. You will live only in my memory and in the news the morning breeze brings to me.' Then she flew away, leaving the king angry that he could not take revenge." (Minuvi, 283–303)

Rather than depicting the culmination of this story—the mother lark's rejection of the king's flattery—this scene emphasizes the impossibility of escaping from punishment, even for royalty. The prince's transgression appears the more serious because he is shown as a mature character. In a manuscript so tightly supervised, such an unflattering portrayal of royalty would not have been included if the work had been commissioned by the ruler or his family.

Having blinded the young prince, the mother lark (actually a more colorful pheasant)[68] takes flight, twisting her scarlet head to look back at her victim. Prone and helpless, the prince supports himself awkwardly on the palms of his open hands; raising his bloodied eyes toward the bird, he strains to see what he no longer can. Pathetically, he runs his fingers over the grout of the tiles to orient himself—an ingenious detail that captures, as does his poignant pose, the full measure of his punishment. The addition of the horrified queen, who does not appear in the text, and of her dramatic gesture, calls attention to the prince's mutilated eyes and humanizes the agony of the mother lark.

While the lark flies freely toward the safety of the margin, the prince and

51
"The Lark and the Blinded Prince"
(IUL f. 10v) 24 × 16 cm
sides and lower edge cropped;
dado tiles overpainted

queen are confined within an architectural setting, devised to dramatize the text. The prince is bounded on the terrace by a tiled wall and a wooden-grille fence, but an opening in the latter accentuates his vulnerability, exposing a steep incline (seen more clearly in the uncropped Rampur copy) and a garden pool. The ash trees in the margin may reflect the ages and relationships of the central figures; the Rampur copy also makes it clear that they accentuate the ascendant path of the lark and the relative limitations of the queen and her son.

The prince, queen, and lark form a triangle, a configuration which effectively reflects the emotional web into which the prince's heartless act has thrown them. The prince, at the apex of what is the only equilateral triangle of the cycle, has brought suffering on the mother lark, and she, in turn, on him. Furthermore, the bird's grief is equated with the sorrow of the queen, also—albeit indirectly—caused by the prince. Thus the painting demonstrates the ramifications of ruthless action by an impetuous prince and emphasizes the inevitability of punishment—even for those of royal blood.

The Chapter of the Lion-King and the Ascetic Jackal

The Ascetic Jackal and His Brothers

The Raja said, "I have heard the story of the enemy whom one should never trust. Now tell me about the king whose advisors conspire against one another but make their peace once their actions are brought to light. Do you think the king should continue to rely on them?" The Brahman replied, "If kings do not forgive their subjects' minor intrigues, they only make matters worse. It is said that in India there was a saintly vegetarian jackal. His fellow jackals complained that his behavior isolated him, and that he suffered needlessly, since death would take no note of his virtuous life. To this, the jackal replied, 'My friends and brothers, the only value of this sinful and deceitful world is the opportunity it affords to prepare for the next. Be content with whatever you can gain without tormenting others.' His words spread across the land.

"The jackal soon became the lion-king's closest advisor. The king's other advisors became very jealous, and conspired to slander the jackal; they were successful in rousing the king's anger. It was not until the lioness advised her son that he realized that he had been duped. After promising the jackal that he would punish traitors and not let storytellers corrupt his mind again, he restored the jackal to his position of power." (Minuvi, 304–305)

141

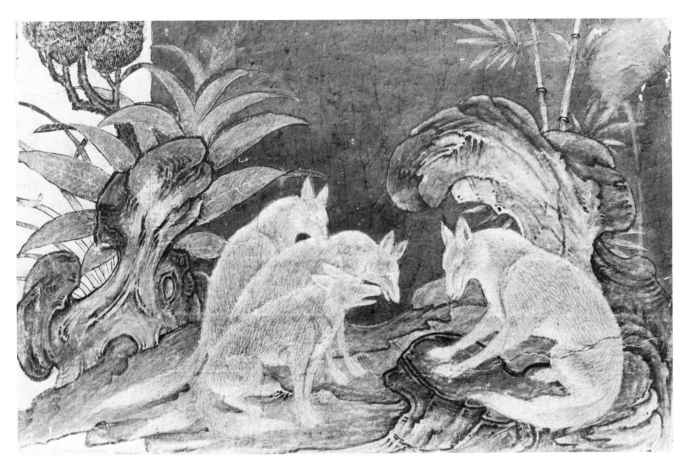

52a
"The Ascetic Jackal and
His Brothers"
(IUL f. 19) 12.5 × 17 cm
left and upper edges cropped;
bamboo at right added;
sky at right retouched
(color pl. XXIV)

52b
(TKS H.363 f. 183)

The moral of this story, which advocates abstaining from aggressive acts in favor of peaceful coexistence, is reinforced by the addition to Nasr Allah's text of the line reading, "In all cases one should observe moderation and follow the commands of the Lawgiver." This scene appears in only one earlier version of the *Kalila wa Dimna*,[69] and its inclusion here is even more notable for the particular emphasis given to the pious jackal, which departs from the literal text. As the only illustration for this chapter, this scene is also not representative of the main story.

Elevated on a rock throne, the saintly jackal sits, head humbly bowed, opposite his three carnivorous brothers. The trio berate the vegetarian for his ascetic habits; the jackal in the foreground with his mouth open and ears thrust back leads the criticism. The surfacing of the light underpainting used for markings gives the jackals a more bland expression than they would have had originally.

The painting exaggerates the ascetic's righteousness, not only by the elevation of his character, but also by the configuration of the landscape, which heightens the impression of the animals' opposing natures. The three carnivores are grouped on open terrain, a jagged border framing them from behind; its thrusting projection and the jackals' exposed position mirror their aggressive characters. The ascetic jackal is embraced by a curving rock whose formation, like the animal's prayerful, self-contained pose, reflects his contemplative nature.[70]

52c
(Cairo 1343/44 f. 81v)

A correspondence between this scene and "The Father's Advice" (8) is established by both the similarity of subject matter and the grouping of figures. Whereas the "path of knowledge" is exemplified by the teaching role of the merchant-father in (8), the ascetic jackal incarnates the harmonious state that is revealed by the spiritual path of wisdom. This is in sharp contrast to the depiction of the scheming, bloodthirsty jackal, Dimna, at the beginning of the cycle.

The Chapter of the Lioness and Her Dead Cubs

The Lioness Laments Her Dead Cubs

The Raja said, "I have just heard a story telling of violence and betrayal, separation, punishment, and finally reconciliation between a king and his subject. Now tell me about the man who avoids harming other people or animals to protect his own soul." The Brahman replied, "A wise man does not do to others what he would not like done to himself. Actions always bring reward or punishment. He who conceals wrongdoing under a veil of hypocrisy should know that the truth will come out, and he will finally be chastised and cleansed.

"One day a lioness left her two cubs in a field while she hunted. On her return, she found that her children had been killed and then skinned by a hunter. An old jackal heard her mournful crying and said to her, 'In all circumstances, you must accept your heavenly fate. For whatever ill the hunter has done you, you too have caused the tears of other animals. Do you think that those whose meat you have hunted for so many years lacked parents or dear ones to mourn their deaths?'

"The lioness took the jackal's words to heart, and henceforth ate only fruit. But the jackal, who himself lived on fruit, then told her angrily, 'Those who depend on the fruit of this tree will soon perish because they must now share it with such a huge and hungry creature.' On hearing this, the lioness gave up all worldly pleasures and lived out her life in prayer." (Minuvi, 334–37)

In this painting, a jackal and a lion are the central figures, as in the first scene of the cycle. Unlike the crafty Dimna, however, the jackal shown here is a wise and virtuous subject who urges his royal master to adopt a selfless way of life.

Crying for her skinned whelps, the lioness throws her head back toward the sky while her body rests limply on the ground. Her curved tail encircles the jagged, ruddy ridge on which the pathetic whelps lie and in which howling

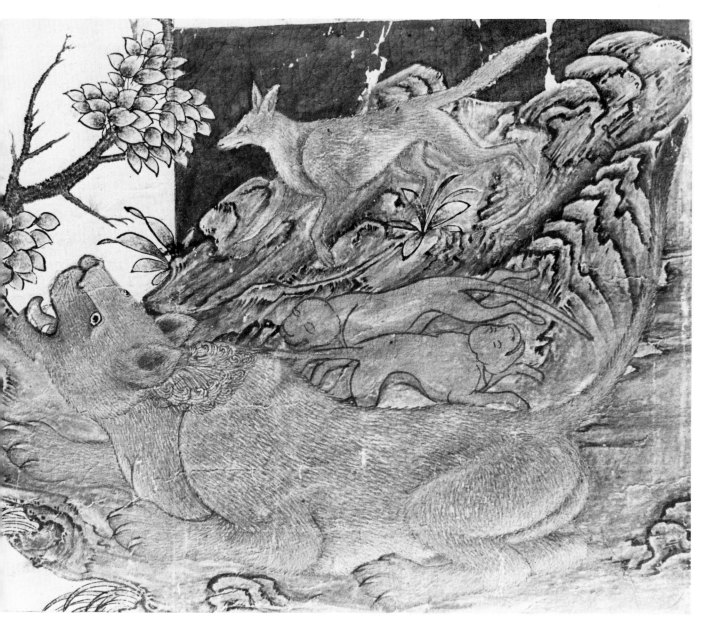

53a
"The Lioness Laments Her Dead Cubs"
(IUL f. 20) 18.5 × 18 cm
cropped along left and right
(color pl. XXII)

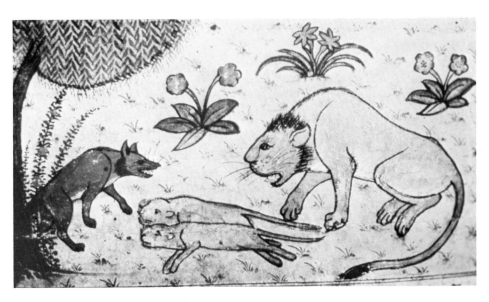

53b
(Cairo 1343/44 f. 88)

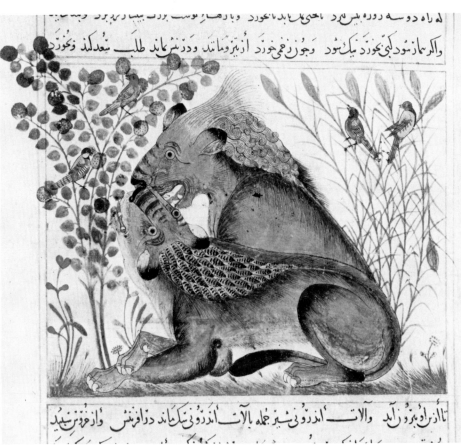

53c
"The Lion and His Lioness"
(*Manafi al-Hayawan*
[Ms. 500, Pierpont Morgan
Library] f. 11)

146

skeletal-like forms are etched into the receding planes. Attracted by the lioness's moaning, the benevolent jackal trots down the hill, his head held high and his ears and tail raised alertly.

The dramatic consequences of the imminent encounter of the lioness and jackal are borne out compositionally. The jackal and blue hill descend to intersect with the angle of the lioness's head; her anguished face is the focal point. The two animals are also linked visually—as their fates will be—by the foliage of the fruit tree framing their heads. While the jackal moves freely, the lioness is weighed down by her surroundings. Angular, uneasy forms reverberating in the lower landscape contrast with the rounded terrain that conveys the jackal's piety.

The lioness's nearly anthropomorphic pose merits consideration. The arc of her prone body recalls the pose of the treacherous madam (14), though its grace stands in marked contrast to—even mocks—the ungainly posture of the old prostitute. The actual description of the lioness, including the thrust of her upturned head, probably is derived from a model reminiscent of the lion-couple illustrated in the *Manafi* (53c). Although the *Kalila wa Dimna* lioness is more finely modeled and textured and her anatomy more fluent, her pose and profile, the flap of skin that describes her nose, and her stylized mane are like those of the *Manafi* painting.

The Chapter of the Ascetic and His Guest

The Crow Imitates the Partridge

The Brahman said to the Raja, "Those people who abandon their inherited tradition and work in a profession unsuitable to their background will be thrown into confusion and regret. There once lived an ascetic who strove conscientiously to meet the requirements of his faith. One day a traveler came to his house, and the ascetic was delighted to offer his hospitality.

"The guest discovered that the ascetic spoke Hebrew, a language which he longed to know, and he asked the ascetic to teach him. The ascetic agreed, but the guest found that the task of learning the language was painfully hard. Finally, the ascetic said, 'Learning Hebrew is a very difficult undertaking. One who forsakes the language of his ancestors in order to learn another is not likely to succeed.' The guest replied, 'Relying on foolish ancestors demonstrates more foolishness, whereas acquiring new knowledge is a sign of wisdom.' The ascetic answered, 'I am afraid that your efforts will end badly, like those of the crow who envied the gait of the

54
"The Crow Imitates the Partridge"
(IUL f. 24v) 16 × 9.8 cm
cropped along right side and left margin;
fragment of margin's sky repositioned above painting

partridge. Although he followed the partridge for some time and imitated his harmonious movements, he could not learn them. After a time, the crow forgot how to walk in his own fashion. I tell you this story to show you that you will not only forget your own language, but also fail to learn Hebrew.' " (Minuvi, 340–42)

This scene is an appropriate conclusion to the cycle, as it reflects the patron's faith in one's ability to achieve, through inherent wisdom, the ultimate stage of the mystical absolute—the "stage of nothingness." The narrative of this painting—the merits of adhering to one's innate knowledge—must also have held particular interest for the patron of this manuscript, an erudite member of the Persian elite whose own traditions were being threatened by the alien Mongol culture.[71]

At the left, the graceful partridge (appropriately enough, a Persian *chukar*) strides effortlessly toward the expanse of the margin. The crow shadows him; his head, however, is held unnaturally high, and his weight falls backward, forcing him to balance absurdly on the heel of his talon. The somber crow not only is clumsy and out of step, but also is making a fool of himself.

The ground of this world is closely associated—by color, shape, and proximity—with the eternal realm. The partridge's gray oval body, laced with white breast markings, echoes the terrain and the forms of the rock and blooming rock-rose of the margin; the partridge is in harmony with both the physical world and the ideal to which he is drawn. His imminent flight represents the final attainment of the release of the soul from the earthly body. This eternal bliss is celebrated by the billowy clouds ascending to the ideal world.

NOTES

Introduction

1. Wood, *"Kalila and Dimna,"* xiv.

2. See J. Carswell's article in a forthcoming issue of *Ancient Ceylon;* see also Raby, "Between Sogdia and the Mamluks," 391–92, fig. 21. I am grateful to the author for showing this informative work to me prior to publication. This Jataka tale also appears in Indonesian temple carvings of the eighth and ninth centuries.

3. This is only one such example. As Jataka tales, many of these stories were widely illustrated on Indian Buddhist sculpture from the second century B.C. on.

4. Dikshit, "Excavations at Paharpur, Bengal," 63ff.; Raby, "Between Sogdia and the Mamluks," figs. 17 and 18.

5. Kramisch, "A Painted Ceiling," 175–82; Agarwala, *Wall Paintings from Central India,* 45–49.

6. Belenitski and Marshak, "L'Art de Piandjikent"; for most recent bibliography, see Raby, "Between Sogdia and the Mamluks." Besides suggesting evidence for the influence of those Soghdian wall paintings on Ayyubid and Mamluk versions of the *Kalila wa Dimna,* Raby believes that there was an unbroken tradition of illustrating these fables from the sixth through the fourteenth century.

7. See Ettinghausen, "Persian Elements," and Raby, "Between Sogdia and the Mamluks."

8. See Ettinghausen, "Persian Elements," figs. 7–14. See also Raby, "Between Sogdia and the Mamluks," who quite rightly argues that these paintings were patterned after Arabic models that predate the tenth century. Both authors contend that Ibn Muqaffa and Nasr Allah tell of the existence of accompanying illustrations. However, the texts that they cite are questionable. An introduction, supposedly written by Ibn Muqaffa, appears only in an eighteenth-century corrupted text quoted in Cheiko, *La Version arabe de Kalilah et Dimnah,* 51–52, and in Sacy, *Kalila et Dimna.* This does not appear in Miquel's translation of the earliest known version, the 618/1221 *Kalila wa Dimna* in the Library of the Aya Sofia, Istanbul. Raby also discusses, in n. 26 of his article, the inclusion of illustrations in Nasr Allah's earlier metrical version of the *Kalila wa Dimna.* However, there is no mention in Nasr Allah's prose version of this, which otherwise is thorough in its account; see Minuvi, *Kalila wa Dimna.* I am grateful to Professor E. Yar Shater for lending me this book.

9. In-depth studies of this group of manuscripts have unearthed complex interconnections; see Atil, *"Kalila wa Dimna,"* for up-to-date bibliography, and Haldane, *Mamluk Painting,* for full description. The influence of the Mamluk school even surfaces in a Gujarati *Kalila wa Dimna* (Metropolitan Museum of Art 1981.373) of the mid-sixteenth-century Sultanate period.

For illustration and discussion, see Welch, *India,* 137–39 and fig. 81. Çağman and Tanindi deal with the Mamluk influence on the Turkish 974/1566–67 *Humayunnama,* made in Cairo (TKS H.359) *(The Topkapi Saray Museum,* 48, n. 9).

10. An incomplete and widely dispersed cycle, frequently appearing at auction. See Cowen, "An Il-Khanid Masterpiece"; Gray, "Fourteenth-Century Illustrations"; and Grube, *Muslim Miniature Paintings,* 38–39. For comparison and illustration of the 1333 *Shahnama,* see Adamova and Giuzallian, *Miniatiury Rukopisi Poemy "Shahname" 1333 Goda.* The 1307/8 *Kalila wa Dimna* in the British Library appears on stylistic grounds to be a precursor of the Inju school (see Waley and Titley, "An Illustrated Persian Text"), but, on the grounds of its distinctive turban styles and iconographic dependence on Arabe 3465, it merits consideration with the *Kalila wa Dimna* cycles of the Mamluk school. Its provincial character and choice of scenes to provide embellishment rather than interpretation throw no new light on the non-Mamluk tradition of illustrating these stories. See Cowen, "An Il-Khanid Masterpiece," for discussion of the choice of scenes illustrated.

11. Karatay, *Topkapü Sarayi Kütüphânesi,* 302; Öğütmen, *Miniature Art,* 8; Ipşiroğlu, *Das Bild,* 37; Waley and Titley, "An Illustrated Persian Text," 54; Barrucand, "Les Représentations d'architectures"; Çağman and Tanindi, *The Topkapi Saray Museum,* 48, n. 8.

12. For discussion and bibliography, see Cowen, "Drama and Morality."

13. Only a few of its illustrations have been published. See Gangoly, "An Illustrated Manuscript of *Anvar-i-Suhaili.*" For discussion, see Stchoukine, *La Peinture iranienne,* 102; Holter, "Die islamischen Miniaturhandschriften," 24, fig. 65; Grube, *Persian Painting in the Fourteenth Century,* 32; and Schroeder, "Ahmed Musa and Shams al-Dīn," 126, n. 63a. Promod Chandra of Harvard University is publishing this manuscript in his catalogue on the Nawab Collection of Rampur. The *Kalila wa Dimna* (Ms. 2982) consists of 134 folios and measures 26.8 × 17.5 cm (about two-thirds of the size of the Mongol *Kalila wa Dimna*).

14. For further discussion of the East–West connections that flourished in Tabriz, see Boyle, "The Il-Khans of Persia." For excellent background and bibliography, see Boyle, *The Cambridge History of Iran,* vol. 5; Howorth, *History of the Mongols;* and Spuler, *Die Mongolen in Iran.*

15. Wilbur and Minuvi, "Notes on the *Rab'-i-Rashidi*"; Blair, "Il-Khanid Architecture and Society."

16. For latest bibliographical references, see Rice and Gray, *The Illustrations to the "World History";* Gray, *The World History;* and A. Welch, "The Arts of the Book." See also Allen, "Byzantine Sources." For illustrations added to this text

later, see Inal, "Some Miniatures from the *Jāmi' al-Tavārīkh*." Rogers suggests that fragments in the Diez Berlin album were originally the illustrations to the *Tarikh-i Mubarak-i Ghazani* painted in an early-fourteenth-century Mongol milieu; see his "Note on Iconography." For more extensive reading on these and other Mongol works, see Rohani, *A Bibliography*.

17. Soucek, "An Illustrated Manuscript of al-Biruni's *Chronology*."

18. Ipşiroğlu, *Saray-Alben;* Atasoy, "Four Istanbul Albums," especially her group IV. For extensive bibliography, see Grube, *Persian Painting in the Fourteenth Century*.

19. Ettinghausen, "Persian Ascension Miniatures," 360–83.

20. Grabar and Blair, *Epic Images and Contemporary History*.

The Manuscript

1. As noted on folio 3 of the album. For discussion of Shah Quli Kalifa and his dates of office (1533–58), see Dickson and Welch, *The Houghton Shahnama*, 270.

2. Lines of text in the Istanbul cycle can be found attached to the following illustrations in F.1422:

"The Clever Merchant and the Gullible Thief" (4)	3 lines, f. 24
"Man's Fate" (6)	1 line, f. 25v
"The Old Madam and the Young Couple" (14)	1 line, f. 11v
"The Fate of the Go-Between" (16)	1 line, f. 21
"The Rogue and the Simpleton" (24)	1 line, f. 28v
"The Hunter Pursues the Tortoise" (31)	1 line, f. 10
"The Crow Spy" (36)	2 lines, f. 6
"Kardana and the Tortoise Become Friends" (44)	1 line, f. 19v
"The Tortoise Ferries Kardana" (45)	2 lines, f. 22v
"Kardana's Escape" (46)	1 line, f. 19v
"The Ascetic Jackal and His Brothers" (52)	1 line, f. 19

The album comprises eighty-nine numbered folios, each of which measures 47.9 × 34.5 cm, and two additional numbered pages. The album has a magnificent Safavid lacquer-painted binding with a sumptuous gold-tooled doublure.

3. The identified paintings and fragments are "The Fool and the Well" (Rampur, p. 25); "The Go-Between and the Shoe-maker" (Rampur, p. 51) (fragment IUL f. 10); "The Crab Kills the Heron" (Rampur, p. 56); "The Dead Hunter and the Wolf" (Rampur, p. 114); and "The Tortoise Ferries Kardana" (Rampur, p. 74) (fragment IUL f. 22).

4. Schroeder says that the miniatures are "executed in a Tahmaspi technique, especially evident in the foliage" ("Ahmed Musa and Shams al-Dīn," 126, n. 63a), and Grube says that without seeing them he cannot determine whether Schroeder is correct or whether the paintings are another fourteenth-

century work, partly restored in India (*Persian Painting in the Fourteenth Century,* 32). For further discussion, illustrations, and bibliography of the Shaybanid style, see Robinson, "A Survey of Persian Painting," 13–14, 60–64, and Ashrafi-Aini, "The School of Bukhara," 249–72. For extensive treatment of the Shaybanid style, applied to specific miniatures, see Cowen, "An Il-Khanid Masterpiece," the intent of which is to serve as a basis for further study of the Rampur cycle. My study was based only on photographs because the outbreak of civil conflict in 1980 prohibited an extended trip to Rampur.

5. According to Ghazi Ahmad, Mawlana Sultan Muhammad ibn Nur Allah was "known everywhere" as Muhammad Nur; see Minorsky, *Calligraphers and Painters,* 134. I thank Basil W. Robinson for providing the dates and locale. The colophon of the 1524/25 *Khamsa* of Nizami in the Metropolitan Museum of Art is signed by Sultan Muhammad ibn Nur Allah, which, on the stylistic basis of its paintings, suggests he penned in Herat. See Chelkowski, *Mirror of the Invisible World*.

6. In fact, almost all later Mongol-related dynasties paid homage to their IlKhanid forefathers by commissioning their own illustrated copies of the *Kalila wa Dimna* and *Shahnama*. For related material on the former, see Robinson, "Prince Baysunghur" and "The Teheran Manuscript of *Kalila wa Dimna*," and Grube, "Two *Kalilah wa Dimnah*," 115–22. For discussion and fine illustrations of the *Kalila wa Dimna* in the Gulastan Palace Library, see Gray, *Persian Painting*. See also (and for color illustrations) Grube and Sims, "The School of Herat," 156–57, figs. 91, 92, and 93, and pls. xlvii, xlviii, and xlix; Golombek, "Toward a Classification," 24, fig. 2; and Hourani, "The Cycle of Miniatures."

7. For a history of the manuscript and its travels, see Hammer-Purgstall, *Geschichte des osmanischer Reiches,* 517–22, and Dickson and Welch, *The Houghton Shahnama,* 270. For a contemporary (circa 1581) illustration of the Persian emissaries' presentation of such an album to Murad III, see Atasoy and Çağman, *Turkish Miniature Painting,* pl. 18. In Turkey the *muraqqa* was taken to the imperial harem in the Topkapi Saray in 1682; Sultan Abdul Hamid II (1876–1909) added it to the Yildiz Collection (hence it has been known as the Yildiz *Kalila wa Dimna*); and, under his program of decentralization, Kemal Atatürk removed it to its present location, the Istanbul University Library, in 1925. See Atasoy, "Istanbul Universitesi Kütüphânesi."

8. This is based on the height of the three extant lines of "The Clever Merchant and the Gullible Thief" (4).

9. Dr. H. Aksu, former librarian of the Istanbul University Library, has compiled an extensive, as yet unpublished, index of the contents of the *muraqqa* (IUL F. 1422).

10. The manuscript used is Minuvi, *Kalila wa Dimna,* in the Jar Allah Library, Effendi no. 1727. This constitutes the most

reliable critical edition in Persian of Nasr Allah's text. See also Mahjoub, *Darbarah "Kalila wa Dimna."*

11. For discussion of the *Panchatantra* and its subsequent *Kalila wa Dimna*, see Edgerton, *Panchatantra Reconstructed;* and for a comprehensive history of the text, with particular emphasis on the *Kalila wa Dimna* and extensive bibliography, see Brockelmann, "Kalila wa-Dimna," vol. 4, 503–506. See also Penzer, *The Ocean of Story,* vol. 5.

12. See Edgerton, *Panchatantra,* 11, 23.

13. Edgerton claims that this lost Pahlavi translation preserved 80 percent of the original Sanskrit prose and more than 70 percent of its verses (*Panchatantra,* 25, n. 3); also see Chand and Abidi, "*Panchākhyāna,*" 240, n. 9.

14. For the Manichean derivations of the *Kalila wa Dimna,* see Boyce, "Middle Persian Literature." The bawdy humor of "The Old Madam and the Young Couple," for example, strongly suggests folk origins. A contemporary sixth-century collection of beast fables, the *Marzubanama,* also sheds light on the sources of the *Kalila wa Dimna;* see Levy, *The Tales of Marzuban,* 14.

15. Gabrieli, "Ibn al-Muḳaffaʿ," 883–85. Although not a single word of Ibn Muqaffa's original text remains, the best surviving version based on Ibn Muqaffa is Miquel, *Le Livre de "Kalila et Dimna."* See also Sourdel, "La Biographie d'ibn al-Muqaffa," and Brockelmann, "Kalila wa-Dimna," vol. 4, 503–506.

16. For a superlative discussion of Nasr Allah's life and work, see Minuvi, *Kalila wa Dimna.* For further literary analysis, see Arberry, *Classical Persian Literature,* 95–97; and for comparison with the *Anwar-i Suhayli,* see Browne, *A Literary History of Persia,* vol. 2, 349–53. Regarding sources on Nasr Allah's metrical version, see Raby, "Between Sogdia and the Mamluks," n. 27, and Minuvi, *Kalila wa Dimna.*

17. Minuvi, *Kalila wa Dimna,* 18.

18. Ibn Muqaffa is also credited with writing his own "mirror for princes," the *Adab kabir,* one of the earliest Arabic *Fürstenspiegel,* which draws on such earlier literary sources as the Persian *andarz* as well as on the author's own experience. See Gabrieli, "Ibn al-Muḳaffaʿ," 884–85. Another example of this genre is the *Qabusnama.*

The Mastery of Illustration

1. Quoted by Esin, review of Gray's *La Peinture persane,* 385, 389, n. 21, which cites Tabari. See also Browne, *A Literary History of Persia,* vol. 2, 331–32. Although this story cannot be verified, it is interesting; a century before this, these stories were illustrated as the *Panchatantra* at Panjikent. See Raby,

"Between Sogdia and the Mamluks," nn. 28, 31, for references regarding Afshin Haydar and the art of this area.

2. See Qazvini, *Bīst Maqāla,* 33, for the Persian text; for an English translation, see Arnold, *Painting in Islam,* 25–26. In an early preface to the *Shahnama,* Firdawsi also confirms the story of Rudaki's version. Minorsky, "The Older Preface to the Shah-nama," vol. 2, 168. A Chinese princess did go to Bukhara to marry this Samanid Amir, and she could have brought Chinese artists in her entourage.

3. Hunt argues that its "Byzantinising" character is closely related to the slightly *earlier* BN Arabe 6094 *Maqamat* of al-Hariri, dated 1222/3 ("Christian–Muslim Relations," 142). The soft folds and use of color in Arabe 3465 mark "the first step in the move towards the hardening of the style in Copte-Arabe 1/Bibl. 94, and so associate it with the same workshop in Cairo in c. 1230" (137). In addition, Hunt notes that the "partial use of Coptic letters in the numbering system" of Arabe 3465 also "supports reattribution to Egypt" (137). Buchtal estimates that Arabe 3465 dates to around 1220 and concludes that it was probably illustrated in northern Syria itself, not just painted by cosmopolitan artists with close ties to the Syrian-Jacobite community (" 'Hellenistic' Miniatures"). For basic bibliography, see also Atil, "*Kalila wa Dimna,*" 67. These miniatures have been substantially retouched, remounted, and cropped, and eight of the ninety-eight paintings (appearing on ff. 2, 3v, 22, 25v, 138v, 139v, 141, and 143) were added at a later date.

4. See Golombek, "Toward a Classification," 23–24, and Cowen, "An Il-Khanid Masterpiece," for further discussion of the purpose of illustration in Arabe 3465. See also Seyler, "The School of Oriental and African Studies," for an interesting discussion of the importance of painting, which took precedence over the text, in determining page format and choice of scenes in a Mughal sixteenth-century version of these stories.

5. After this date, Iran and Mesopotamia were riddled by warfare and the Black Death, which help to account for the artistic decline during the mid-fourteenth century, as seen in the 743/1343-4 *Kalila wa Dimna* in Cairo and the 755/1354 *Garshaspnama* in the Topkapi Saray, H.674. See Ettinghausen, "On Some Mongol Miniatures," 44–51; for a more complete listing and bibliography, though not necessarily for conclusions, see Grube, *Persian Painting in the Fourteenth Century.* Although I disagree with his conclusion that the Istanbul *Kalila wa Dimna* is a Jalayirid cycle, I concur with his suggestion that many of the *Shahnama* album pages in TKS H.2152 (35 of Grube) constitute the middle ground between late IlKhanid court production and the mature Jalayirid style of the 1396 *Masnavi* of Khwaju Kirmani (British Library Add. 18113).

6. See Introduction, n. 10, for differing opinions on the TKS H. 363, with dates from the first half of the thirteenth century through the fourteenth century, and styles from Seljuk Baghdad to Mesopotamian schools; see Appendix for a list of published illustrations.

7. Although similar in details, the *Kalila wa Dimna* illustrates more complex personalities and specific situations than the *Warqa wa Gulsha*, painted in an earlier, free-flowing, abstract narrative style. One of its paintings is signed by the artist Abd al-Mumin ibn Muhammad of Khoy, a town located in northwestern Iran. See Ettinghausen and Grabar, *The Art and Architecture of Islam*, fig. 381, for illustration, and 407, n. 3, for references on the related figure-style in Seljuk ceramics. For the most complete discussion of this manuscript, see Melikian-Chirvani, "Le Roman de Varqe et Golšāh," and Daneshvari, *Animal Symbolism in Warqa wa Gulshah*.

8. For historical context, see Whelan, "The Public Figure," 33–34.

9. For full illustration and discussion, see Cowen, "Drama and Morality." For the *Manafi*, see Barasch, "Some Problems in the Manāfiʿ al-Hayawān," especially for identification of paintings contemporary with the text; Gray, *Persian Painting*, 19–23; and Ettinghausen, *Arab Painting*, 134–37.

10. For discussion of the use of images without text, see Shrieve-Simpson, "The Narrative Structure"; see also Atasoy, "Illustrations Prepared for Display," 262–72, and Yorukan, "Some Roll Fragments." Further evidence of the effect of oral tradition on pictorialization is the portrayal of Shanzaba not as an ox, but as a Persian fallow deer (*Dama mesopotamica*), native to Iran or Iraq. During mating season, this animal bellows in a deep and loud voice, which may explain its appropriateness as Shanzaba.

11. The connection between Aesop's fables and the *Panchatantra* may have influenced the scenes of Dimna's chastisement in the TKS H.2152, which merits further consideration. For discussions of the two texts and their assimilation in images, see Avery, "Miniatures of Bidpai"; Belenitski and Marshak, "L'Art de Piandjikent"; and Perry, *Aesopica*, 26ff.

12. For color illustration, see Ipşiroğlu, *Das Bild*, fig. 14.

13. Some of the most interesting discussions on the iconography of these frontispieces appear in Simpson, "The Role of Baghdad in the Formation of Persian Painting"; Ettinghausen, "On Some Mongol Miniatures," 47–51; and Esin, "Two Miniatures."

14. For illustration, see Barasch, "Some Problems in the Manāfiʿ al-Hayawān," ff. 13 and 14v, 18 and 18v, 19 and 20v, 24 and 25, 28 and 29v, 30 and 31.

15. Rice and Gray, *The Illustrations to the "World History,"* and Gray, *The World History*.

16. See Grabar and Blair, *Epic Images and Contemporary History*, 177–89.

17. The influence of this device on the choice and manner of representation is also an interesting issue. This occurs in the Muzaffarid *Kalila wa Dimna* (c. 1390), BN Pers. 377, frontispiece, ff. 1v-2 (illustrated in Stchoukine, *Les Peintures des manuscrits timūrides*, pl. 9). See Sims, "The Garrett Manuscript," 149–51, for a list of manuscripts from Shiraz and Herat with a double-page format. The pairing of images occurs throughout Jalayirid court painting, as in the 1405 *Divan* of Sultan Ahmad (Washington, D.C., Smithsonian Institution, Freer Gallery of Art, 32.35) (see Klimburg-Salter, "A Sufi Theme").

18. The Istanbul cycle forshadows the sensibility, in spite of the change of style and scale, of the 1396 *Masnavi* of Khwaju Kirmani and the 1405 *Divan* of Sultan Ahmad; for a sensitive discussion of the artistry of the *Divan*, see Klimburg-Salter, "A Sufi Theme."

19. See Schimmel, "The Celestial Garden in Islam," 11–39. Though it may not have precisely the same ramifications, paradisiacal imagery also occurs in the 1398 *Anthology* (Turkish and Islamic Museum, Istanbul, no. 1950); see Gray, "The School of Shiraz," pl. xxvi and 122, n. 11. Koranic paradisiacal imagery also inspired the placement of Mongol funerary structures in a garden setting—Rashid al-Din's in Tabriz and Oljeitu's in Sultaniya. For discussion of the use of this imagery as "places of ascent to Paradise (firdaws)," see Blair, "The Mongol Capital of Sultaniya," 145.

20. See Hanaway, "Paradise on Earth," 41–68. For the inner garden and Sufism, see Lehrman, *Earthly Paradise*, and Schimmel, "The Celestial Garden in Islam."

21. These artists did not seem to differentiate between roses and mallow roses, as both are imbued with the same symbolic significance. The rose is also a symbol of virtue in Western medieval literature (for example, *Roman de la rose*), a convention that probably derived from the East through the songs of troubadors and Provençal love poems.

22. This remains a little-explored area of scholarship in preTimurid painting; the ramifications of similar and related imagery have been discussed by Melikian-Chirvani, "Le Roman de Varqe et Golšāh"; Soucek, "An Illustrated Manuscript of al-Biruni's *Chronology*"; and Klimburg-Salter, "A Sufi Theme." For further discussion of Sufism, see Melikian-Chirvani, "Le Shah-name."

Artistry

1. The term "metropolitan" style was coined by Grube, in *The Classical Style*, and Robinson, in *Persian Miniature Painting*.

2. Binyon, Wilkinson, and Gray, *Persian Miniature Painting*, 184. For the Persian text, see Chaghtai, *A Treatise on Calligraphists and Miniaturists*. Abu Said's name appears at the beginning of the quote.

3. These measurements are based on the most complete paintings in the album, "The Clever Merchant and the Gullible Thief" (4) and "The Owls Attack the Crows" (33).

4. This format also enhances the dramatic tension between the lion and his interlopers. Grabar and Blair note that six of the fifty-eight Demotte miniatures break with the traditional square or rectangular shape to use a stepped format; two of the six also effectively strengthen the impact of a confrontation (*Epic Images and Contemporary History*, 14). Throughout the Istanbul *Kalila wa Dimna*, format is more consistently designed to maximize the dramatic impact. A stepped format occurs erratically in the paintings of the thirteenth-century TKS H.363, in the 1314/15 *World History*, and in some of the TKS H.2153 *Shahnama* album pages. It is used primarily to accommodate eccentric vertical elements.

5. See Grabar and Blair, *Epic Images and Contemporary History*, 36, n. 16, for citation of recent studies on the geometric grouping of figures. Also, for an examination of compositional arrangements of the Mongol period, see Stchoukine, *La Peinture iranienne*.

6. For illustrations, see Rice and Gray, *The Illustrations to the "World History,"* figs. 16 and 18, which are exemplary of the use of hierarchical isosceles triangles; the actual grouping of figures, however, is more integrated by patterns of gestures and eye contact than by geometric arrangement.

7. Figures positioned above, which help to focus attention on the central action, occur in Islamic manuscript paintings from the thirteenth century. See, for example, *The Epistles of the Sincere Brethren*, dated 1287, painted in Baghdad (illustrated in Ettinghausen, *Arab Painting*, 98–99), and Soucek, "An Illustrated Manuscript of al-Biruni's *Chronology*," 108, 119, 124, for other examples. Though used fairly commonly, these figures serve as a dramatic detail rather than as a dynamic compositional device. The *Kalila wa Dimna* artists elevate the voyeur to a position from which he actively organizes the composition. See also Grabar and Blair, *Epic Images and Contemporary History*, 59, 69, 75, 79, 87, and 91, for examples in the Demotte.

8. For a discussion of the use of the frame "not as an enclosure but as a pictorial milieu of the image," see Schapiro, "On Some Problems in the Semiotics of Visual Art," 11–12.

9. As seen in this Ching copy of the twelfth- or thirteenth-century painting *Ch'ing-ming chang-ho t'u* in the British Museum. For depiction on Chinese porcelain, see Saito, "The Yuan Blue-and-White and the Yuan Drama in the Middle of the 14th Century."

10. Schroeder, "Ahmed Musa and Shams al-Dīn," 127, n. 67.

11. For a discussion of space in painting from the Seljuk through the Mongol periods, see Barrucand, "Les Représentations d'architectures." For the Mesopotamian school, see James, "Space-Forms," and Grabar, "A Newly Discovered Manuscript of the *Maqāmāt*." For the Mongol period in particular, see Schroeder, "Ahmed Musa and Shams al-Dīn"; Gray, *Persian Painting*, 19–27; Ettinghausen, "On Some Mongol Miniatures"; and Inal, "Artistic Relationship Between the Far and the Near East."

12. See Grabar and Blair, *Epic Images and Contemporary History*, 16, for a notable discussion of "set pieces" and the significance of the lack of an embellished setting.

13. See Grabar and Blair, *Epic Images and Contemporary History*, 24ff.

14. This seems to be a *sub rosa* topic among Chinese art historians which merits thorough study. One accepted example is the devil-faced rocks in *The Long Roll: Sakyamuni Buddha; The Patriarch Kasyapa* (1173–76). For illustration, see Chapin, "A Long Roll of Buddhist Images." I am grateful to Professor John Hay for giving me this reference.

15. Daneshvari, *Animal Symbolism in Warqa wa Gulshah*.

16. See Travis, "The Battle of Ardavan and Ardashir."

17. For visual analysis of the archaistic use of Liao and Sung styles in Yüan and Mongol paintings, see Schroeder, "Ahmed Musa and Shams al-Dīn," 127, n. 67. Also see Cowen, "An Il-Khanid Masterpiece," for specific citations of Persian Mongol–Yüan stylistic associations, and Gray, "Chinese Influence in Persian Painting."

18. Although it is not certain which Chinese objects were known to the Mongols, it is certain that they acquired Eastern paintings. More common objects of trade, however, were textiles, lacquer toilet sets, writing sets, and colored woodblock prints. The last are notable for their decorative treatment of the T'ang and Sung styles and for their distortion of scale. See Lee and Ho, *Chinese Art Under the Mongols*, figs. 13, 286, and 306; Medley, "Sources of Decoration"; Rice and Gray, *The Illustrations to the "World History,"* viii–ix; Gray, *Persian Painting*, 36–37, and "Art under the Mongol Dynasties"; Inal, "Artistic Relationship Between the Far and the Near East"; and Loehr, "Chinese Elements in the Istanbul Miniatures." It is known that Chinese and Central Asian artists were employed by Rashid al-Din; their contributions were complemented by the frequent visits of Far Eastern embassies to Mongol courts in Iran. An embassy to Amir Choban arrived in 1326; in 1331, the Yüan ruler again sent a delegation to the Persian Mongol court. See also Rohani, "China," in *A Bibliography*, 151. Yüan painting at Tun Huang has a highly decorative style, especially noticeable in the treatment of vegeta-

tion. Provincial Buddhist wall painting of Central Asia was undoubtedly one of the main influences.

19. The most significant discussions are to be found in Grabar and Blair, *Epic Images and Contemporary History*, 199, n. 26, and Grube, *Persian Painting in the Fourteenth Century*, 29ff. See also Edhem and Stchoukine, *Les Manuscrits orientaux*, 42, fig. 34, and Stchoukine, *La Peinture iranienne*, 102. See Appendix.

20. See Owen, *Painting*, 202–204, for a commendable exploration of the contrary effect—flattening space by a later manner of positioning figures. Owen points out that in the paintings of Behzad, conceptual perspective is effected by a combination of viewpoints; Behzad's figures are not, as are the Mongol figures, tilted upward, downward, and sideways.

21. For examples of such drawings in the TKS H.2153, see Klimburg-Salter, "A Sufi Theme," 55ff. Also see Ipşiroğlu, *Saray-Alben*, and Kühnel, "Malernamen."

22. For a discussion of the impact of Far Eastern art on Persian painting and on these figure types, their stylized representation, and their settings, see Inal, "Artistic Relationship Between the Far and the Near East," 116.

23. See Rice and Gray, *The Illustrations to the "World History*," 10–15, for a discussion of the wider range of ethnic and racial types represented in the 1306/7 *World History*. See also Simpson, "The Role of Baghdad in the Formation of Persian Painting," 109, and nn. 56, 58.

The Patron

1. Like those of the Demotte, the six *Shahnama* paintings, identified by Atasoy in the TKS album H.2153 ("Four Istanbul Albums," 11–13, figs. 11–16), share with the Istanbul *Kalila wa Dimna* the following iconographic and stylistic features: elaborate audience halls with an adjacent garden, asymmetrical enthronement scenes with figures related diagonally by gesture and eye contact, and the opening of the vista with sky and trees behind grilled windows; expressive inky outlining of rocks and trees with much texturing and modeling; an emphasis on the color orange in interior scenes; veined plant leaves with twisted red-and-gold tips; carpet and textile designs; and concepts of space. See Grabar and Blair, *Epic Images and Contemporary History*, 199, n. 26; Grube, *Persian Painting in the Fourteenth Century*, 32–33; and Cowen, "An Il-Khanid Masterpiece."

2. For the questions of dating and provenance, made complicated by the alleged repainting of several miniatures, and for illustrations, see Grube, *Persian Painting in the Fourteenth Century*; Gray et al., "Arts of the Book," 332, fig. 541; Buch-

tal, "Indian Fables in Islamic Art," 317, pl. 4, figs. 5 and 6; Ettinghausen, "On Some Mongol Miniatures," 57–60 and fig. 11; Kühnel, "A Bidpai Manuscript of 1343/44," figs. 1–3; Stchoukine, "Les Manuscrits illustrés," 140ff., figs. 5 and 7; Badeau et al., *The Genius of Arab Civilization*, 28; and Duda, "Buchmalerei."

3. First published by Ettinghausen, "On Some Mongol Miniatures," with an astute discussion of the evolution of the late IlKhanid and mid-fourteenth-century styles; see also Grube, *Persian Painting in the Fourteenth Century*, 18ff., for a controversial discussion and bibliography.

4. No one has as yet compared these two cycles in their entirety. Such a comparison is sure to unearth valuable material regarding the ideological program of the 1343/44 *Kalila wa Dimna*.

5. See Chapter III, n. 2, and Dickson, in Dickson and Welch, *The Houghton Shahnama*, 246ff., for a discussion of Dust Muhammad's aesthetic predilections and own work.

6. See Introduction, n. 17, and Grube, *Persian Painting in the Fourteenth Century*, 34–38. No one as yet has studied this cycle as a single entity.

7. For an excellent study of dress, see Schroeder, "Ahmed Musa and Shams al-Dīn"; for carpets, see Briggs, "Timurid Carpets." The zigzag carpet with Kufesque border in (8) and (30) appears to be an abstract rendering of a Seljuk type illustrated in Aslanapa, *Turkish Art and Architecture*, pl. 12. The painting's black dots placed on the angles of the red stripes are probably abbreviated palmettes. For other illustrations of the zigzag pattern, see Brend, "A Carpet and Related Pictures." However, there are problems with Brend's analysis of stylistic development and with the chronology based on it. The wide range of textiles merits further study. The Yüan-style cloud-patterned coverlet in (14) and the lozenge palmette brocade (*panni Tartarici*) in (1) are related to period textiles. The first is similar in design to but different in color from one illustrated in Falke, *Kunstgeschichte der Seidenweberei*, fig. 270. The second is comparable to one found in the tomb of Can Grande I (dated 1329) in the Castello Vecchio, Verona. For illustration, see Ackerman, "Islamic Textiles," 2042–62. The red brick or plaster, arch forms, interior decoration, and vertical proportions in (1), (2), (4), (14), (16), (37), and (38) are typical of Mongol architecture in Azerbaijan, the finest example of which is Oljeitu's Mausoleum at Sultaniya.

8. See the chapters "The Ideological Program of the Manuscript" and "The Milieu and Date of the Manuscript" in Grabar and Blair, *Epic Images and Contemporary History*.

9. See Wilbur, *The Architecture of Islamic Iran*, for a discussion of the monuments Abu Said sponsored, and Bowery, "Abu Said," for his other cultural interests and a bibliography of primary sources.

10. Gibb, *Ibn Battūta*, 101. See also Lech, *Al-ʿUmari*, 149–50, for another fourteenth-century description of Tabriz.

11. See Petrushevsky, "Feodal'noe Khozyistvo Rashid-al-dina," 104.

12. See Quatremère, *Histoire des Mongols en Perse*, 99.

13. See Petrushevsky, "The Socio-Economic Condition," 483–537, and Blair, "The Coins of the Later IlKhanids."

14. d'Ohsson, *Histoire des Mongols*, 723. However, the Rab-i Rashidi survived this sacking; one of its palaces was used in the 1380s, and Rashid al-Din's *vaqf* seems to have been operating during the Timurid period. See Rice and Gray, *The Illustrations to the "World History,"* 1.

15. See Quatremère, *Histoire des Mongols en Perse*, lii–lvi, n. 12; Browne, *A Literary History of Persia*, vol. 3, 56ff.; and Minorsky, *Calligraphers and Painters*, 61–62.

16. Hafiz-i Abru, *Chroniques des rois mongols en Iran*, 118.

17. Falina, *Rashīd al-Din*, 275–76 (letter 36). Although figures are inflated, these letters seem to be generally reliable; embellishments that may be traced to Ghiyas al-Din's compilation of the letters should be weighed lightly, considering the wealth of more general information.

18. Petrushevsky, "Rashīd al-Dīn's Conception of the State," 152, n. 16, and 153, n. 19, provides excellent sources.

19. Blair, "Il-Khanid Architecture and Society."

20. Falina, *Rashīd al-Din*, 198–206 (letter 27); see also 497 for an excellent discussion of this epistolary tradition.

21. Such scenes exemplify a moral attitude inappropriate, or simply distasteful, to a patron of royal birth or a ruler; a figure like Abu Said might otherwise be considered a possible patron.

22. Falina, *Rashīd al-Din*, 140 (letter 20).

The Album Paintings

1. These measurements are of the painted surface, including the margin(s).

2. Dress is carefully differentiated to reflect ethnic types, rank or profession, and changes of fashion during the second quarter of the fourteenth century. Green robes are usually worn by *Sayyids* (descendants of the Prophet), men who have made the hajj, or, as here, Islamic "men of the pen" and, elsewhere in the cycle, judges. Burzuya and Buzurgmihr in "The Sasanians," though not Muslims, wear green robes as signs of their learnedness. Schroeder compares the style of the checked lapels with those pictured in other fourteenth-century painting ("Ahmed Musa and Shams al-Dīn," 119 ff.). The lapels' checked material originates in Central Asia. See Rice and Gray, *The*

Illustrations to the "World History," 19, n. 16. The lesser courtiers—Turko-Mongols—wear Central Asian–style coats, designed so that the left side folds over the right, which fasten with a button or clasp just below the right armpit. See Rice and Gray, *The Illustrations to the "World History,"* 16, 17, and n. 10, who discuss this Central Asian tradition. The "mandarin square" with gold lotus design worn by Nasr Allah as an emblem of rank is probably a later addition. It does not appear in China until the Ming dynasty. Schroeder discusses the style of the guards' fur-brimmed hats ("Ahmed Musa and Shams al-Dīn," 122).

3. See Rosenthal, "A Note on the Mandil," 67, 69, 76–77. The belt of honor and gold-stamped boots are also Central Asian status symbols, although of lesser importance. Nasr Allah is shown wearing both.

4. The elongation of Nasr Allah's index finger is a Byzantine mannerist peculiarity common to this cycle and found in the Rashidiya *World History*, the Demotte *Shahnama*, and the TKS H.2152 and 2153 *Shahnama* album pages. Gestures, like eye contact, in "The Ghaznavids" subtly integrate figure groupings. In "Jamshid Teaches the Crafts," these devices do not succeed in creating as cohesive a composition.

5. The light- and dark-blue tiled dado, painted wall decorations, ornamental brick- or plasterwork, geometric-patterned carpet, and inlaid wooden door can be compared with artifacts of the period. See Chapter IV, n. 7, and Cowen, "An Il-Khanid Masterpiece," 93–95, for more specific discussion.

6. For comparison, see Rice and Gray, *The Illustrations to the "World History,"* 96, fig. 29, where white-bearded Abd al-Muttalib, grandfather of the Prophet, leans on a long red staff in "The Birth of the Prophet Muhammad." This elderly sage-type appears throughout the *Shahnama* album pages and the Demotte. None is quite as sedate and dignified as the figure in "The Ghaznavids."

7. For the tradition of enthronement scenes in earlier Mongol painting, and for their pre-Islamic sources, see Esin, "Two Miniatures." The depiction of the ruler with a pair of weapon-bearers—as found in "The Ghaznavids" and "The Sasanians" (2)—may have originated with Central Asian mandalas, in which the ruler sometimes assumes a Buddha pose and is flanked by two attendants. The inclusion of seven figures may derive from the tradition of portraying seven wise men in classical antiquity. For this tradition in Islamic art, see Ettinghausen, *Arab Painting*, 77. "The Ghaznavids" can also be characterized as combining a realistic court setting similar to those in the *Shahnama* album pages with the formal grandeur of enthronement scenes of the Demotte *Shahnama*.

8. Grabar and Blair, *Epic Images and Contemporary History*, 54; for discussion of the prevalence of this theme in the Demotte and other Mongol works, see 53–54.

9. These trident spears resemble Uighur flagpoles, the symbols of their kingdom. See Esin, "Tös and Moncuk," pl. 9, fig. E. They also appear in the 1306/7 *World History* as another example of the legacy the Mongols inherited from Turkish Inner Asia.

10. Through the years, the following similarities have been noted between this painting and those of the Demotte: Gray says that the embroidered squares on the front of some of the robes are of the same type ("Die 'Kalīla wa Dimna' der Universität Istanbul," 280); Duda notes that Burzuya and Zal in "Zal Before Manuchihr" are drawn in the same hard, graphic manner ("Buchmalerei," 175); and Grube sees a resemblance between this and the "most advanced compositions of the Demotte" (*Persian Painting in the Fourteenth Century*, 31). "Jamshid Teaches the Crafts" and two of the related *Shahnama* album pages also feature grille openings (Atasoy, "Four Istanbul Albums," pls. 6 and 7), but there seems to be no consistent emblematic designation of the ruler by such openings. Blair discusses the importance of grille doorways (*shabakat*) in IlKhanid tomb complexes ("The Mongol Capital of Sultaniyya," 143).

11. The embroidered yoke on this robe is post-Mongol in style. Schroeder says, "There is a possibility that the embroidery is retouched (faulty drawing on shoulder, overriding of joint of shoulder and breast, bright tone)" ("Ahmed Musa and Shams al-Dīn," 126).

12. Fidelity to the fourteenth-century original is particularly evident in the careful rendering of broken blades of grass; this motif was popular both in Mongol painting and in Yüan paintings of windblown orchis plants. The broken blades attest to the fourteenth-century artist's sophistication and delight in natural imperfections.

13. Petsopoulos, *Kilims*, pl. 320; it is said to be a forerunner of those made later in Fars.

14. Hanaway, "Paradise on Earth," 53, which is taken from Firdawsi, *Shahnamih*, vol. 1, 157.

15. Although cobalt-colored tiles are standard in this cycle, this eccentric green-tiled dado is realistic; similar green tiles appear on the outside dome of the altar of the Monastery of John the Baptist, built in Maragha and dedicated in 1301 (see Wilbur, *The Architecture of Islamic Iran*, 19) and in the related *Shahnama* scene "Jamshid Teaches the Crafts."

16. Koran LV:52. Two types of fruit trees growing in a garden also appear in "Daud Judges Between Two Brothers," in the 1306/7 *World History*, illustrated in Rice and Gray, *The Illustrations to the "World History,"* figs. 20 and 81. In such examples, though it may be related to standard poetic imagery, garden imagery is never as well developed, or as pointed, as in the paintings of the Istanbul cycle.

17. This compositional device has the same meaning in (14) and (22).

18. His red tongue is the central focus of the painting; its centrality also anchors the composition.

19. The artist deviates from the text, which refers to a stream. This change is characteristic of this cycle, where artists use elements of landscape to echo the figurative subject; here the pool repeats the circular posture of the hound.

20. See Figure 2B for a schematic drawing that reconstructs the original page. This same posture can be seen in the BN Arabe 3465, f. 43v.

21. Briggs categorizes this carpet as type II, but she might also have included it under type IIIa ("Timurid Carpets," 28). The bottom point of the octagon, which is the only one visible, turns downward, and therefore the point at the top must face in the opposite direction.

22. Forked beards occur in Uighur murals as a mark of high rank. See Esin, "Court Attendants in Turkish Iconography."

23. This striking orange color appears in the TKS H.363 version of this scene (f. 118), where Bidpai wears a prominent orange scarf. For the Cairo 1343/44 version, see 7b and Chapter IV, for discussion.

24. The artist seems to have altered the son's collar to resemble his father's more closely; the underpainting is evidence of this change.

25. The adze resting on the lower section of the plank is evidence of the care and precision with which realistic detail is noted; this section has not yet been worked and bears no lines or incisions. It is customary to work on one end and then the other.

26. A similar container appears in the same scene in the TKS H.363 *Kalila wa Dimna* (f. 38v), although it is not mentioned in the text.

27. The stylization of the lion's mane into wavy curls recalls that of the *Manafi* (53c); it nonetheless falls realistically over the shoulders of the *Kalila wa Dimna* lion.

28. These projecting rocks are comparable to those found in Yüan painting, such as *Lohan Watching the Dragons* by Lu Hsin; see Schroeder, "Ahmed Musa and Shams al-Dīn," n. 70 and fig. 11, who notes the pervasive Yüan influence on landscapes throughout the Istanbul cycle.

29. See Barasch, "Some Problems in the Mañāfiᶜ al-Hayawān," f. 37, fig. 29.

30. In the TKS H.363 version of this scene (f. 48), the colors of the textiles are strikingly similar. The couple lies on green and lavender material, which also covers the pillows. In addition, a gold band on the coverlet wraps the lovers in both

scenes, and the prostitute wears a lavender *chadur* and blue robe. For Yüan textiles with similar patterns (though differently colored), see Falke, *Kunstgeschichte der Seidenweberei*, fig. 270.

31. For illustration, see Grabar and Blair, *Epic Images and Contemporary History,* fig. 40.

32. Folio 10v in the Istanbul University Album.

33. See Rice and Gray, *The Illustrations to the "World History,"* figs. 32 and 37, and, for further discussion of this figure-type, see Simpson, "The Role of Baghdad in the Formation of Persian Painting," 108.

34. Duda discusses the representation of Chinese celadon in these paintings ("Buchmalerei," 178, n. 75); see also Gray, *Persian Painting,* 37. Aside from its color, this pot has more affinity with metalwork.

35. This stylization, a decorative interpretation of waves, can be seen in the Yüan murals at Yung-lo; see Teng, *Yung-lo Kuan Pi Hau.* It may well have been introduced into Iran through Yüan textiles, for example, "Kuan-yin with Willow Branch" (1295); see Lee and Ho, *Chinese Art Under the Mongols,* fig. 304. On the whole, the pattern of spray is fairly consistent throughout the cycle, with the basic style being varied slightly to conform to expressive needs. The calligraphic rendering of waves is a thirteenth-century Chinese convention (see Rice and Gray, *The Illustrations to the "World History,"* viii, 25, 62, and Gray, *Persian Painting,* 36–37, for post-1350 dating of this stylization). For other examples within this cycle, see (17), (39), (41), (43), (44), (45), and (48).

36. The mountainous landscape with small pines and a cascading stream appears in the 1314/15 *World History* as well; for illustration, see Gray, *The World History,* 20. However, the more organic approach to composition and the three-dimensional representation of mass in the Istanbul cycle far surpass the earlier diagrammatic portrayal of space and form.

37. In the TKS H.363 version of this scene (f. 72v), the ox also holds a front leg bent, though it seems unnecessary because he is standing erect. The inclusion of this detail in later versions attests to the persistence of certain motifs once they become embedded in the vocabulary of forms.

38. The Rampur copy of this scene provides merely the pool's lower edge and a missing portion of the water.

39. This subtle manipulation of a convention suggests that the two scenes were painted by the same capable artist.

40. The ruler's reliance on another's advice is expressed more poignantly than in those scenes that portray human characters at court: (1), (2), (7).

41. Although other paintings in the cycle have similar markings, none are as specifically animated by the use of this convention. In the broader tradition of this dash-and-eye pattern in fourteenth-century painting, however, this cycle is an exception to the Mongols' inorganic use of this pattern as a mere manneristic device.

42. Illustrated in Buchtal, " 'Hellenistic' Miniatures," fig. 34.

43. The sheepskin, part of the ascetic's possessions, is a reminder of man's animal soul (Koran XII: 53), which must be extinguished in order for man to achieve unity with God.

44. Schroeder compares the treatment of plants and clumps of grass in this painting with that in two Chinese works of the Sung and Yüan periods ("Ahmed Musa and Shams al-Dīn," n. 70, figs. 5 and 8). (Fig. 8 provides a good comparison, for its brushwork is deliberately distorted for expressive effect.)

45. This consistency, compared with the variation in the portrayal of figures, seems to indicate that the IlKhanid artists are more concerned with landscape painting than with figure representation. In the more figure-oriented Rampur manuscript, the hunters are identical.

46. Though he is below the crow, the owl sits on a rocklike throne; other animals are similarly designated in (12) and (52).

47. The same device is used to underscore the monkey-king's fall from power and his subsequent isolation (43).

48. Mihrabs were carved in stone caves near Shiraz as early as the twelfth century; like them, the mihrab shown here is composed of three recessed sections; see Fehérvári, "Tombstone or Mihrab?" 245–46, fig. 3, and "Two Early Mihrabs." The emphatic verticality of the mihrab pictured here is in keeping with Mongol taste.

49. See Daneshvari for medieval Sufi texts sharing the analogous belief that "nothing can better symbolize the greed, evil and untrustworthy 'self' than a cat" (*Animal Symbolism in Warqa wa Gulshah,* 40). The cat and his visitors are arranged in the same way in the TKS H.363 version (f. 128v) and in the 1343/44 *Kalila wa Dimna;* for an illustration of the latter, see Ettinghausen, "The Early History, Use and Iconography of the Prayer Rug," 14, fig. 5.

50. The corresponding text actually mentions four owl-ministers at court with their king, but the IlKhanid artists reduced the number of ministers to accommodate the scenes they chose to illustrate.

51. Although it takes an asymmetrical form in this painting, the old *chinar* is, in fact, a variation of the traditional Persian tree, which is placed in the center of the composition and flanked by animal pairs. The tree's location here in the upper half of the composition and the asymmetrical arrangement of its branches can be compared with the old trees depicted in certain Chinese paintings, for example, *Bamboo and Rock*

Under an Old Tree by Li Ti (1110–60). See Tomita, *Portfolio of Chinese Paintings*, pl. 72.

52. The stippling pattern added to give form and texture is more than likely derived from Chinese woodblock prints of flora; see Medley, "Sources of Decoration," 58–67. It is worth noting that Gray calls attention to Rashid al-Din's vast admiration for the skills of Chinese woodblock printers (*The World History*, 14).

53. Similar demons are widespread in contemporary Asian art, for example, Yen Hui's *The Lantern Night Excursion of Chung K'uei*, an early-fourteenth-century Yüan handscroll (Lee and Ho, *Chinese Art Under the Mongols*, fig. 206), and *Illustrated Legends of the Yuzu Nembutsu Sect*, an early-fourteenth-century handscroll from Japan. For illustration of the latter, see Rosenfield and Grotenhuis, *Journey of the Three Jewels*, fig. 40.

54. At Oljeitu's Mausoleum (dated 710/1310) at Sultaniya, however, a (blind) segmental arch is flanked by a (blind) narrow ogival arch. The grouping at Sultaniya is less idiosyncratic, however, and the openings are articulated in separate rectangular panels; see Wilbur, *The Architecture of Islamic Iran*, fig. 71. This scene in TKS H.363, f. 135, also has two floors, a brass ewer, and bedcovers with exaggerated folds—none of which appear in the text.

55. These patterns also appear on materials in the 1306/7 *World History*; there, however, they lack the ease and naturalness of representation of those in the *Kalila wa Dimna*. Such checked materials appear to have originated in Turfan. See Rice and Gray, *The Illustrations to the "World History,"* 19.

56. This is particularly evident when compared with the TKS H.363 version of this scene (14b), where the lover is placed above the other two figures. For other examples of the contemporary portrayal of women, see Grabar and Blair, *Epic Images and Contemporary History*, 20ff.

57. In the TKS H.363 version of this scene (f. 169), an ascetic also sits by a stream with his right foot prominent, comfortably but inappropriately resting on a thick cushion. However, that ascetic is much thinner.

58. Special mention should be made of the uncanny resemblance between this ascetic and the one in "The Lady and the Banker," dated 1485 and attributed to Behzad (from the *Khamsa* of Amir Khusraw, f. 209v); for illustration, see Robinson, *Persian Drawing*, pl. 24. It is interesting to note that not only is the appearance of these figures similar, but both stories deal with the miraculous transformation of a character.

59. Their stylization is reminiscent of that in "Destruction of the Temple at Jerusalem" from *al-Athar al-baqiya* of al-Biruni

(f. 158v). For illustration, see Gray, *Persian Painting*, 27, who also discusses this.

60. The uncropped Rampur painting shows that a stream originally flowed at the bottom—as is also the case in the scene of the first confrontation between the owls and the crows (33).

61. For the prevalence of this theme in contemporary and other works, see Grabar and Blair, *Epic Images and Contemporary History*, 25, n. 28.

62. For example, this theme is central to the contemporary paintings of the Demotte; for illustration of "The Execution of Ardawan," see Grabar, "Notes on the Iconography of the 'Demotte' *Shahnama*," 38, fig. 10.

63. The Rampur and Istanbul texts are only slightly out of phase here: the Rampur text begins one line ahead of the existing Istanbul fragment and includes an additional line of text.

64. The monkey strikes a similar pose in the TKS H.363 version of this scene (f. 151). In addition, the two share certain other features: turbulent waves, a grassy shoreline, and a rocky hillside next to the margin, from which grows a second tree, bending to one side (see 46b).

65. Schroeder compares this twisted, striated tree with one in a Yüan painting, *Hut in a Misty Landscape*, by Chang K'ung-sun ("Ahmed Musa and Shams al-Din," 127, fig. 10).

66. A similar arrangement can be seen in the TKS H.363 version of this scene (f. 158), although there the animals communicate along horizontal rather than diagonal axes. In both paintings, the cat is white with gold markings.

67. This scene recalls the conventional asymmetrical settings of such paintings as Ts'ui Po's *Hare and Jays*; in both, a tree grows diagonally from one corner to another.

68. A pheasant, rather than a lark, also appears in the Cairo 1343/44 version of this scene.

69. Although no number is specified in the text, four jackals are also shown in the TKS H.363 *Kalila wa Dimna* version of this scene (f. 183); in the earlier version, however, the ascetic jackal is not distinguished from his brothers (compare 52a and 52b).

70. Though generically related to other rock thrones in this cycle, its particular shape and the manner in which it rises to encircle the jackal call to mind the Rashidiya *World History* painting, "Muhammad Receiving His First Revelation through the Angel Gabriel." See Rice and Gray, *The Illustrations to the "World History,"* fig. 32.

71. Given Ghiyas al-Din's Jewish heritage, the Hebrew lan-

guage may have held particular poignancy for him. His father, although renowned for his Muslim piety and scholarship, had been immersed, before his conversion to Islam at age thirty, in Jewish culture and tradition. Reasonable conjecture suggests that Ghiyas al-Din was left a paternal legacy of some Hebrew as well as Sufi belief. For further discussion and sources on Ghiyas al-Din's Jewish heritage, see Fischel, "Azarbaijan in Jewish History," 15–18, and Spuler, *Die Mongolen in Iran,* 247–49.

Evidence of Rashid al-Din's knowledge of Judaism is found in his *World History,* where man's creation is derived from Midrashic sources. He was also accused of plotting the murder of Oljeitu by colluding with his alleged accomplices in Hebrew, which his enemies denounced as a secret code.

BIBLIOGRAPHY

Ackerman, P. "Islamic Textiles: A History, the Fourteenth Century." In A. U. Pope, ed., *A Survey of Persian Art.* Vol. 3. London and New York: 1939.

Adamova, A. T., and L. T. Giuzallian. *Miniatiury Rukopisi Poemy "Shahname" 1333 Goda.* Leningrad: 1985.

Afshar, I., and M. Minuvi. *Waqfiyya-i Rab i-Rashidi* [facsimile of Rashid al-Din's *vaqf*]. Teheran: 1971.

Agarawala, R. A. *Wall Paintings from Central India.* Delhi: 1987.

Allen, T. "Byzantine Sources for the *Jami' al-Tavarikh* of Rashid al-Din." *Ars Orientalis* 15 (1985): 121–38.

Arberry, A. J. et al. *Classical Persian Literature.* London: 1958.

Arnold, T. W. *Painting in Islam.* New York: 1965.

The Arts of Islam. London: 1976.

Ashrafi-Aini, M. M. "The School of Bukhara to c. 1550." In B. Gray, ed., *The Arts of the Book in Central Asia.* Paris and London: 1979.

Aslanapa, O. *Turkish Art and Architecture.* New York: 1971.

Atasoy, N. "Four Istanbul Albums and Some Fragments from Fourteenth Century *Shah-namehs.*" *Ars Orientalis* 8 (1970): 19–49.

———. "Illustrations Prepared for Display during Shahname Recitations." In *Memorial Volume of the 5th International Congress of Iranian Art and Archaeology.* Teheran: 1972.

———. "Istanbul Universitesi Kütüphânesi." *Istanbul Universitesi Bulteni* (1977): 30–32.

Atasoy, N., and F. Çağman. *Turkish Miniature Painting.* Istanbul: 1974.

Atil, E. *"Kalila wa Dimna": Fables from a Fourteenth Century Arabic Manuscript.* Washington, D.C.: 1981.

Avery, M. "Miniatures of the Fables of Bidpai and of the Life of Aesop in the Pierpont Morgan Library." *Art Bulletin* 23 (June 1941): 103–16.

Badeau, J. S. et al. *The Genius of Arab Civilization.* New York: 1975.

Barasch, M. "Some Problems in the Manāfi' al-Hayawān M. 500 of the Morgan Library." Master's thesis, New York University, Institute of Fine Arts, 1975.

Barrucand, M. "Les Représentations d'architectures dans la miniature islamique en Orient du début du XIIIᵉ au début du XIVᵉ siècle." *Cahiers Archéologiques* 34 (1986): 119–41.

Bausani, A. "Religion under the Mongols." In J. A. Boyle, ed., *The Cambridge History of Iran.* Vol. 5, *The Saljuq and Mongol Periods.* Cambridge: 1968.

Belenitski, A. M., and B. I. Marshak. "L'Art de Piandjikent à la lumière des dernières fouilles (1958–1968)." *Arts Asiatiques* 23 (1971): 3–41.

Binyon, L. *The Spirit of Man in Asian Art.* Cambridge, Mass.: 1936.

Binyon, L., J. V. S. Wilkinson, and B. Gray. *Persian Miniature Painting.* New York: 1933.

Blair, S. "The Coins of the Later IlKhanids: Mint Organization, Regionalization, and Urbanism." *American Numismatic Society Notes* 27 (1982): 209–27.

———. "Il-Khanid Architecture and Society: An Analysis of the Endowment Deed of the Rabi-Rashidi." *Iran* 22 (1984): 67–90.

———. "The Mongol Capital of Sultaniyya, 'The Imperial.' " *Iran* 24 (1986): 139–52.

Blochet, E. "On a Book of Kings of about 1200 A.D." *Rupam* 41 (1930): 2–10.

———. 'L'Origine byzantine des cartons des écoles de peinture persane, à Hérat au XVᵉ et au XVIᵉ siècles." *Seminarium Kondakovianum* (1931): 111–19.

Bowery, G. "Abu Said." In *Encyclopedia Iranica.* Vol. 1. London: 1983.

Boyce, M. "Middle Persian Literature." In *Handbuch der Orientalistik.* Vol. 4, *Iranistik.* Leiden: 1968.

Boyle, J. A. "The Il-Khans of Persia and the Princes of Europe." *Central Asiatic Journal* 20 (1975–76): 25–41.

———, ed. *The Cambridge History of Iran.* Vol. 5, *The Saljuq and Mongol Periods.* Cambridge: 1968.

Brend, B. "A Carpet and Related Pictures—A Legacy of Timur's Samarqand?" *Oriental Art* 20 (1984): 178–88.

Briggs, A. "Timurid Carpets." Part 1: "Geometric Carpets." *Ars Islamica* 7 (1940): 20–54.

Brockelmann, C. "Kalīla wa-Dimna." In *Encyclopaedia of Islam.* 1st ed. Vol. 2. Leiden and London: 1927.

———. "Kalīla wa-Dimna." In *Encyclopaedia of Islam.* 2nd ed. Vol. 4. Leiden: 1978.

Browne, E. G. *A Literary History of Persia.* Vols. 2 and 3. Cambridge: 1956.

Buchthal, H. " 'Hellenistic' Miniatures in Early Islamic Manuscripts." *Ars Islamica* 7 (1940): 125–33.

———. "Indian Fables in Islamic Art." *Journal of the Royal Asiatic Society* (1941): 317–24.

Buchthal, H., O. Kurz, and R. Ettinghausen. "Supplementary Notes to K. Holter's Check-list of Islamic Illuminated Manuscripts Before A.D. 1350." *Ars Islamica* 7 (1940): 147–64.

Çağman, F., and Z. Tanindi. *The Topkapi Saray Museum.* Ed. and trans. J. M. Rogers. Boston: 1986.

Chaghtai, M. A. *A Treatise on Calligraphists and Miniaturists by Dust Muhammad, the Librarian of Behram Mirza, d. 1550* (in Persian). Lahore: 1936.

Chand, T., and S. A. H. Abidi. "Pañchākhyāna." *Proceedings of the Twenty-Sixth International Congress of Orientalists* 2 (1968): 240–51.

Chapin, H. B. "A Long Roll of Buddhist Images." *Artibus Asiae* (1972).

Cheiko, L. *La Version arabe de Kalilah et Dimnah d'après le plus ancien manuscrit arab daté*. Beirut: 1905.

Chelkowski, P. *Mirror of the Invisible World: Tales from the "Khamseh" of Nizami*. New York: 1975.

Cowen, J. S. "Drama and Morality in Two Early Mongol Illustrated Sequences from the *Kalila wa Dimna*." *Oriental Art* 30 (Summer 1984): 167–77.

———. "The Istanbul University Library *Kalila wa Dimna*: An Il-Khanid Masterpiece." Ph.D. dissertation, New York University, Institute of Fine Arts, 1980.

Daneshvari, A. *Animal Symbolism in Warqa wa Gulshah*. Oxford Studies in Islamic Art, vol. 2. Oxford: 1986.

David-Weill, J. "Sur quelques illustrations de Kalila et Dimna." In O. Aslanapa, ed., *Beitrage zur Kunstgeschichte Asiens, in Memoriam Ernst Diez*. Istanbul: 1963.

Dickson, M. B., and S. C. Welch. *The Houghton Shahnama*. Boston: 1981.

Dikshit, K. N. "Excavations at Paharpur, Bengal." *Memoirs of the Archaeological Survey of India* 55 (1938).

d'Ohsson, A. C. M. *Histoire des Mongols*. Vol. 4. Amsterdam: 1852.

Duda, D. "Die Buchmalerei der Ġala' iriden." Parts 1 and 2. *Der Islam* 48 (1971) and 49 (1972): 153–221.

Edgerton, F., trans. *Pañchatantra Reconstructed*. 2 vols. New Haven, Conn.: 1924.

Edhem, F., and I. Stchoukine. *Les Manuscrits orientaux illustrés de la Bibliothèque de l'Université de Stamboul*. Paris: 1933.

Encyclopaedia of Islam. 2nd ed. 4 vols. Leiden: 1960–78.

Esin, E. "Court Attendants in Turkish Iconography." *Central Asian Journal* 14 (1970): 77–118.

———. Review of *La Peinture persane*, by Basil Gray. *Belleten* 26 (1962): 382–90.

———. "Tös and Moncuk: Notes on Turkish Flag Pole Finials." *Central Asiatic Journal* 16 (1972): 14–37.

———. "Two Miniatures from the Collections of the Topkapi." *Ars Orientalis* 5 (1963): 141–52.

Ettinghausen, R. *Arab Painting*. Geneva: 1962.

———. "The Early History, Use and Iconography of the Prayer Rug." In R. Ettinghausen, ed., *Prayer Rugs*. Washington, D.C.; 1974.

———. "Ilkhans." In *Encyclopaedia of Islam*. 2nd ed. Vol. 3. Leiden: 1971.

———. "On Some Mongol Miniatures." *Kunst de Orients* 3 (1959): 44–65.

———. "Persian Ascension Miniatures of the Fourteenth Century." *Accademia Nazionale dei Lincei, 12 Convegno "Volta."* Rome: 1957.

———. "Persian Elements in the Morgan Bidpai Cycle." Appendix to M. Avery, "Miniatures of the Fables of Bidpai and of the Life of Aesop in the Pierpont Morgan Library." *Art Bulletin* 23 (June 1941): 114–16.

Ettinghausen, R., and O. Grabar. *The Art and Architecture of Islam, 650–1250*. Harmondsworth and New York: 1987.

Falina, A. I., ed. *Rashīd al-Din: Perepiska* [Letters]. Moscow: 1971.

Falke, O. V. *Kunstgeschichte der Seidenweberei*. Berlin: 1921.

Fehérvári, G. "Tombstone or Mihrab? A Speculation." In R. Ettinghausen, ed., *Islamic Art in the Metropolitan Museum of Art*. New York: 1972.

———. "Two Early Mihrabs Outside Shiraz." *Bulletin of the Asia Institute* 1 (1969): 3–11.

Fischel, W. J. "Azarbaijan in Jewish History." *Proceedings of the American Academy for Jewish Research* 2 (1953): 1–21.

Gabrieli, F. "Ibn al-Mukaffaʿ." In *Encyclopaedia of Islam*. 2nd ed. Vol. 3. Leiden: 1971.

Gangoly, O. C. "An Illustrated Manuscript of *Anvar-i-Suhaili*: A New Version." *Rupam* 42 (1930): 11–14.

Gibb, H. A. R., ed. and trans. *Ibn Battūta: Travels in Asia and Africa, 1325–1354*. Vol. 2. London: 1963.

Golombek, L. "Toward a Classification of Islamic Painting." In R. Ettinghausen, ed., *Islamic Art in the Metropolitan Museum of Art*. New York: 1972.

Grabar, O. "A Newly Discovered Illustrated Manuscript of the *Maqāmāt* of Ḥarīri." *Ars Orientalis* 5 (1963): 97–111.

———. "Notes on the Iconography of the 'Demotte' *Shahnama*." In R. Pinder-Wilson, ed., *Paintings from Islamic Lands: Oriental Studies* 4. Oxford: 1969.

———. "The Visual Arts, 1050–1350." In J. A. Boyle, ed., *The Cambridge History of Iran*. Vol. 5, *The Saljuq and Mongol Periods*. Cambridge: 1968.

Grabar, O., and S. Blair. *Epic Images and Contemporary History: The Illustration of the Great Mongol "Shahnama."* Chicago: 1980.

Gray, B. "Art under the Mongol Dynasties of China and Persia." *Oriental Art*, n.s., 1 (1955): 159–67.

———. "Chinese Influence in Persian Painting." *The Westward Influence of Chinese Arts*. London: 1972.

———. "Fourteenth-Century Illustrations of the 'Kalilah and Dimna.'" Part 1. *Ars Islamica* 7 (1940): 134–40.

———. "History of Miniature Painting: The Fourteenth Century." In B. Gray, ed., *The Arts of the Book in Central Asia*. Paris and London: 1979.

———. "Die 'Kalila wa Dimna' der Universität Istanbul." *Pantheon* 12 (1933): 380–83.

———. *Persian Painting*. New York: 1961.

———. "The School of Shiraz from 1391 to 1453." In B. Gray, ed., *The Arts of the Book in Central Asia*. Paris and London: 1979.

———. *The World History of Rashid al-Din. A Study of the Royal Asiatic Society Manuscript.* London: 1978.

Gray, B. et al. "Arts of the Book." In *The Arts of Islam.* London: 1976.

Grube, E. J. *The Classical Style in Islamic Painting.* Rome: 1968.

———. "The *Kalilah wa Dimnah* of the Istanbul University Library and the Problem of Early Jalairid Painting." In *Akten des VII International Kongresses für Iranische Kunst und Archaologie, München (1976).* Berlin: 1979.

———. *Muslim Miniature Paintings from the XIII to the XIX Century.* Venice: 1962.

———. *Persian Painting in the Fourteenth Century: A Research Report. Annali,* Instituto Orientale di Napoli, vol. 38, suppl. 17 (1978).

———. "Persian Painting in the Fourteenth Century." In *Memorial Volume. Sixth International Congress of Iranian Art and Archaeology, Oxford (1972).* Teheran: 1976.

———. *La piturra del'Islam: miniature persiane del XII al XVI sec.* Bologna: 1980.

———. "Two *Kalilah wa Dimna* Codices Made for Baysunghur Mīrzā: The Concept of the 'Classical Style' Reconsidered." In *Problemi dell'età timuride.* Venice: 1979.

Grube, E. J., and E. Sims. "The School of Herat from 1400 to 1450." In B. Gray, ed., *The Arts of the Book in Central Asia.* Paris and London: 1979.

Hafiz-i Abru. *Chroniques des rois mongols en Iran.* Ed. K. Bayani. Paris: 1936.

Haldane, D. *Mamluk Painting.* Warminster: 1978.

Hammer-Purgstall, J. V. *Geschichte des osmanischer Reiches.* Vol. 3. Pest: 1827–35.

Hanaway, W. L., Jr. "Paradise on Earth: The Terrestrial Garden in Persian Literature." In E. B. MacDougal and R. Ettinghausen, eds., *The Islamic Garden.* Washington, D.C.: 1976.

Henning, W. B. "Sogdian Tales." *Bulletin of the School of Oriental and African Studies* (London) 11 (1945): 465–87.

Holter, K. "Die Galen Handschrift und die Makamen des Hariri der Wiener Nationalbibliothek." *Jahrbuch der Kunsthistorischen Sammlungen Wien* 11 (1937): 1–48.

———. "Die islamischen Miniaturhandschriften vor 1350." *Zentralblatt für Bibliothekwesen* 54 (1937): 1–34.

Hourani, Z. "The Cycle of Miniatures in Arabic and Persian Manuscripts of *Kalila wa Dimna* Produced Before 1500 A.D." Master's thesis, Oxford University, 1979.

Howorth, H. H. *History of the Mongols from the Ninth to the Nineteenth Century.* Vol. 3. London: 1888.

Hunt, L. A. "Christian–Muslim Relations in Painting in Egypt of the Twelfth to Mid-Thirteenth Centuries: Sources of Wall-painting at Deir es Suriani and the Illustration of the New Testament MS Paris, Copte-Arabe 1/

Cairo, Bibl. 94." *Cahiers Archéologiques* 33 (1985): 111–55.

Inal, G. "Artistic Relationship Between the Far and the Near East as Reflected in the Miniatures of the *Ğāmiᶜ al-Tawārīh.*" *Kunst des Orients* 10 (1975): 108–43.

———. "Some Miniatures from the *Jāmiᶜ al-Tavārīkh* in Istanbul, Topkapi Museum, Hazine Library No. 1654." *Ars Orientalis* 5 (1963): 163–75.

Ipşiroğlu, M. S. *Das Bild im Islam.* Vienna: 1971.

———. *Painting and Culture of the Mongols.* New York: 1966.

———. *Saray-Alben, Diez'sche Klebebande aus den Berliner Sammlungen.* Weisbaden: 1964.

———. *Saray-Alben: Verzeichnig der orientalischen Handschriften in Deutschland.* Vol. 8. Wiesbaden: 1964.

Ipşiroğlu, M. S., and S. Eyüboğlu. *Turkey: Ancient Miniatures.* Paris: 1961.

James, D. "Space-Forms in the Work of the Baghdad *Maqamat* Illustrations, 1223–58." *Bulletin of the School of Oriental and African Studies* 37 (1974): 305–20.

Karatay, F. E. *Topkapü Sarayi Kütüphânesi: Farsça Yazmalar Kataloğu.* Istanbul: 1961.

Kevorkian, A. M., and J. P. Sicre. *Les Jardins du désir.* Paris: 1983.

Klimburg-Salter, D. E. "A Sufi Theme in Persian Painting: The Diwan of Sultan Ahmad Ğalā'ir in the Freer Gallery of Art, Washington, D.C." *Kunst des Orients* 2 (1976–77): 43–84.

Kramisch, S. "A Painted Ceiling." *Journal of the Indian Society of Oriental Art* 7 (1939): 175–83.

Kühnel, E. "A Bidpai Manuscript of 1343/44 (744 H.) in Cairo." *American Institute for Iranian Art and Archeology* 5 (1937): 137–41.

———. "History of Miniature Painting and Drawing." In A. U. Pope, ed., *A Survey of Persian Art.* Vol. 3. London and New York: 1939.

———. "Malernamen in den Berliner Saray-Alban." *Kunst des Orients* 3 (1959): 66–78.

Lech, K., ed. and trans. *Al-'Umari: Darstellung der mongolische Weltreich.* Wiesbaden: 1968.

Lee, S. E., and W.-K. Ho. *Chinese Art Under the Mongols: The Yüan Dynasty, 1279–1368.* Cleveland: 1968.

Lehrman, J. *Earthly Paradise: Garden and Courtyard in Islam.* Berkeley and Los Angeles: 1980.

Levy, R. *The Tales of Marzuban.* London: 1959.

———, ed. and trans. *Ferdowsi: The Epic of the Kings (Shahnama).* London: 1967.

Loehr, M. "Chinese Elements in the Istanbul Miniatures." *Ars Orientalis* 1 (1954): 85–89.

Mahjoub, M. J. *Darbarah "Kalila wa Dimna"* [About "Kalila and Dimna"]. Teheran: n.d.

Martin, F. R. *Miniatures from the Period of Timur in a Ms. of the Poems of Sultan Ahmed Jalair.* Vienna: 1926.

Medley, M. "Sources of Decoration in Chinese Porcelain from the 14th to 16th Century." In M. Medley, ed., *Chinese Painting and the Decorative Style: Colloquies on Art and Archaeology in Asia, No. 5*. London: 1975.

Melikian-Chirvani, A. S. "Le Roman de Varqe et Golšāh." *Arts Asiatiques* 22 (1970): 1–262.

———. "Le *Shah-name*, la gnose soufie et le pouvoir mongol." *Journal Asiatique* (1984): 249–335.

Minorsky, V. "The Older Preface to the Shah-nama." *Studi orientalistici in onore di Giorgio Levi della Vida*. Vol. 2. Rome: 1956.

———, ed. and trans. *Calligraphers and Painters: A Treatise by Qadi Ahmad, son of Mir-Munshi, c. 1015/1601*. Washington, D.C.: 1959.

Minuvi, M., ed. *Kalila wa Dimna [as Written by Abu al-Maali Nasr Allah Munshi]*. Teheran: 1964.

Miquel, A., ed. and trans. *Le Livre de "Kalila et Dimna," Fables de Bidpai, par Ibn al-Mouquaffa*. Paris: 1957.

Öğütmen, F. *Miniature Art from the XIIth to the XVIIIth Century (A Guide to the Miniature Section of Topkapi Sarayi)*. Istanbul: 1966.

Owen, P. *Painting*. New York and Toronto: 1970.

Penzer, N. M., ed. *The Ocean of Story*. Vol. 5. London: 1926.

Perry, B. E. *Aesopica*. Urbana, Ill.: 1952.

Petrushevsky, I. P. "Feodal'noe Khozyistvo Rashid-al-dina" [Rashid al-Din's feudal estate]. *Voprosy Istorii* 4 (1951): 87–104.

———. "Rashīd al-Dīn's Conception of the State." *Central Asiatic Journal* 14 (1970): 148–62.

———. "The Socio-Economic Condition of Iran under the Il-Khāns." In J. A. Boyle, ed., *The Cambridge History of Iran*. Vol. 5, *The Saljuq and Mongol Periods*. Cambridge: 1968.

Petsopoulos, Y. *Kilims*. New York: 1979.

Plotinus. Review of *La Miniature persane du XIIᵉ au XVIIᵉ siècle*, by A. B. Sakisian. *Rupam* 40 (1929): 34–35.

Qazvini, M. *Bist Maqāla* [Twenty discourses]. Vol. 2. Teheran: 1953.

Quatremère, E. M. *Histoire des Mongols en Perse, écrit en persan par Raschid-eldin, publiée, traduite en français, accompagnée de notes et d'un mémoire sur la vie et les ouvrages de l'auteur*. Vol. 1. Paris: 1836.

Raby, J. "Between Sogdia and the Mamluks: A Note on the Earliest Illustration of the *Kalila wa Dimna*." *Oriental Art* (1987–88): 381–98.

Rice, D. S., and B. Gray. *The Illustrations to the "World History" of Rashid al-Din*. Edinburgh: 1976.

Robinson, B. W. "Der Kampf des Lowen mit den Ochsen Šanzaba." In J. V. Sourdel-Thomine and B. Spuler, eds., *Die Kunst des Islam: Propyläen Kunstgeschichte 4*. Berlin: 1973.

———. *Persian Drawing from the 14th through the 19th Century*. New York: 1965.

———. *Persian Miniature Painting from the Collections in the British Isles*. London: 1967.

———. "Prince Baysunghur and the Fables of Bidpai." *Oriental Art* 16 (1970): 145–54.

———. "A Survey of Persian Painting (1350–1896)." In C. Adle, ed., *Art et société dans le monde iranien*. Bibliothèque Iranienne, no. 26. Paris: 1982.

———. "The Tehran Manuscript of *Kalila wa Dimna*: A Reconsideration." *Oriental Art* 4 (1958): 108–15.

Rogers, J. M. "Note on Iconography." *Central Asiatic Journal* 14 (1970): 223–27.

Rohani, N. *A Bibliography of Persian Miniature Painting*. Cambridge: 1982.

Rosenfield, J., and E. ten Grotenhuis. *Journey of the Three Jewels*. New York: 1979.

Rosenthal, F. "A Note on the Mandil." In F. Rosenthal, ed., *Four Essays in Art and Literature in Islam*. Leiden: 1971.

Rossabi, M. "The Muslims in the Early Yüan Dynasty." In J. D. Langolis, Jr., ed., *China under Mongol Rule*. Princeton, N.J.: 1981.

Saito, K. "The Yuan Blue-and-White and the Yuan Drama in the Middle of the 14th Century, Part I." *Kobijutsu* 18 (1967): 25–41.

———. "The Yuan Blue-and-White and the Yuan Drama in the Middle of the 14th Century, Part II." *Kobijutsu* 19 (1967): 52–74.

Sacy, S. de. *Kalila et Dimna ou fables de Bidpai*. Paris: 1816.

Sakisian, A. B. "Co-existent Schools of Persian Miniature Painting." *Burlington Magazine* 76 (1940): 144–55.

———. "L'École de miniature pré-mongole de la Perse orientale." *Revue des Arts Asiatiques* 7 (1931): 156–62.

———. "Une École de peinture pré-mongole dans la Perse orientale." *Gazette des Beaux-Arts*, 5th ser., 7 (1923): 16–30.

———. *La Miniature persane du XIIᵉ au XVIIᵉ siècle*. Paris and Brussels: 1929.

Schapiro, M. "On Some Problems in the Semiotics of Visual Art: Field and Vehicle in Image-Signs." *Simiolus: Netherlands Quarterly for the History of Art* 6 (1972–73): 9–19.

Schimmel, A. "The Celestial Garden in Islam." In E. B. MacDougal and R. Ettinghausen, eds., *The Islamic Garden*. Washington, D.C.: 1976.

Schroeder, E. "Ahmed Musa and Shams al-Dīn: A Review of Fourteenth Century Paintings." *Ars Islamica* 6 (1938–39): 113–42.

Seyler, J. "The School of Oriental and African Studies. *Anvār-i Suhayli*." *Ars Orientalis* 16 (1986): 119–52.

Shrieve-Simpson, M. "The Narrative Structure of a Medieval Iranian Beaker." *Ars Orientalis* 12 (1981): 15–25.

Simpson, M. S. "The Role of Baghdad in the Formation of Persian Painting." In C. Adle, ed., *Art et société dans le monde iranien.* Bibliothèque Iranienne, no. 26. Paris: 1982.

Sims, E. G. "The Garrett Manuscript of the *Zafar-name.*" Ph.D. dissertation, New York University, Institute of Fine Arts, 1973.

Smith, J. M., Jr. *The History of the Sarbadar Dynasty, 1336–1381 A.D., and Its Sources.* The Hague: 1970.

Soucek, P. "An Illustrated Manuscript of al-Biruni's *Chronology of Ancient Nations.*" In P. J. Chelkowski, ed., *The Scholar and the Saint.* New York: 1975.

———. "Illustrated Manuscripts of Nizami's *Khamsa:* 1386–1482." Ph.D. dissertation, New York University, Institute of Fine Arts, 1971.

Sourdel, M. D. "La Biographie d'ibn al-Muqaffa d'après les sources anciennes." *Arabica* 1 (1954): 307–23.

Sourdel-Thomine, J., and B. Spuler. *Die Kunst des Islam: Propyläen Kunstgeschichte 4.* Berlin: 1973.

Sprengling, M. "Kalila Studies." Part 1. *American Journal of Semitic Languages and Literatures* 40 (1924): 81–97.

Spuler, B. *Die Mongolen in Iran.* Berlin: 1955.

Stchoukine, I. "Les Manuscrits illustrés musulmans de la Bibliothèque du Caire." *Gazette de Beaux-Arts* 13 (1935): 138–58.

———. *La Peinture iranienne sous les derniers 'Abbasides et les îl-Khâns.* Bruges: 1936.

———. *Les Peintures des manuscrits tîmûrides.* Paris: 1954.

———. Review of *La Miniature persane du XII^e au XVII^e siècle,* by A. B. Sakisian. *Revue des Arts Asiatiques* 6 (1929–30): 57–64.

Surieu, R. *Sarv é Naz.* Geneva: 1967.

Teng, F., ed. *Yung-lo Kuan Pi Hua* [Paintings of the Yung-lo Kuan]. Shanghai: 1959.

Tomita, K. *Portfolio of Chinese Paintings in the Museum of Fine Arts, Boston.* Boston: 1962.

Travis, J. "The Battle of Ardavan and Ardashir from the Demotte *Shah Nameh.*" *Art Quarterly* 31 (1968): 63–75.

Waley, P., and N. Titley. "An Illustrated Persian Text of *Kalila and Dimna* Dated 707/1307–8." *British Library Journal* 1 (1975): 42–62.

Welch, A. "The Arts of the Book." In T. Falk, ed., *Treasures of Islam.* Geneva: 1985.

———. *Collection of Islamic Art: Prince Sadruddin Aga Khan.* Geneva: 1972.

Welch, S. C. *India: Art and Culture.* New York: 1985.

West, S. H. "Mongol Influence on the Development of Northern Drama." In J. D. Langlois, Jr., ed., *China under Mongol Rule.* Princeton, N.J.: 1981.

Whelan, E. J. "The Public Figure: Political Iconography in Medieval Mesopotamia." Ph.D. dissertation, New York University, Institute of Fine Arts, 1979.

Wilbur, D. N. *The Architecture of Islamic Iran: The Il Khānid Period.* Princeton, N.J.: 1955.

Wilbur, D. N., and Minuvi, M. "Notes on the Rab-i-Rashidi." *American Institute for Iranian Art and Archeology Bulletin* 5 (1938): 247–54.

Wood, R., adapted by. *"Kalila and Dimna": Selected Fables of Bidpai.* Introduction by Doris Lessing. New York: 1980.

Yorukan, B. "Some Roll Fragments Found in the Topkapi Serayi Museum." *Sanat Tarihi Yilligi* (1964–65): 188–202.

Zimmer, H. *The Art of Indian Asia.* Bollingen Series 39. Princeton, N.J.: 1955.

APPENDIX

Published Color Illustrations from the Istanbul
Kalila wa Dimna *(IUL F.1422)*

"The Clever Merchant and the Gullible Thief"
Gray, *Persian Painting,* 39

"The Greedy Dog and His Bone"
Sourdel-Thomine and Spuler, *Die Kunst des Islam,* pl. 48
(upper half)

"The Old Madam and the Young Couple"
Gray, *Persian Painting,* pl. 38
Ipşiroğlu and Eyüboğlu, *Turkey: Ancient Miniatures,* pl. 6
Surieu, *Sarv é Naz,* 60–64

"The Lion-King Receives Shanzaba"
Ipşiroğlu, *Das Bild,* pl. 51

"The Battle of the Lion-King and Shanzaba"
Sourdel-Thomine and Spuler, *Die Kunst des Islam,* pl. 48
(lower half)

"The Weasel and the Deceitful Frog"
Gray, "History of Miniature Painting," 100, pl. 25

"The Rogue and the Simpleton"
Gray, "History of Miniature Painting," 100, pl. 24
Kevorkian and Sicre, *Les Jardins du désir,* 28.

"The Lioness Confronts Dimna"
Ipşiroğlu and Eyüboğlu, *Turkey: Ancient Miniatures,* pl. 6

"The Cuckolded Carpenter"
Surieu, *Sarv é Naz,* 68–72

"The Ascetic and the Adopted Mouse"
Surieu, *Sarv é Naz,* 68–72

"The Old Snake"
Gray, "History of Miniature Painting," 100, pl. 25

"Kardana's Deposition"
Gray, "History of Miniature Painting," 100, pl. 25

"Kardana and the Tortoise Become Friends"
Gray, *Persian Painting,* 35 (upper half)
Kevorkian and Sicre, *Les Jardins du désir,* 84 (lower half)

"Kardana's Escape"
Gray, *Persian Painting,* 35 (upper half)
Kevorkian and Sicre, *Les Jardins du désir,* 84 (upper half)

"The Frightened Mouse and the Trapped Cat"
Ipşiroğlu and Eyüboğlu, *Turkey: Ancient Miniatures,* pl. 5

"The Ascetic Jackal and His Brothers"
Ipşiroğlu, *Das Bild,* pl. 50
Ipşiroğlu and Eyüboğlu, *Turkey: Ancient Miniatures,* pl. 5

Published Illustrations from the
TKS H.363 Kalila wa Dimna

Double frontispiece: "The Sasanians" and Their Scribes (ff. 1v
and 2)
Çağman and Tanindi, *The Topkapi Saray Museum,* fig. 25
(color)

"The Ghaznavids" (f. 6)
Çağman and Tanindi, *The Topkapi Saray Museum,* fig. 26
(color)

"Shanzaba and the Ploughman" (f. 27)
Çağman and Tanindi, *The Topkapi Saray Museum,* fig. 27
(color)

"Story of Incense: Two Men Talking" (f. 28v)
Barrucand, "Les Représentations d'architectures," 127, fig.
12 (line drawing)

"The Greedy Dog and His Bone" (f. 32v)
Ipşiroğlu, *Das Bild,* fig. 8 (color)

"Man's Fate" (f. 35v)
Çağman and Tanindi, *The Topkapi Saray Museum,* fig. 28
(color)

"The Lion-King Receives Dimna" (f. 42)
Ipşiroğlu, *Das Bild,* fig. 11

"The Crow and the Snake" (f. 54v)
Çağman and Tanindi, *The Topkapi Saray Museum,* fig. 29
(color)

"The Battle of the Lion-King and Shanzaba" (f. 72v)
Waley and Titley, "An Illustrated Persian Text," fig. 15

"Kalila and Dimna Talking" (f. 73v)
Barrucand, "Les Représentations d'architectures," 127, fig.
13 (line drawing)

"The Servant Enjoying the Wife" (f. 87)
Çağman and Tanindi, *The Topkapi Saray Museum,* fig. 30

"Dimna Imprisoned" (f. 88v)
Ipşiroğlu, *Das Bild,* fig. 12 (color)

"The Hunter and the Ensnared Doves" (f. 99v)
Ipşiroğlu, *Das Bild,* fig. 7 (color)

"The Brahman Tells His Wife the Story of the Dead Hunter
and the Wolf" (f. 106v)
Barrucand, "Les Représentations d'architectures," 126, fig.
10 (line drawing)

"The Woman and the Husked Sesame Seeds" (f. 107v)
Ipşiroğlu, *Das Bild,* fig. 13 (color)

"The Crow-King Consults His Ministers" (f. 119v)
Ipşiroğlu, *Das Bild,* fig. 9

"The Crow Insults the Owls" (f. 124v)
Waley and Titley, "An Illustrated Persian Text," fig. 16

"The Hare Tricks the Elephant" (f. 127v)
Çağman and Tanindi, *The Topkapi Saray Museum*, fig. 31

"The Crow Spy" (f. 132v)
Ipşiroğlu, *Das Bild*, fig. 10

"The Cuckolded Carpenter" (f. 136)
Ipşiroğlu, *Das Bild*, fig. 14 (color)

"The Two Ascetics and the Mouse Maiden" (f. 169v)
Waley and Titley, "An Illustrated Persian Text," fig. 14 (incorrectly titled "Irandukht with Two Men")

Published Datings and Provenances

1923	Sakisian, "Une École de peinture pré-mongole," 18, 30	Pre-Mongol, early thirteenth century, Khorasan.
1926	Martin, *Miniatures from the Period of Timur*, 20	Circa thirteenth century, Baghdad or Khorasan. Decorative adaptations of Sung painting.
1929	Sakisian, *La Miniature persane*, 14–15	Revises to late twelfth century. Calligraphic evidence.
1929	Plotinus, review of Sakisian, 34–35	Sixteenth century. Relates to realism of Mongol school.
1929–30	Stchoukine, review of Sakisian, 61	Fourteenth century, Mongol school. Western influences important.
1930	Gangoly, "An Illustrated Manuscript of *Anvar-i Suhaili*," 13–14	Late fourteenth or early fifteenth century. First to connect Rampur ms. but reverses the two cycles' time sequence.
1930	Blochet, "On a Book of Kings," 6–7	Fifteenth century. Relates to Timurid painting of 1380–1400. Differentiates Iranian and Sung palette.
1931	Blochet, "L'Origine byzantine des cartons," 119	Circa 1390. Chinese influence in Tabriz.
1931	Sakisian, "L'École de miniature pré-mongole," 158	Reasserts pre-Mongol, based on orthography, and compares with *Bidpai* ms. of 1279–80.
1933	Gray, "Die 'Kalila wa Dimna,'" 282	1350. Compares motifs such as clothes and architecture with contemporary mss. Midway between the *World History* and the *Khamsa*.
1933	Edhem and Stchoukine, *Les Manuscrits orientaux*, 42	Late fourteenth or early fifteenth century. Suggests two versions of *Kalila wa Dimna* were pasted into album.
1933	Binyon, Wilkinson, and Gray, *Persian Miniature Painting*, 36–37	Mid-fourteenth century, Tabriz, large-style school.
1936	Binyon, *The Spirit of Man in Asian Art*, 118	Revises to thirteenth century. Unassimilated Chinese influence.
1936	Stchoukine, *La Peinture iranienne*, 101–2	Revises to mid-fourteenth century, Mongol school. Similarities to Demotte *Shahnama*. Two stylistic groups, two artists.
1937	Holter, "Die islamischen Miniaturhandschriften," 24	Confirms Blochet's late-fourteenth-century date.
1937	Kühnel, "A Bidpai Manuscript of 1343/44," 137	Places cycle in Herat. Compares with the 1343/44 Cairo *Kalila wa Dimna*.
1939	Schroeder, "Ahmed Musa and Shams al-Dīn," 128, 130	1320–40. Study of costumes. Uses Dust Muhammad's account; attributes to Ahmad Musa.
1939	Kühnel, "History of Miniature Painting and Drawing," 1836–37	Confirms mid-fourteenth-century date and Herat location.
1940	Briggs, "Timurid Carpets," 28	Accepts Gray's 1350 date.
1940	Gray, "Fourteenth-Century Illustrations of the 'Kalilah and Dimna,'" 139–40	Revises to Schroeder's date, circa 1330. Resolution of Iranian and Mongol influences.
1940	Sakisian, "Co-existent Schools," 150	Pre-thirteenth century. Based on orthography.

1954	Stchoukine, *Les Peintures des manuscrits tîmûrides*, 38	Mongol school of Tabriz, second half of fourteenth century.
1957	Ettinghausen, "Persian Ascension Miniatures," 372	Second quarter of fourteenth century. Attributes to Ahmad Musa.
1961	Gray, *Persian Painting*, 36–37	Redates to third quarter of fourteenth century. Water patterns borrowed from post-1350 Chinese porcelain.
1961	Ipşiroğlu and Eyüboğlu, *Turkey: Ancient Miniatures*, 20–21	Fourteenth century. Relates to Demotte *Shahnama*.
1963	David-Weill, "Sur quelques illustrations de Kalila et Dimna," 260	Supports Sakisian's twelfth-century date.
1965	Ipşiroğlu, *Painting and Culture of the Mongols*, 59	Revises to 1370, Mongol school.
1967	Surieu, *Sarv é Naz*, 181	Mongol, mid-fourteenth century, Tabriz.
1968	Grabar, "The Visual Arts," 649	1330–70. Chinese influence. Compares with the Demotte *Shahnama*.
1970	Atasoy, "Four Istanbul Albums," 32–33	Pre-1374. Attributes to Shams al-Din.
1971	Ettinghausen, "Ilkhans," 1127	Post–Demotte *Shahnama* of 1330–40. More "experimental."
1971	Soucek, "Illustrated Manuscripts of Nizami's *Khamsa*," 188–89	*Kalila wa Dimna* and Demotte *Shahnama* "assured" works, prior to *Farhadnama* of 1372 by about twenty-five years.
1971–72	Duda, "Buchmalerei," 172–80	1370–80, Tabriz. Falls between Gray's stylistic and Blochet's orthographic dating.
1972	Welch, A., *Collection of Islamic Art*, 39	1365, Mongol school, Tabriz.
1973	Robinson, "Der Kampf des Lowen," 314	First half of fourteenth century.
1976 (published posthumously)	Rice and Gray, *The Illustrations to the "World History*," 31	Second half of fourteenth century. Refers to Gray for stylistic analysis.
1976	Grube, "Persian Painting in the Fourteenth Century"	1360–70; attributes to Ahmad Musa.
1978	Grube, *Persian Painting in the Fourteenth Century*, 30	1360–70; attributes to Ahmad Musa.
1979	Grube, "The *Kalilah wa Dimna*," 496–99.	1360–70; attributes to Ahmad Musa.
1979	Gray, "History of Miniature Painting," 100, 108	Revises to 1370–74; stylistic similarity to Demotte *Shahnama* album pages.
1980	Grabar and Blair, *Epic Images and Contemporary History*, 39–40	Note similarities with Demotte *Shahnama* but noncommittal about dating.
1980	Grube, *La piturra del'Islam*, 28	Jalayirid period of 1360.
1980	Cowen, "An Il-Khanid Masterpiece"	1327–35, Tabriz; the 1343/44 *Kalila wa Dimna* provides *terminus ante quem*.
1982	Robinson, "A Survey of Persian Painting"	Dust Muhammad was probably correct, but picture captions attribute paintings to mid-fourteenth-century Baghdad.
1982	Kevorkian and Sicre, *Les Jardins du désir*, 28	Cite opinions of Gray and Grube.

INDEX

Page numbers in bold face refer to illustrations.